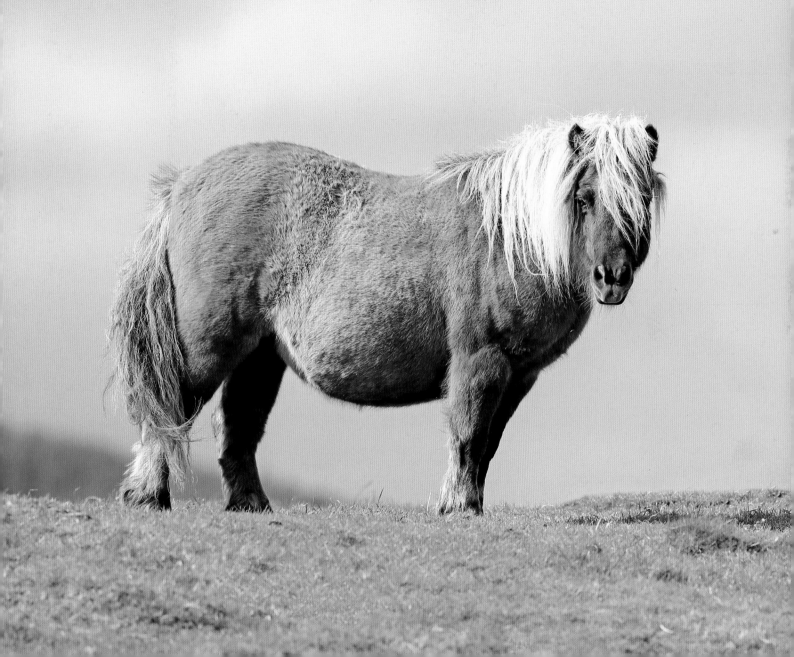

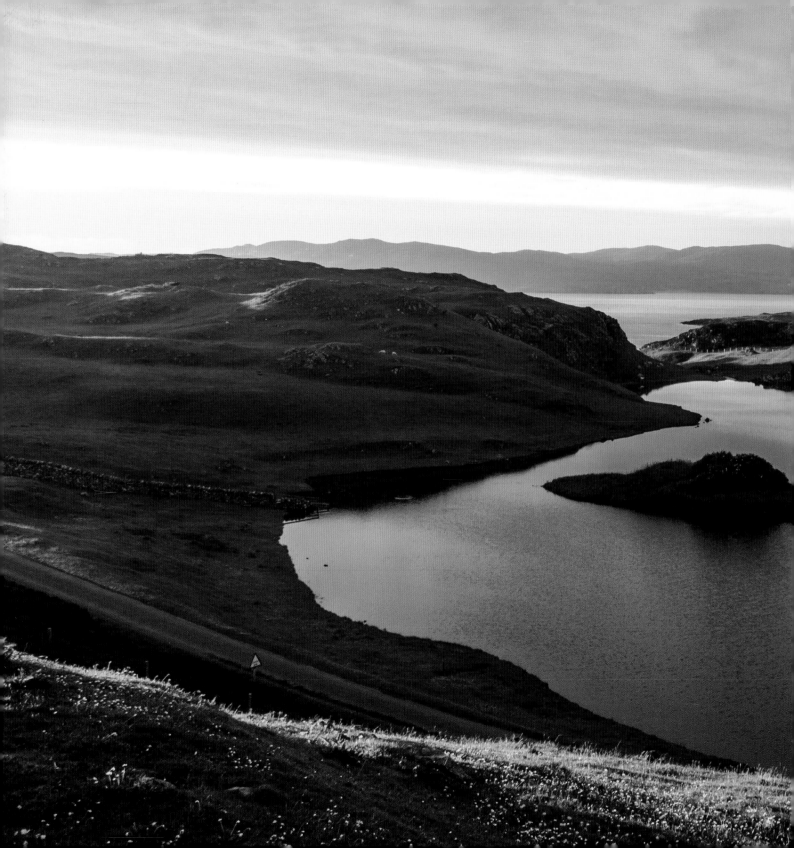

# SHETLAND

## Ann Cleeves

MACMILLAN

**PREVIOUS PAGE** *A small loch near Vementry.*

**BELOW** *Eshaness Lighthouse and cliff.*

**OVERLEAF** *Fair Isle South Light.*

# Contents

Introduction

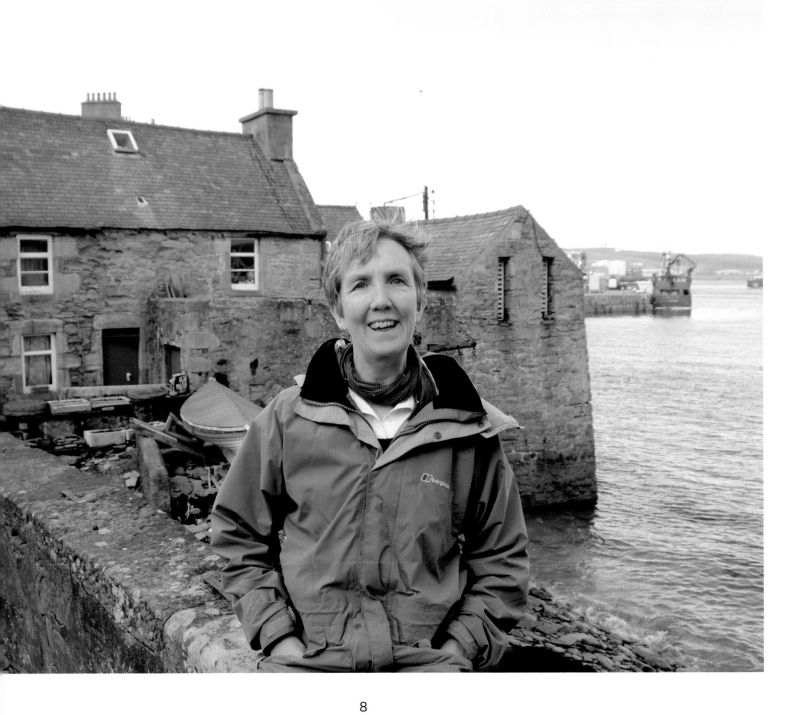

It's exactly forty years since I first went to Shetland. I'd dropped out of university and found myself, lost and a little miserable, in London. I was working as a childcare officer for Camden Social Services, a job that I enjoyed, but which involved very long hours. I'd grown up in the country, and in London I had few friends and little support. Then, after a chance meeting in a pub, I was offered a job as assistant cook in the bird observatory in Fair Isle. I wasn't even quite sure where Fair Isle was, but I was young, it sounded like an adventure and, more importantly, it represented escape from the city. I arrived on the most remote inhabited island in Shetland, and the UK, in the wake of gale-force winds, very seasick and feeling like an impostor – after all, I knew nothing about birds and I couldn't cook!

But it was spring, the cliffs were raucous with seabirds and pink with thrift, and from the moment I stepped ashore I was enchanted. I loved the island and its people, the routine of crofting and bird migration, the stories of shipwrecks and storms. I met my husband there – he came as a visiting birdwatcher and then returned the following year to camp, and to work on a friend's croft in return for food and home-brew. We left as a couple and we're still together. Since then Shetland has been my place of sanctuary and inspiration. It's where I go to spend time with friends, to blow away the anxieties of everyday life and to write. I've set six novels there, and I'm already planning two more, and the BBC's TV adaptation of my work is airing across the world. Another series is in production.

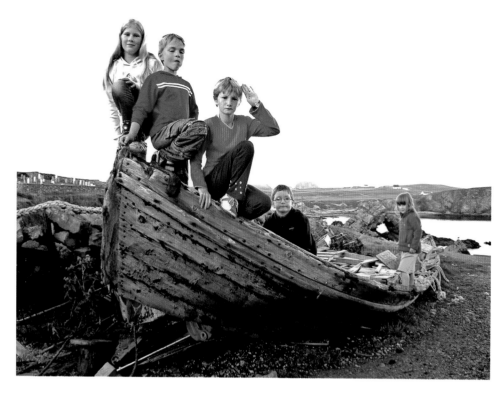

LEFT *Fair Isle children.*

RIGHT *The new observatory was completed in 2010.*

My first visit to Shetland was a time of dramatic change in the islands. Oil was being extracted from the North Sea for the first time, and the big terminal at Sullom Voe in North Mainland was under construction. On my rare visits to Shetland Mainland, Lerwick – the islands' biggest settlement – had the feel of a gold-rush town. There was an influx of people who saw the chance of making money; I bumped into suited executives, contractors and oilmen on their way to the rigs.

Shetland has a history of people arriving from outside, though, and I think it managed the time of transition well. It still welcomes visitors with grace and hospitality, whether they're tourists desperate to experience the fire festival of Up Helly Aa or a BBC film crew. I enjoy writing about the islands just because they are dynamic, changing and energetic. Don't come to Shetland imagining a Viking theme park, a place fixed in the past. History is important here, but the community looks to the future, to developing sustainable energy and becoming as self-sufficient in food as it can manage. Artists and craftspeople use the traditions of spinning and knitting to create new textile designs. Young musicians play old tunes and write their own music. The islands are bleak and beautiful and very alive.

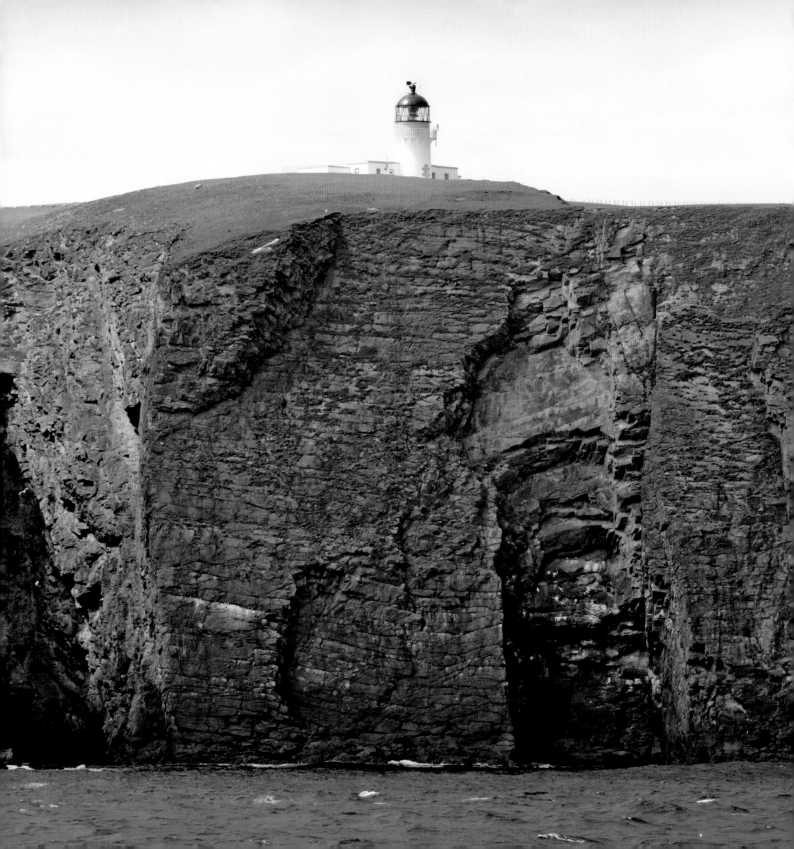

**LEFT** *Fair Isle North Light.*

**BELOW** *Muckle Flugga Lighthouse.*

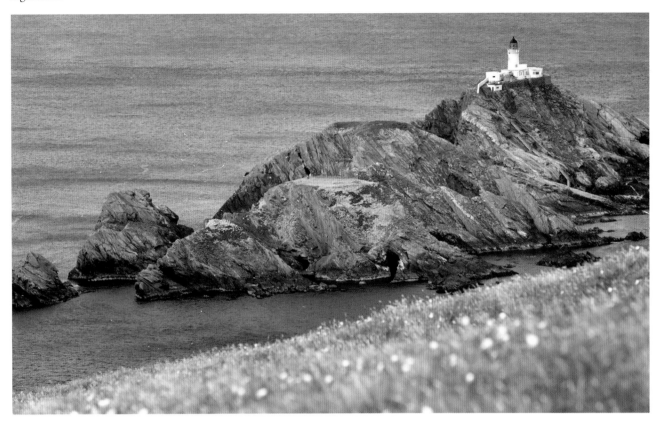

Shetland is an archipelago of more than a hundred islands that lie at the most northerly point of the United Kingdom. It's over ninety miles long from Out Stack in the north to Fair Isle in the south. The islands are long and thin and perhaps the shape – a little like the hilt of a sword – provides an explanation of its name in Norse, 'Hjaltland'. Most of the islands are uninhabited, and approximately one-third of the population of about 22,000 lives in Lerwick. Shetland extends from 59° 51' north to 61° north, the same line of latitude as Anchorage in Alaska and the southern tip of Greenland. Lerwick is in fact closer to the Arctic Circle than to London. Yet while the winters are often wet and windy, Atlantic currents carrying warm water that originated in the Caribbean mean that they are relatively mild. It was the contrast between the dark days of winter and the light nights of summer that prompted me to use the changing seasons as a background to my first four books.

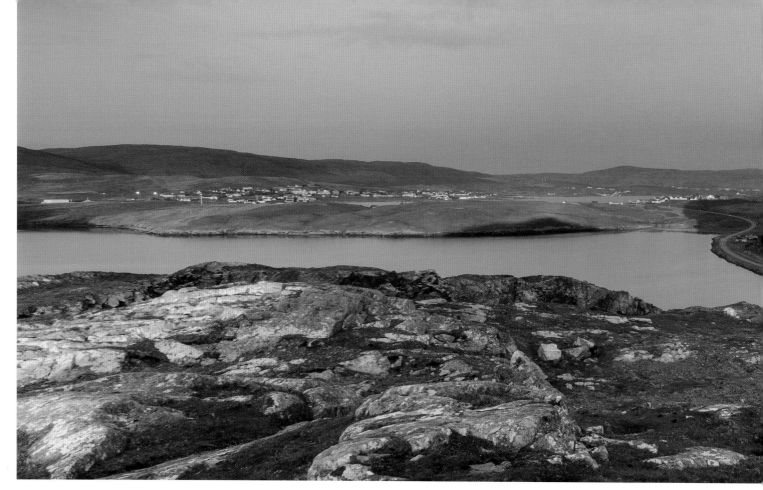

The magic of Shetland's landscape lies in its coastline – it has more than 1,500 miles of shoreline, and wherever one stands the view is of the water. It's impossible to be more than three miles from the sea. At Mavis Grind in Northmavine the island is so narrow that it would be possible to throw a rock from the North Sea to the Atlantic – if you have a strong arm. There are dramatic sea cliffs at Eshaness in Northmavine, at Hermaness in Unst, in Noss and, most spectacularly, in the island of Foula, where a small population, and a primary school and teacher, still survives.

**ABOVE** *Mavis Grind.*

**RIGHT** *Foula.*

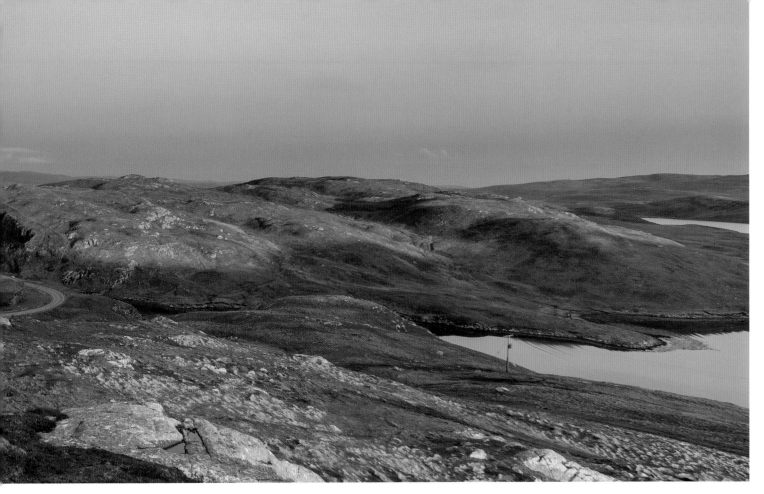

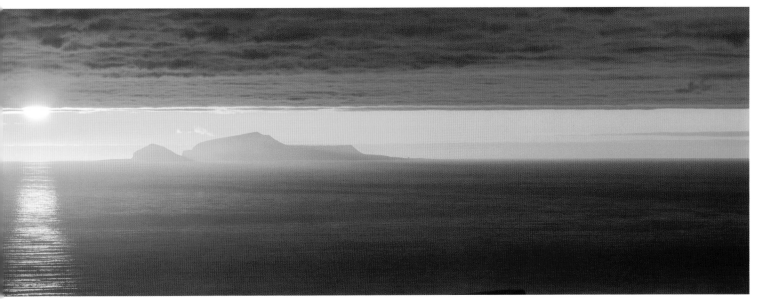

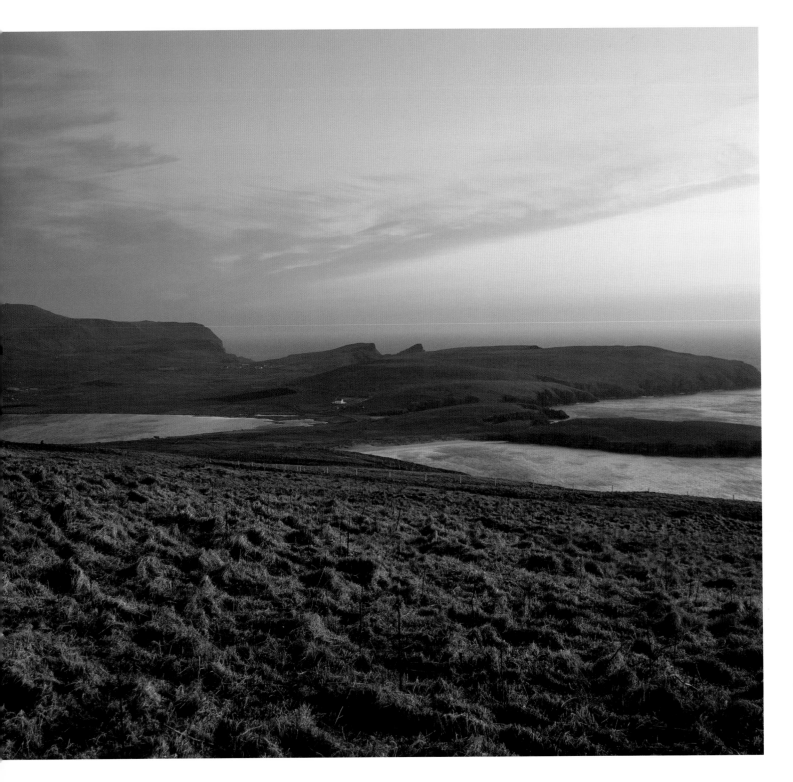

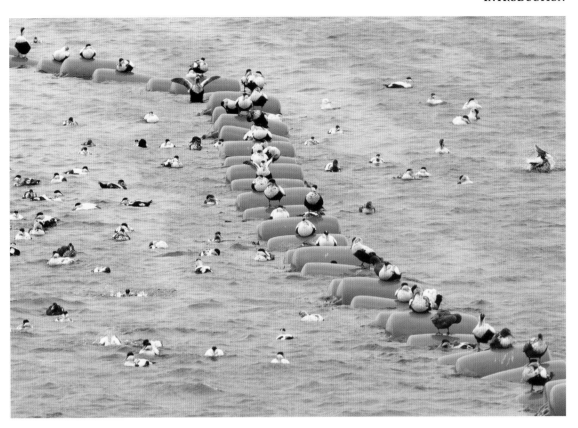

**LEFT** *Spiggie Loch.*

**RIGHT** *Eider ducks on mussel rope buoys.*

**BELOW** *Spiggie Beach.*

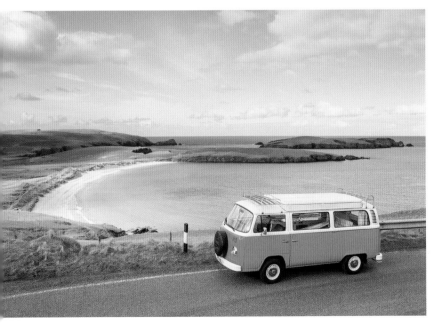

There are voes, flooded valleys that were scooped out by glaciers and now cut into the land. These provide space for mussel and salmon farms – the mussel ropes look like strings of jet beads, with each bead as a buoy marking the rope below; and the salmon are farmed in cages. And there are lochs, big ones like Spiggie, separated from the sea only by a line of dunes, and small nameless pools in the hills. It has been estimated that there are 1,600 lochs and pools in the islands. Light is splintered by the water and the weather is reflected in it, so the outlook changes according to the sunlight and cloud and the time of day.

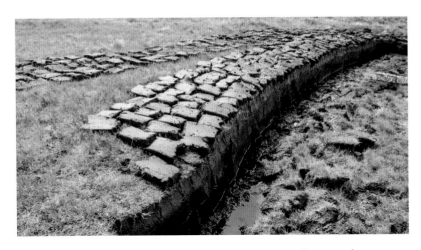

**ABOVE** *Cut peats drying.*

**RIGHT** *Farmhouse and ruined crofts on Foula.*

There is a rich variety of habitats throughout the archipelago. The high granite areas of North Mainland and Unst are known as 'fellfield' and are home to arctic or dwarf forms of plant. Though once it was heavily forested with birch scrub and rowan, there are now few trees in Shetland; a few native species remain in isolated pockets not reached by sheep or rabbits, and attempts have been made to plant conifer plantations. The bare hills create a landscape of long horizons and big skies. About 50 per cent of Shetland is covered in peat and it is still cut for fuel. Intricately arranged stacks are built to allow the peat to dry. Agriculture is based around sheep – there are more than 100,000 of them in the islands. Though some of the lowland is cultivated, the pattern of small crofts with strip fields, more common when I first arrived in the 1970s, has largely disappeared.

The inhabited islands are connected by bridge (like that to Trondra, both Burra Isles and Muckle Roe) or by regular ferry – it's possible to commute to Lerwick from Bressay, Whalsay or even Yell. The more remote islands of Foula and Fair Isle are reached by a mailboat that can take passengers, but not their cars. These crossings aren't always comfortable or even possible, and many islanders and visitors prefer to use the small planes operated by Shetland Island Council from Tingwall airport. On a clear day it's a spectacular way to come into the more remote islands. Visitors arrive into Shetland by plane from Glasgow, Inverness, Edinburgh or Aberdeen, into Sumburgh airport to the south of Mainland, or by overnight ferry from Aberdeen into Lerwick.

**BELOW** *Burra Bridge.*

**RIGHT** *Tingwall looking towards Trondra Bridge.*

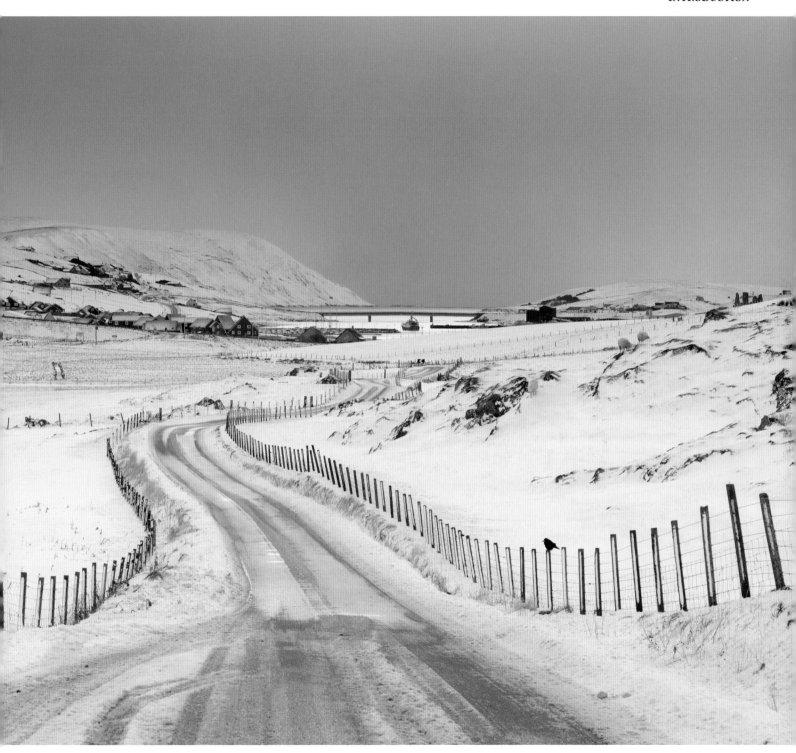

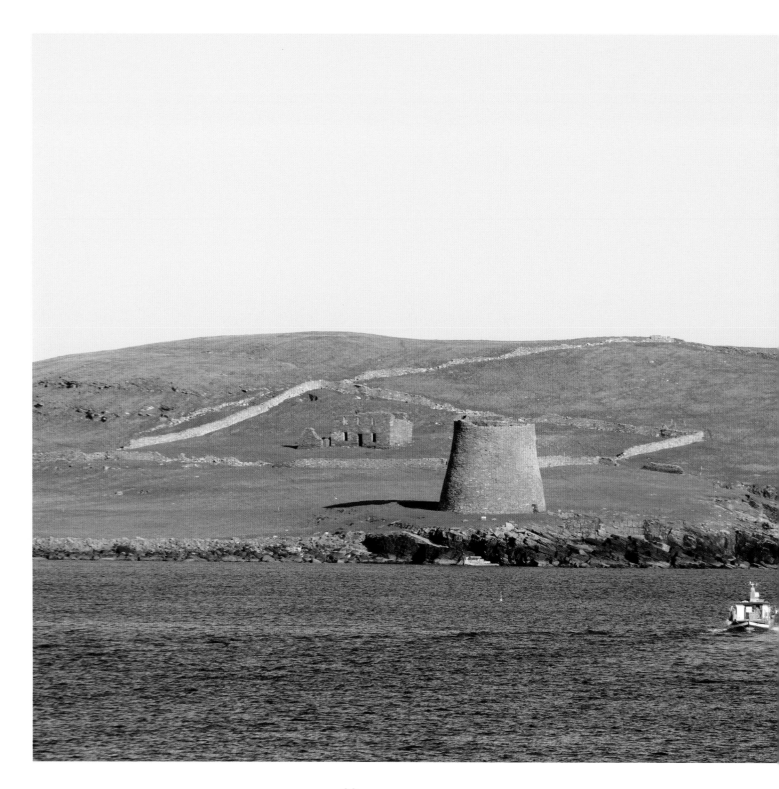

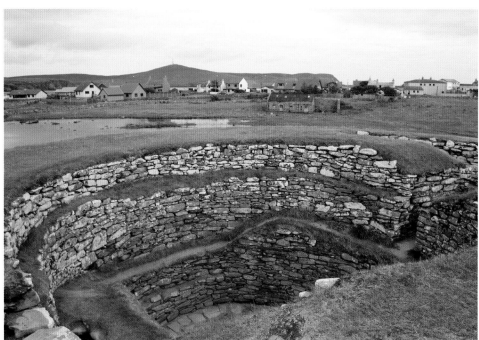

Of course the first visitors to Shetland came by boat and the journey must have been long and arduous. It is possible they arrived before 5000 BC, but the oldest remaining structures – chambered cairns, houses and field walls left by Neolithic farmers – date from 3250 BC. There is a sense of history everywhere in the islands, a feeling that every standing stone and ruined house can tell a story or holds a secret – inspiration for any crime writer. During the Iron Age, from around 500 BC, the distinctive brochs were built. Brochs are drystone towers, with outer and inner walls. It's still possible to climb the stone steps between the walls in the amazingly well-preserved broch on the island of Mousa, and another remains in Clickimin Loch, close to Lerwick town centre.

**LEFT** *Mousa Broch.*

**ABOVE** *Clickimin Broch.*

By the sixth century AD the Picts had arrived in Shetland, and spectacular evidence of their presence was found in the St Ninian's Isle treasure, which was discovered beneath the floor of a chapel in a larchwood box, along with the jawbone of a porpoise. There were twenty-eight silver objects, and these included drinking bowls, sword fittings and brooches. Replicas of these beautifully carved items can be seen in the museum in Lerwick's Hay's Dock.

Shetland is best known for its Viking heritage. Though we have no accurate date of their first arrival in the islands, the Vikings probably didn't settle until the ninth century AD. We do know that the existing language was replaced very quickly by Old Norse, and that most of Shetland's place names derive from that time. It's clear that the Vikings didn't just come to attack and pillage, but that they stayed and developed sophisticated communities. Just like more recent inhabitants, they were farmers and fishermen. They kept cows, sheep and ponies and grew barley. The tradition of spinning and weaving also began at that time, iron was smelted and water mills were used to grind grain.

Shetland belonged to Denmark until 1469. Denmark was a major power and ruled Norway at the time, so the Norwegian connection to the islands dates back many centuries. When the Danish king couldn't afford a dowry for his daughter, Shetland was handed to Scotland. For many years afterwards it suffered the hardships endured by other rural communities ruled by lairds, whose motivation was more often financial gain than the well-being of their tenants. The croft clearances that had a major impact on the Scottish landscape occurred later in Shetland than they did on the mainland, and some of the island lairds were native Shetlanders. Crofters paid their rent in kind — fish, butter, meat and knitwear — and were then forced to buy other goods either through the landowner or from powerful merchants. In the nineteenth century poverty in Shetland led to mass emigration, mostly to Canada and New Zealand.

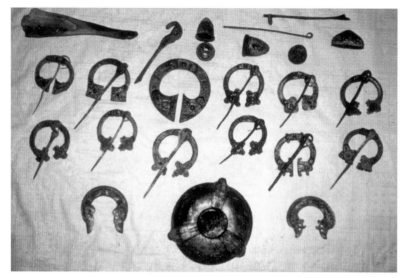

**ABOVE** *St Ninian's Isle Treasure.*

**RIGHT** *Ruined Viking chapel on St Ninian's Isle where the treasure was found by a schoolboy.*

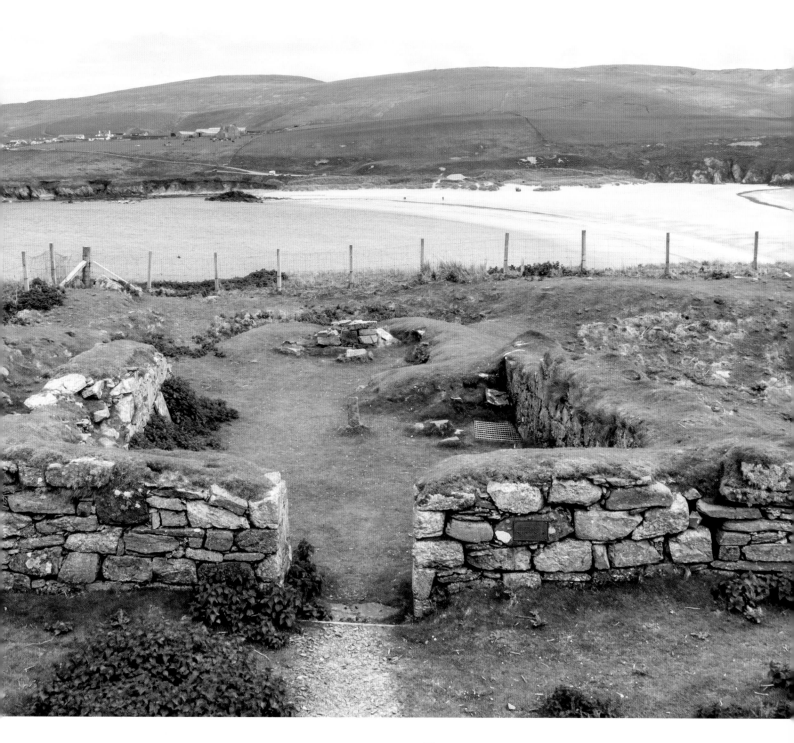

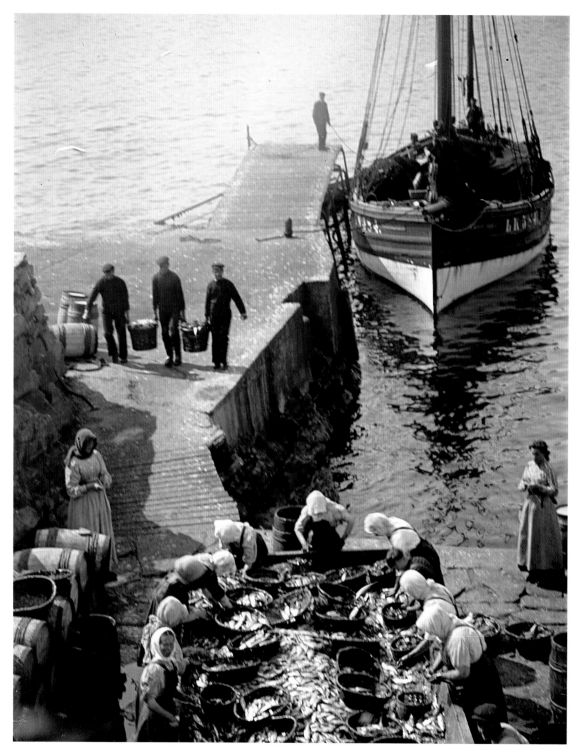

LEFT *Gutting fish in the 1910s at Cumliewick.*

ABOVE *The Hanseatic trading booth at Symbister, right.*

RIGHT *Cutting up a whale carcass at Olna whaling station in the 1920s.*

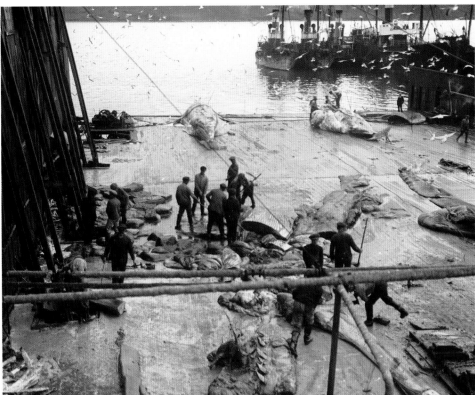

Fishing became more important, and from the fifteenth until the eighteenth centuries fish was exported through the Hanseatic League, a trading partnership based around the North Sea, and mostly in German towns like Bremen and Hamburg. It is still possible to see one of the Hanseatic trading booths at the pier in Symbister in the island of Whalsay, and I used this setting and these historical details in the novel *Red Bones*. From the seventeenth century Arctic whaling ships called into Shetland for supplies and repairs and, because of their skill as seamen, Shetlanders were recruited to join the crews. They were still serving on whalers in the southern oceans until the middle of the twentieth century, when the practice died out as the industry became uneconomic and attitudes to whaling changed. In the late nineteenth century the herring fishery grew and drew in another wave of outside workers; the catch was processed by women and preserved in barrels of salt. There is still a substantial fleet of pelagic trawlers in the islands today, and many of these large and well-equipped ships continue to be based in Whalsay. Fishing is the most lucrative industry in Shetland, despite the wealth created by North Sea oil.

**LEFT** *Pilot boat at Lerwick.*

**RIGHT** *The monument to the 'Shetland Bus' in Scalloway.*

Shetland's link with Scandinavia has been cemented in more recent times by the close relationship between the islands and Norway during the Second World War. Norway was occupied by the Germans, and an operation based in the islands and supervised by British military intelligence helped resistance fighters return to their home country. Small fishing boats, built solely for use in inland waters and fjords, crossed the treacherous waters of the North Sea carrying men, weapons and money. This movement was known as the 'Shetland Bus' and is celebrated by a monument in the small town of Scalloway and in the museum there. In the summer there is now a scheduled direct flight between Sumburgh and Bergen.

In this book I hope to take you on a journey through a year in the life of the islands. You'll meet its people, celebrate its festivals and see how the flora and fauna of Shetland change with the seasons. By the end I hope you'll understand why the place means so much to me.

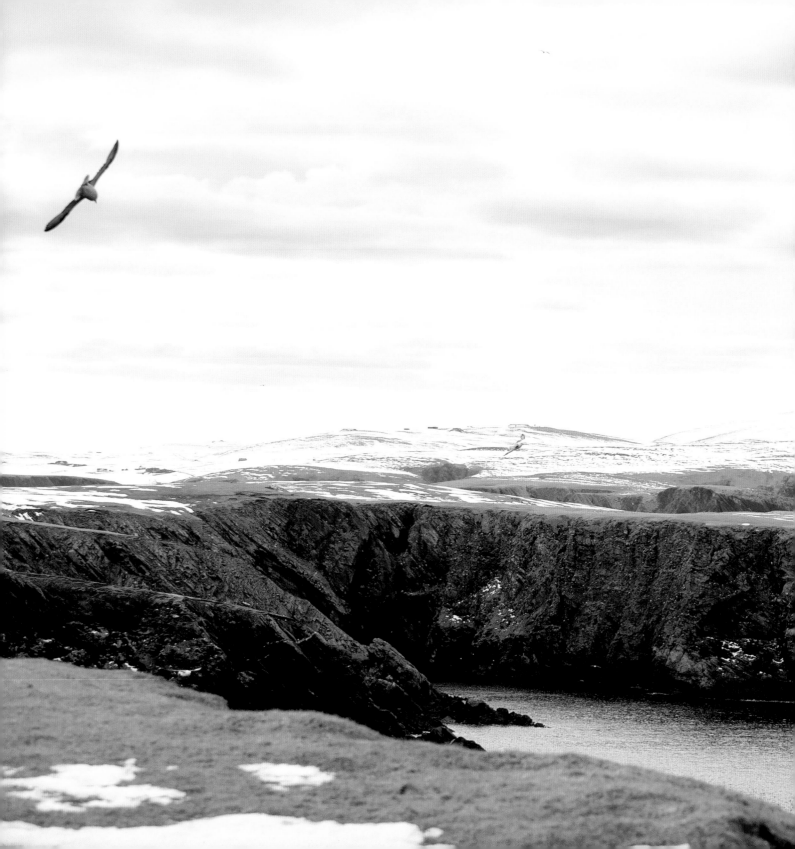

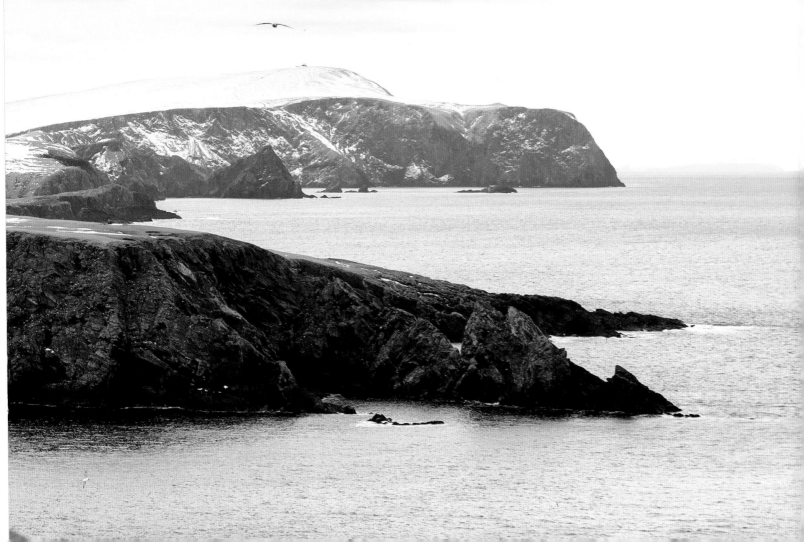

# Winter

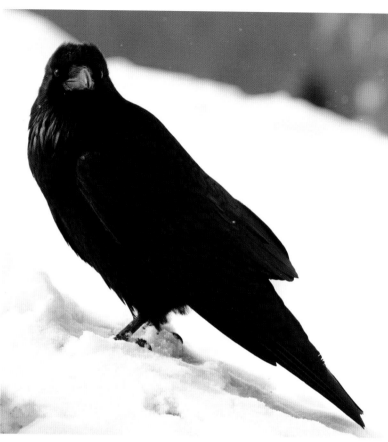

**CHAPTER OPENER** *Fitful Head with Fair Isle in the distance.*

**PREVIOUS PAGE** *Shetland pony in November.*

**LEFT** *Raven in the snow.*

**RIGHT** *Snow at St Ninian's Isle in April.*

a passionate birdwatcher, and a very rare bird had turned up in Lerwick. I hadn't given him a very exciting Christmas gift, so I decided that a day-trip to the islands might be a good belated present. Now it seems a crazy thing to have done: there was a long drive to Aberdeen and an overnight fourteen-hour trip on the ferry, before we arrived into Lerwick well before dawn. Unusually for Shetland, it was still and very cold. There was snow on the ground and even the shore was covered in blue ice. When the sun did come up, it was a huge orange ball in a clear sky. We saw ravens, very black against the snow, with their distinctive wedge-shaped tails and harsh calls. And because I'm a crime writer, I thought if there was blood too, it would remind the reader of a scene from a fairy tale, where the princess has skin as white as snow, lips as red as blood and hair as black as ebony. Very mythic somehow. That's how the novel was started. I began planning it on the ferry south, though at that point I thought it might be a short story. It seemed impertinent for an outsider to write a Shetland novel, and it was only the encouragement of the islands' literature officer that persuaded me to continue.

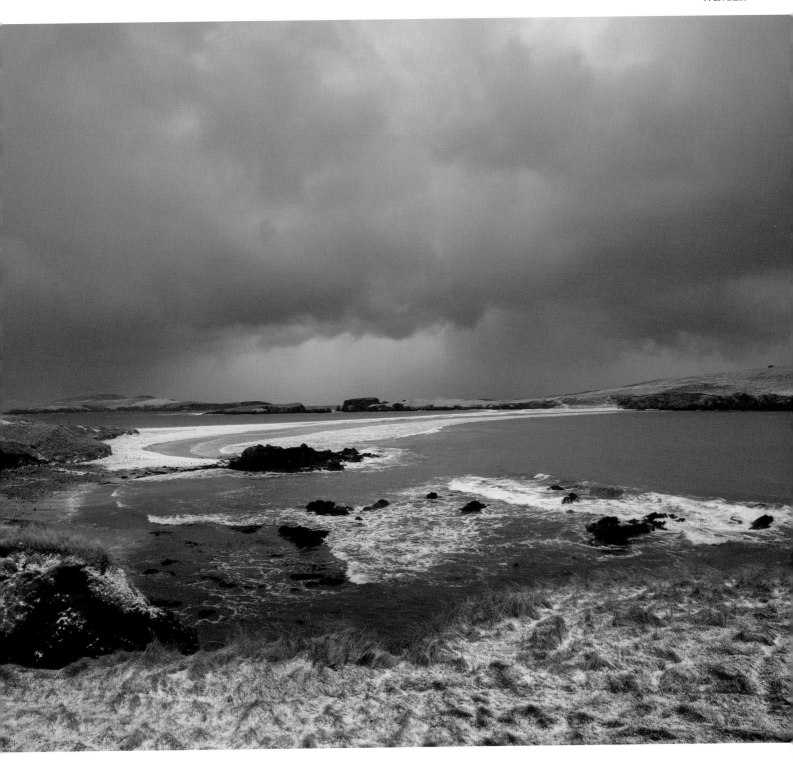

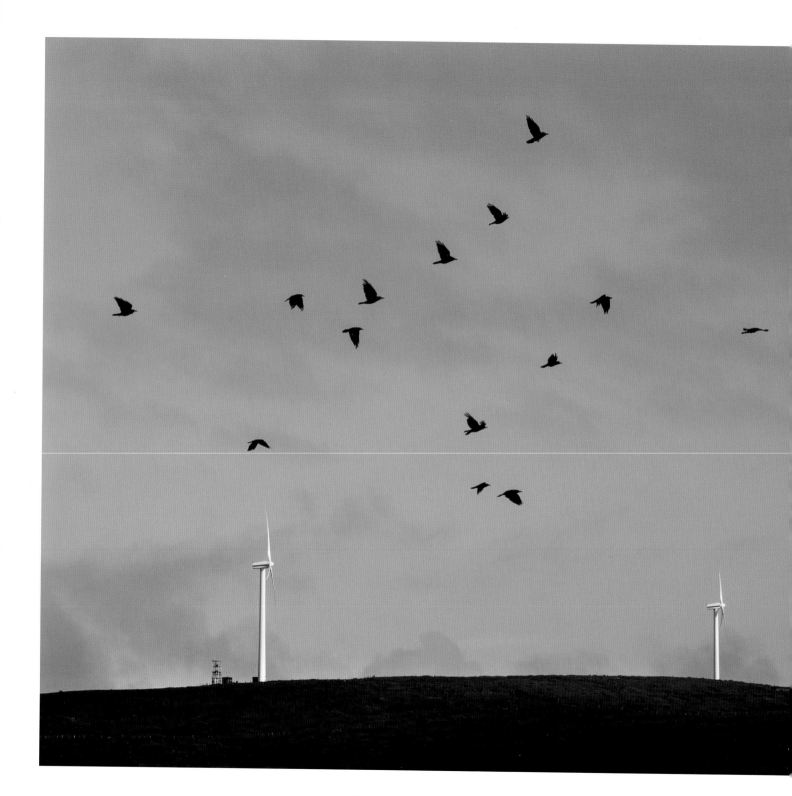

Here Magnus, a character inspired by an elderly Fair Islander who became a good friend, looks out at the ravens on his croft:

*There were ravens on his land, always had been since he was a peerie boy. Sometimes it was as if they were playing. You could see them in the sky wheeling and turning like children chasing each other in a game, then they'd fold up their wings and fall out of the sky. Magnus could feel how exciting that must be, the wind rushing past, the speed of the dive. Then they'd fly out of the fall and their calls sounded like laughter.*

The book's theme is belonging. I've always been interested in the ways outsiders find to fit into their host communities. I needed a central character who was a Shetlander, but also an outsider, so Jimmy Perez was born. He comes from Fair Isle – considered by many Shetlanders as the edge of the known universe – and has Spanish ancestry, which gives him dark hair and olive skin. An Armada ship, blown well off-course, was wrecked on the rocks off Fair Isle; it was called *El Gran Grifón* and its mast tipped onto the rocks and enabled sixty survivors to climb ashore. I took this fact and used it to provide Jimmy's background. I thought it wasn't beyond the bounds of possibility that one of the Spanish sailors had married an island lass and given his name to a new family. I was always told that Fair Isle's famous knitting derived from

**LEFT** *Ravens and wind turbines.*

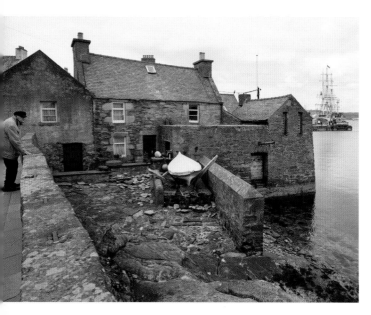

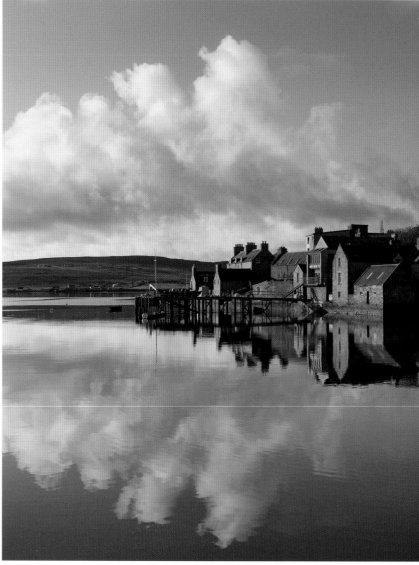

**ABOVE** *The Lodeberrie.*

**RIGHT** *Lerwick waterfront.*

the bright colours and Catholic iconography seen on the Spanish ship – crosses do indeed feature in the traditional patterns; but an expert has informed me that patterned knitting didn't become common in the islands until much more recently, so perhaps the connection has just developed over time into an interesting story.

Most of the action in *Raven Black* takes place in the fictional settlement of Ravenswick. In my head, this is in south-east Mainland, somewhere between Sandwick and the glorious beach at Levenwick, though the geography is very much my own. I've created a headland and a valley leading down to the sea, and Fran's home has a view of the island of Mousa. Jimmy Perez's house, though, is quite real. This is the Lodeberrie, close to the Queen's Hotel in Lerwick. The walls of the house stand in the water and you can still see the pulleys that were once used to bring goods ashore from the boats beneath. The owner is extremely tolerant, and

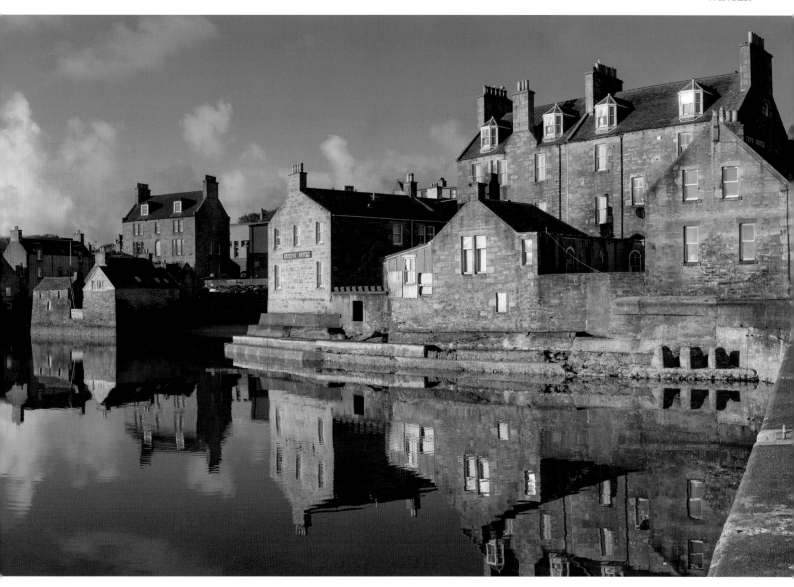

is now used to tourists taking photos, and to
the TV crews who film there. The BBC's interior
of the house has been built in the studio in
Scotland and bears no resemblance to the inside
of the Lodeberrie, though I understand that
people do occasionally knock at the door and
ask for Jimmy Perez.

Another of the places mentioned in *Raven Black* is the Haa, the home belonging to Duncan Hunter. Jimmy went to high school with Duncan, and throughout the first four books he develops a relationship with Duncan's ex-wife Fran. Duncan's family were once lairds, owning land throughout the isles. When I was describing his family home, I had the Busta House Hotel in Brae in my head. Busta is an old laird's house, once belonging to the Gifford family. It was extended over the years, and a new wing was built in the 1970s to provide accommodation for the oil executives who came to work in

**LEFT** *The Busta House Hotel.*

Sullom Voe, not very far away. The oldest part of the house has a beautiful long room, now used as a visitors' lounge. And, if they're lucky, visitors can enjoy music provided by the owners' daughter, who is a harpist. There are wonderful stories attached to Busta House, involving feuds, a secret marriage, an illegitimate heir and a suspicious death. And of course it's supposed to have a ghost. The house has a terraced walled garden leading down to the water and is popular with locals as a wedding venue. The BBC used it as a location when they were filming an adaptation of another book, *Dead Water*.

Winter in Shetland is a time for indoor activity, and a passion for spinning and knitting is still shared by islanders and by people who have settled there more recently. Legend has it that different knitting patterns belonged to individual families, so if a man was lost at sea he could be identified by his jersey or gansey. In the nineteenth century women supplemented their income by knitting and made a major contribution to a community's finances; even before that, Shetland-knitted stockings were traded through the Hanseatic League. Until very recently all Shetland children were taught to knit in school, and 'bairns' knitting classes' are now organized in the Shetland Museum and in Whalsay and Unst.

The natural fleeces from island sheep come in many different shades, from black (dark brown) through mourrit (a reddish-brown), grey and white. White is the most common colour and the most easy to dye. The fleeces are much sought-after by knitters away from Shetland, and the yarn is exported all over the world. While most of us think of Fair Isle patterns on jerseys, hats and mittens, there is a tradition of a very different style of knitting too, in which the yarn has been spun very thin and the finished product is a delicate lace. A young woman's hand-knitted wedding veil traditionally had to be so fine that it could be pulled through her wedding ring.

There is still a flourishing interest in all kinds of textile crafts in the islands – a degree course in the subject is taught at the college

– and young designers have developed novel techniques and use authentic materials in exciting ways. People come from all over the world to Wool Week, when there is a full programme of workshops, lectures and social events. The Textile Museum in Gremista, Lerwick, has fine examples of knitting, and volunteers explain the art and craft of the islands' textile tradition and give spinning demonstrations.

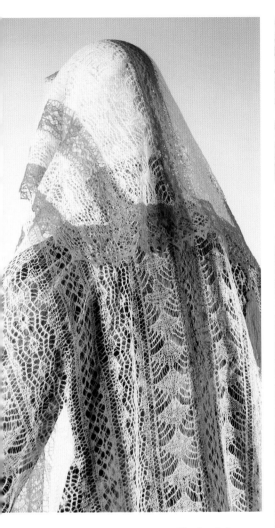

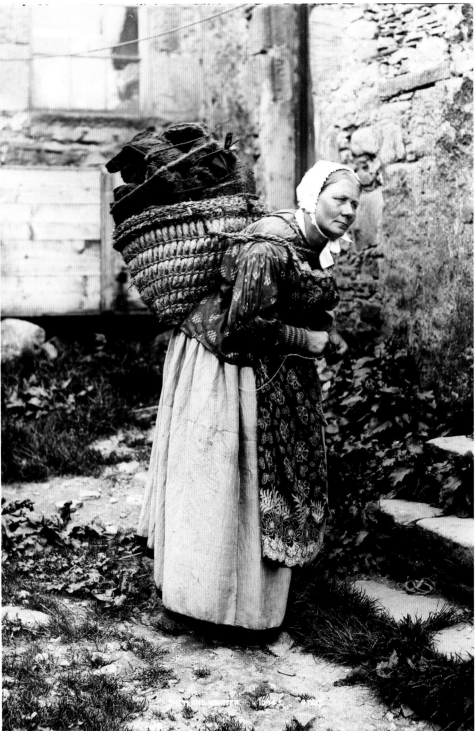

**ABOVE LEFT** *Shetland sheep fleece.*

**ABOVE** *A Shetland lace bridal veil, which won a gold medal at the Great Exhibition in 1851.*

**RIGHT** *A Shetlander knits while carrying a basket of cut peat, c.1885.*

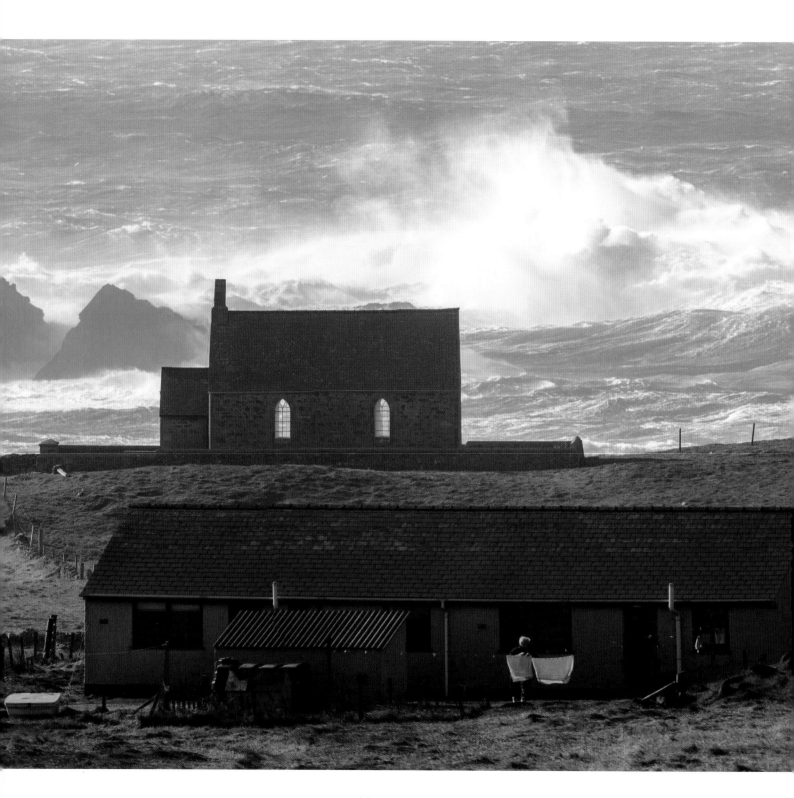

**LEFT** *A good drying day on Fair Isle.*

**RIGHT** *Flying from Fair Isle to Mainland. The view out of the right window is across the Minn beach in Burra.*

**OVERLEAF** *Aurora over Tingwall Loch.*

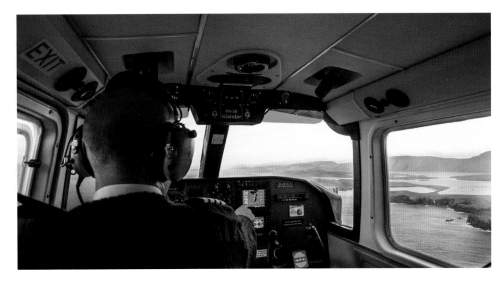

In Shetland, the weather matters. Everyone knows which way the wind is blowing. Wind direction and speed influence which door you use to get into the house, whether the NorthLink ferry can dock in Aberdeen and whether the small planes to the outer islands can take off. These planes provide a vital service for residents in Fair Isle, Foula and the Out Skerries. When children from the out-isles reach the age of eleven they begin boarding in the hostel in the Anderson High School and it's the small planes that take them back to school after the Christmas break. They also carry people to dental, hospital outpatient and hairdressing appointments and deliver newspapers and the post. Strong winds and fog can cause folk to be stranded and miss their connections south.

Most islanders allow time for possible delay or cancellation, but it can be stressful for visitors, who don't quite understand the impact of the weather on everyday life.

Winter is a time of dramatic gales and seas that can lift rocks the size of a small child to the top of the highest cliffs. There is something exhilarating and elemental about watching the huge waves crash over the sea stacks, and tasting the salt in the air as spindrift blows inland. But sometimes the wind drops and the sky clears; winter is the time of year too when on a still, cloudless night it's possible to see the Northern Lights, known in Shetland as the 'mirrie dancers'. Shetland is probably the best place in the UK to view them, though I've never been lucky enough to experience the phenomenon.

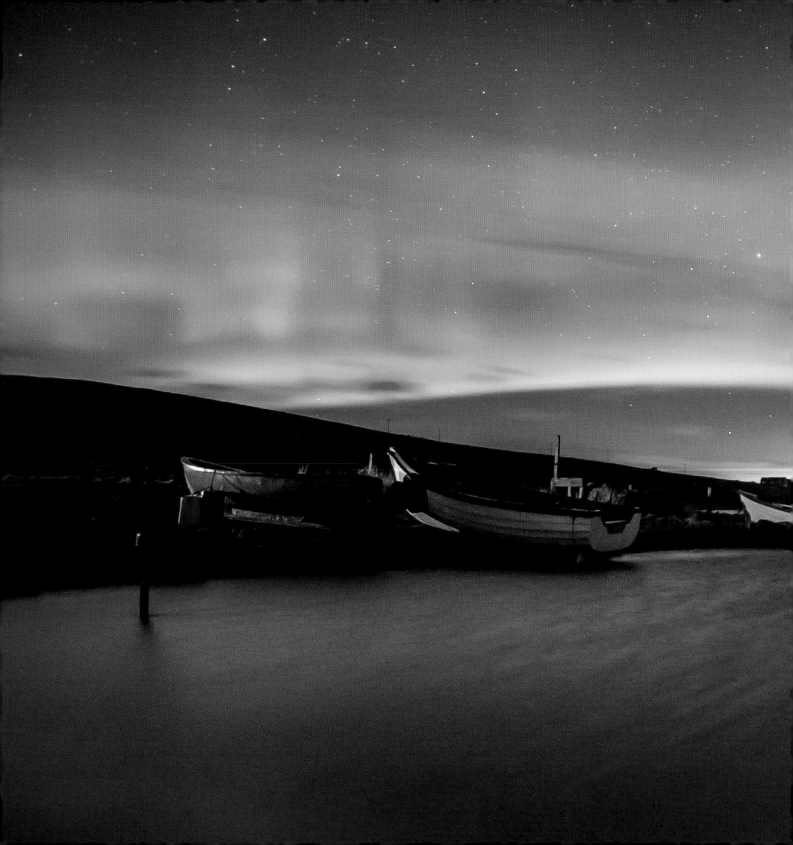

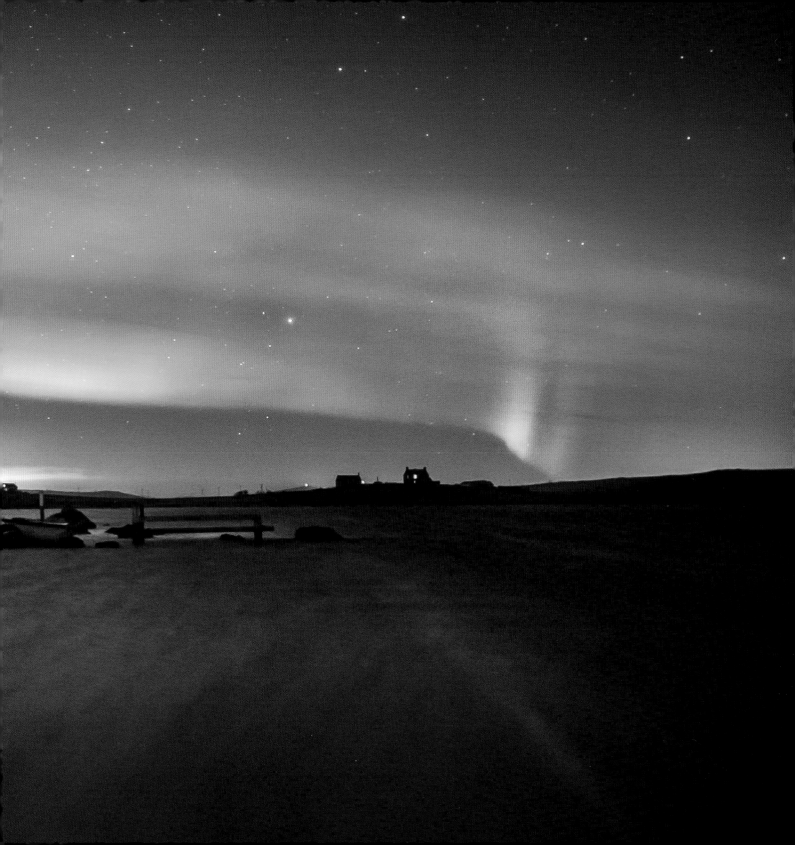

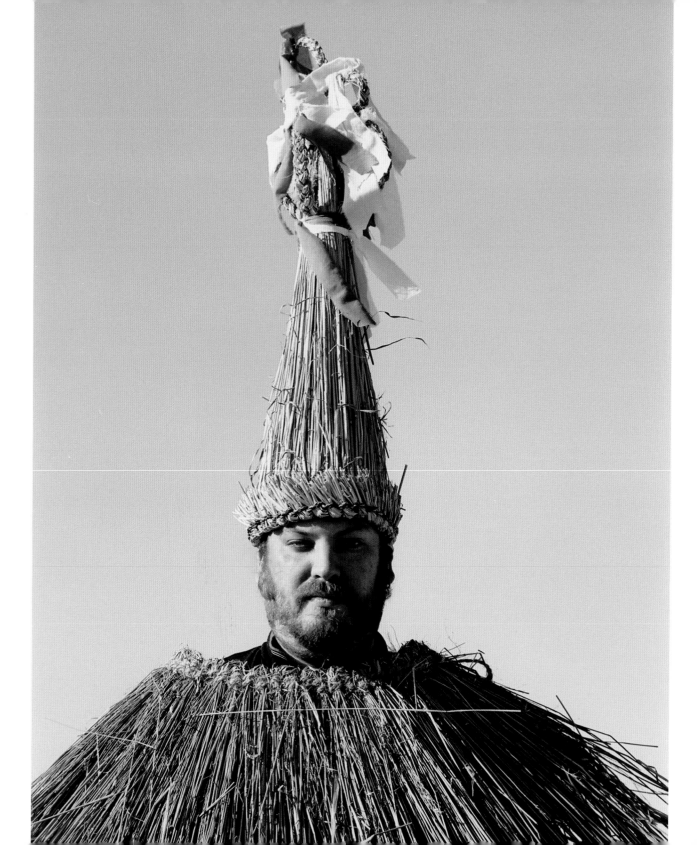

**LEFT AND ABOVE** *Replica skekler outfits, made by Ewan Balfour.*

In the past, Shetlanders had to make their own entertainment in the dark days of winter. While Christmas is now celebrated much as everywhere else in the UK, according to storyteller Elma Johnson, as quoted in *The Shetland Times* in 2009, it seems that in former times superstition played just as much a part as Christianity. Seven nights before Yule the trows were allowed up from their underground lairs. Trows are the little people who dwell beneath the islands and cause mischief and mayhem. There are many stories and tunes about them. The island settlements felt the need to protect their homes and belongings from these mythical folk and devised elaborate rituals, involving plaited animal-hair crosses and a sheep's skull. Special Yule cakes made from oats were baked on Christmas Eve, each a different size according to the age of the family members. The edges of the cakes were pinched into spikes and a hole was formed in the middle – they were meant to represent the sun, and presumably were made to ensure that spring would return.

There is also a tradition of guizing: dressing up and performing sketches and plays to your friends and neighbours at New Year. I remember friends telling me about the work and the imagination that went into creating masks and costumes in Fair Isle. In the Shetland Museum there are examples of skekler dress – these were elaborate costumes made of straw, used by guizers in former times. These days the young people gather at the Market Cross in Lerwick to party and to see in the New Year. The island of Foula, though, still recognizes the Julian calendar and doesn't celebrate New Year until 13 January!

Of course the biggest celebration to mark the passing of midwinter occurs on the last Tuesday of January in Lerwick. This is the fire festival of Up Helly Aa. Up Helly Aa re-creates a Viking celebration, but this isn't a tradition handed down from Viking times. It was a Victorian creation, intended to replace more rowdy and disorganized midwinter activity. There are Up Helly Aa parades throughout the islands, but the grandest – pulling in visitors from all over the world – takes place in Lerwick.

Preparations for Up Helly Aa begin as soon as the previous festival is over – in fact they begin before that. The person who leads the procession in all his Viking finery is known as the Guizer Jarl, and a man will know fifteen years in advance that it's his turn to be Jarl; he is elected to the office by his fellow guizers. He will plan his life around this very special honour, and weddings, career moves and family celebrations all take second place to it. Up Helly Aa is a

**ABOVE** *Preparing for Lerwick Up Helly Aa. Stacked against the wall are torches.*

**RIGHT** *Guizer Jarl Alan Jamieson in 2015.*

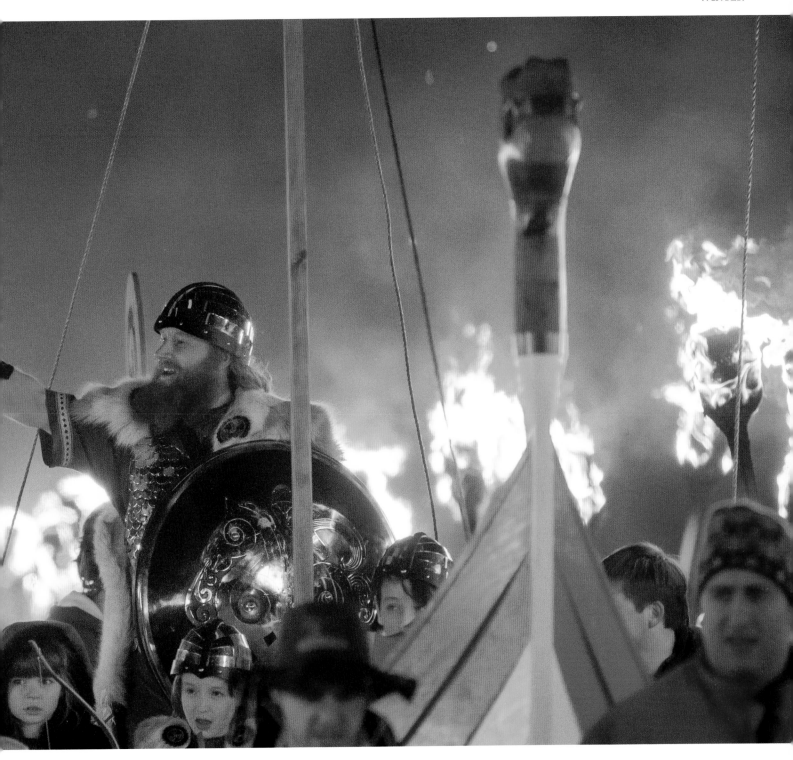

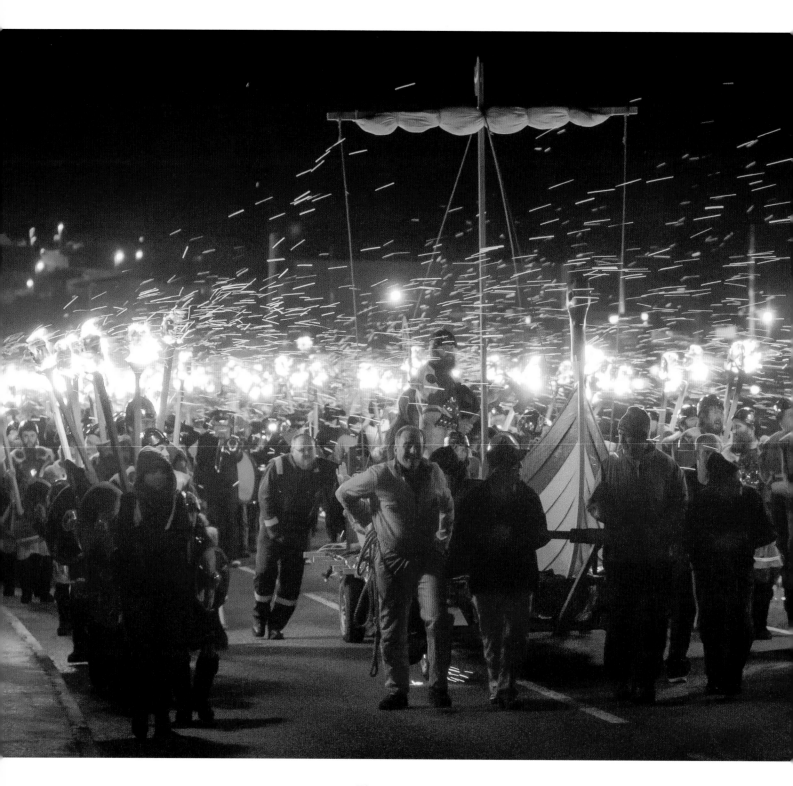

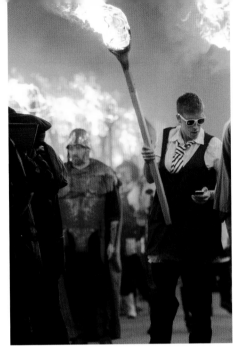

**LEFT** *Wind carries sparks over the Viking galley.*

**RIGHT** *Costumes are an important element in the Up Helly Aa procession.*

**OVERLEAF** *Guizers circle the galley before setting it alight.*

real community event, and although the parade itself is exclusively male, most of the people in the town take part. Up to a thousand guizers in nearly fifty squads make up the procession, which culminates in the burning of a beautifully built Viking galley in a play park in the centre of the town. Only the Jarl's Squad dress up as Vikings. Squad members wear winged helmets, armour and shields and have all grown beards, in preparation for the day. The other squads take themselves less seriously and will have chosen a theme that mocks national politics, local events or celebrity culture. They will have prepared a sketch around the theme, and fishnet tights, corsets and wigs seem to be the preferred costume, leading some to give the day the nickname 'Transvestite Tuesday'.

Businesses, council offices and schools shut on the day following Up Helly Aa, and the whole of the town gears up for the festival throughout the day itself. Proceedings start with the posting of 'the bill' at the Market Cross, the proclamation of Up Helly Aa signed by the Guizer Jarl, and a commentary made up of rhymes and questions poking fun at the events of the previous year. After the broadcast of the BBC pilot of *Shetland*, reference was made to the television show in the bill – though naturally the writers had called it '*Shitland*'.

At 10 a.m. the Jarl's Squad assembles and processes through the streets with the galley, eventually ending up at the harbour, where photographs are taken. The march is accompanied by the Up Helly Aa song, to a Norwegian folk tune. When I brought a group of Norwegian journalists to the festival they recognized all the music played as a background to the day. A red raven banner flies over the town hall. The Squad spends the afternoon visiting old people's homes and the hospital.

This is all in preparation for the main event in the evening. Tourists gather in the streets to watch, and there is an air of expectation as spectators jostle for the best view along the route. At seven o'clock the street lights are turned off and the Guizer Jarl marches to the galley. A maroon goes up, flares are used to light all 1,000 torches and the parade begins,

accompanied by a brass band playing the Up Helly Aa song. I've attended the festival in atrocious weather, when the rain is almost horizontal and sparks from the torches are blown towards the crowd, but the procession is never cancelled because of the weather and it never stops people turning out to watch.

The climax of the event takes place in the 'burning park' – for the rest of the year it's a play park enjoyed by the children of the town. The galley is pulled there and is surrounded by the torch-bearing guizers. When a maroon is fired, the guizers march around the galley, one of them calls for three cheers and all the torches are thrown into the galley, turning it into the most spectacular bonfire, lighting up the otherwise dark night sky.

For visitors the evening ends there and they drift back to their hotels and guest houses, but for islanders the celebrations continue until the following day. The thirteen community halls in Lerwick prepare to host their guests and the guizer squads. Each hall has a team of hosts and hostesses who, with the help of friends, have arranged a feast of home-baking that will sustain people throughout the night. Guests who have been lucky enough to receive a ticket or invitation are expected to take part, too. All through the night the guizer squads arrive to perform their sketches to an appreciative audience, and there is music and dancing. The festivities wind down at about eight o'clock the following morning.

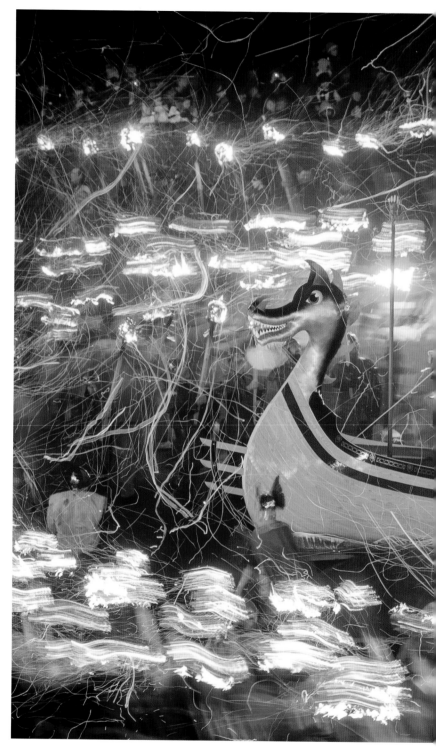

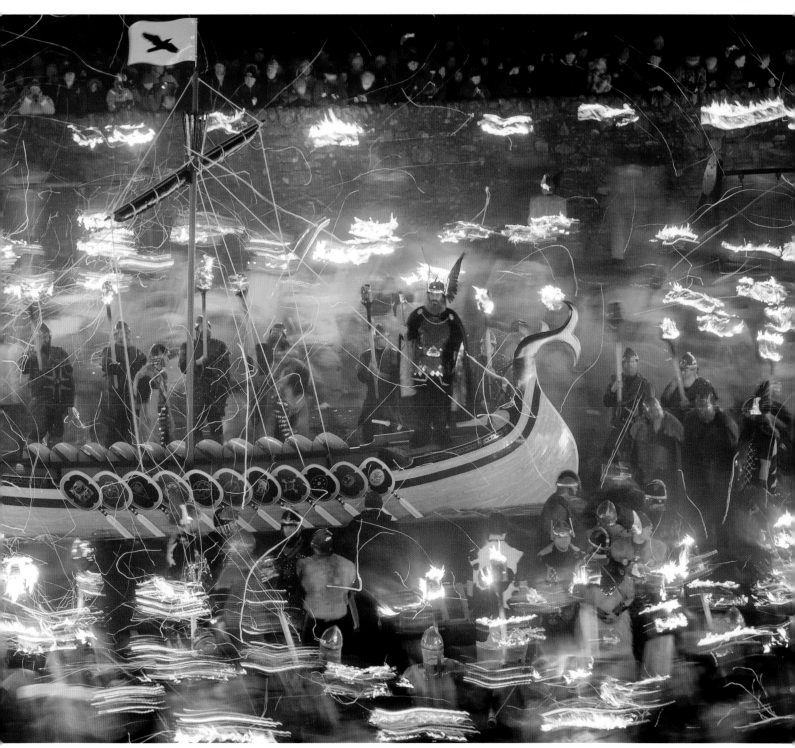

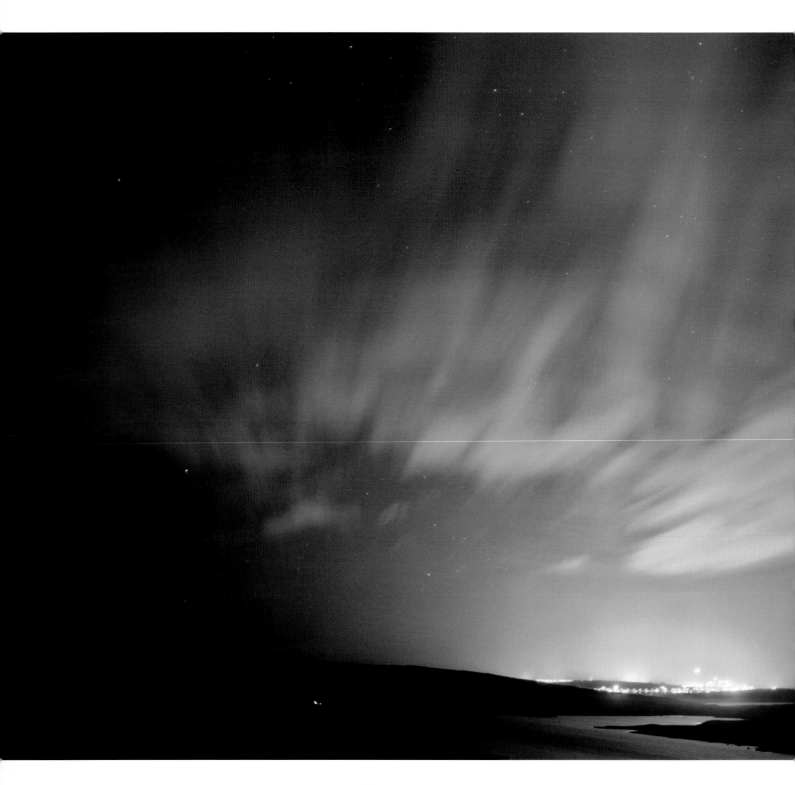

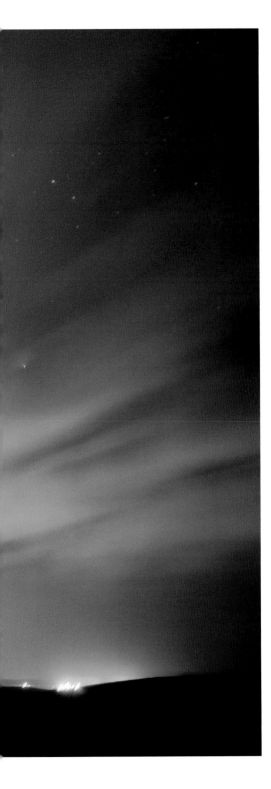

LEFT *The lights of Sullom Voe oil terminal compete with the aurora above.*

When I first visited the islands in winter, most general socializing took place in friends' houses or perhaps at dances in the community halls. Now there are more extensive opportunities for indoor activities. Partly this is a result of negotiations with the oil companies when the Sullom Voe terminal was established. Shetland Island Council agreed to allow oil to come ashore at Sullom, but demanded a percentage of every barrel produced. That money was put into trusts to benefit the islanders and sustain the island way of life. So even small villages have their own swimming pool and sports centre, and the arts have been supported in a way that most communities in the rest of the UK would envy. Throughout the year there are dozens of music and arts festivals – though travel in midwinter can be unreliable, and Up Helly Aa is the only major event at that time of the year marketed to people from the south.

However, two major recent developments at Hay's Dock to the north of Lerwick provide education, entertainment and a chance for Shetlanders to meet up with their friends. The first is the Shetland Museum, a fabulous building that uses outside space and archive recordings of Shetland voices, as well as more traditional displays of artefacts. There is a replica lighthouse lens, full-size traditional boats (yoals) and some beautiful knitwear. I've attended a storytelling session there when tales of the trows – the mythical creatures who can lure you

underground with their music – are told. And I've enjoyed the exhibitions of contemporary art and crafts in the gallery on the ground floor.

More often, though, my visits to the museum have not been to look at the displays, but to visit the Hay's Dock restaurant on the first floor. There were few good places to eat out when I first arrived in Shetland, but now there is an increased pride in the food produced in the islands and a willingness to use traditional recipes. Reestit mutton is sheep meat that has been salted and then air-dried, and reestit-mutton soup is now widely available. And the fish caught and cooked in Shetland will be as fresh as any you can get in the UK. The Scalloway Hotel decides its menus once it knows what the boats have caught, and Frankie's Fish and Chip Shop in Brae is award winning. The best food in the islands is that which uses the traditions of island produce and baking and brings them up to date for a new generation. Each November the Shetland Food Fair takes place in the Clickimin Leisure Centre alongside the Christmas Craft Fair – a great place to sample and purchase treats for the festive season.

There was a big debate in Shetland before the arts-and-performance space of Mareel was built. 'Mareel' is a local word to describe the phosphorescent light seen on the water. It's an ambitious building right on the shore, and at a time when funding was tight some people saw it

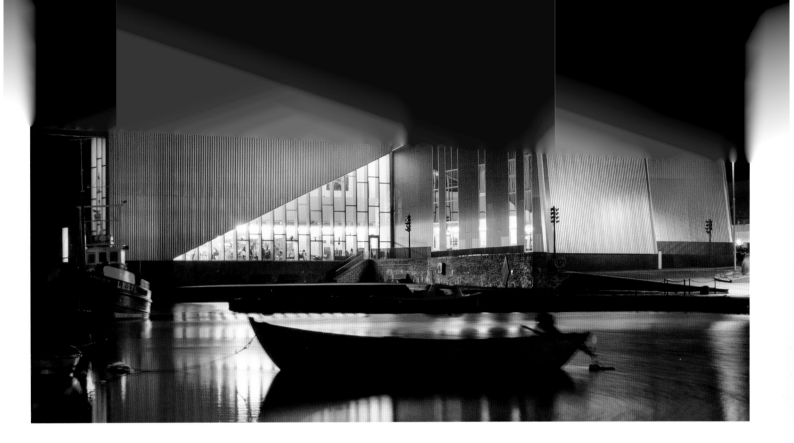

as an extravagance that the community couldn't afford. Now that it's built, though, Mareel is a great resource for Shetland, and specifically for its young people. The cinema can screen films at the same time as they're released in mainland UK and the auditorium is a music venue that attracts people with every taste. There are workshop spaces and rehearsal rooms, and students can learn to play, record and produce music to the highest standard. The building is home to Shetland Arts, the organization that encourages artistic endeavour of all kinds. And the bar has become a meeting place for Shetlanders of all ages; it's often my first port of call for coffee when I arrive in the islands, because I know that I'll probably bump into a friend there. In the evening there can be music as well as conversation. In Shetland the two often go hand-in-hand.

Mareel attracts artists and organizations to the islands from all over the world. Musicians especially come for the festivals, which have become a joyous celebration of the islands' love of tunes and song. Professional musicians use the centre to record their music because of the quality of the sound and the studios. The annual film festival, Screenplay, is curated by one of the UK's most famous movie reviewers; and in the crime-fiction festival, Shetland Noir, the centre hosts the very best Nordic, Scottish and English crime writers.

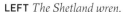

**LEFT** *The Shetland wren.*

**RIGHT** *A mother otter and her cub on the shore.*

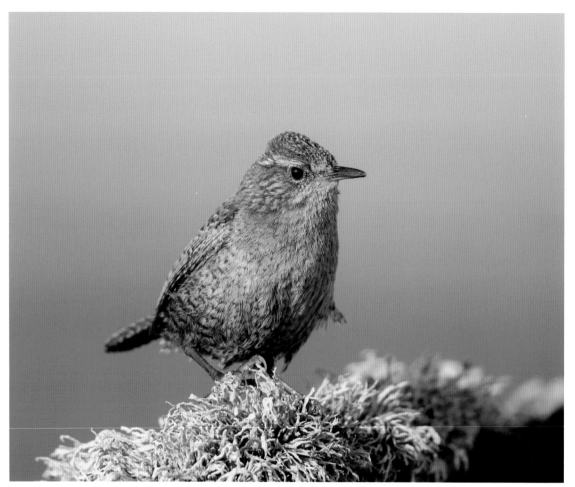

Shetland is famous for its natural history, and many visitors come in the hope of seeing otters, orcas or puffins (known in Shetland as 'tammie norries'). While the islands have a population of around 22,000 people, there are 300,000 pairs of the most common seabird – the fulmar – breeding on the sea cliffs. In winter, however, the cliffs are bare and many of the bird species seen in the islands come from even further north, from the north-west and north-east.

Shetland's resident mammals can be seen throughout the year – after all, they have nowhere to go! It's thought that all the land species in the islands were introduced over the last 6,000 years. Even the otter is unlikely to have arrived unaided. The isolation of the population means that some animals have evolved slightly differently from UK mainland species; for example, there are a number of distinct variations of Shetland mouse, and separate subspecies have been described in Yell,

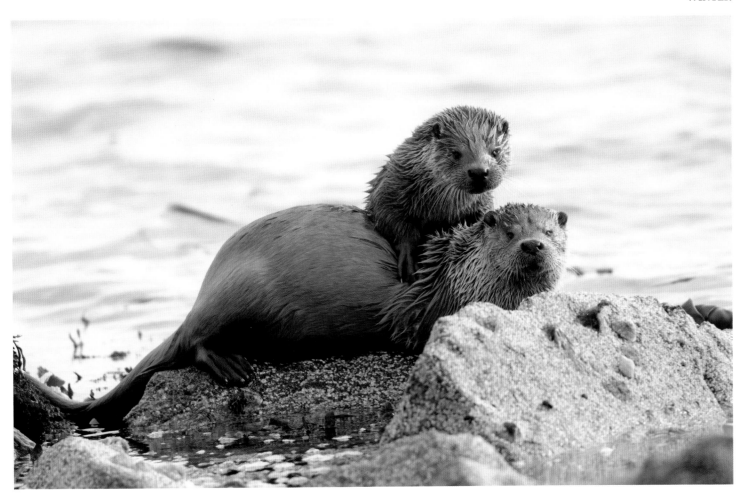

Foula and Fair Isle. All have slightly redder fur than UK mainland mice, and both Shetland house and field mice are slightly larger. The Shetland wren is larger than the bird found elsewhere in Britain, and another separate subspecies has developed just in Fair Isle. The Fair Isle wrens are smaller than those in Mainland Shetland, but bigger than those in mainland UK.

Shetland probably has a larger otter population than anywhere else in Britain, and visitors can see these animals throughout the islands. While they are most readily visible at dawn and dusk, it's possible to catch a glimpse of them at any time of day, especially on the boulder beaches or around the piers while waiting for an inter-island ferry.

There are rabbits in huge numbers and a variety of colours all over the islands. There are no natural predators (except man) in Shetland, so white, black and multicoloured rabbits can survive in the brown landscape, as well as

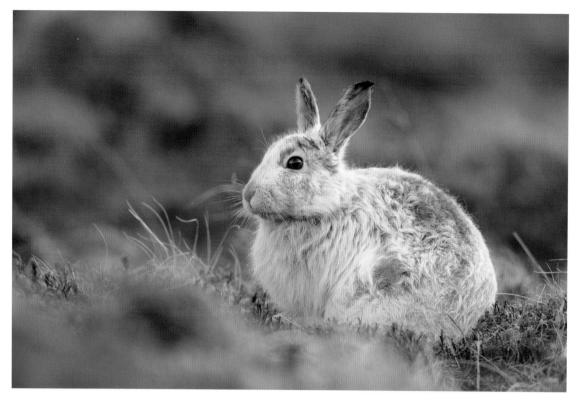

better-camouflaged individuals. The mountain hare was introduced from Scotland to the Kergord Estate in about 1907 and is now found on heather moorland throughout Shetland Mainland. It doesn't turn completely white in winter, but heavy snow is unusual, so it still stands out against the bare hillside. The brown hare, which was also introduced, has now died out.

Most of Shetland's breeding birds desert the islands in the winter, but they are replaced by migrants moving south, often from their breeding territories. Sheltered voes and coastal bays are home to divers and to Slavonian grebes. The black-throated diver is a rare visitor, but the larger and impressive great northern diver is more regular. It has a distinctive thickset head, stout neck and long straight bill. In flight its feet project behind it, like big spades. Research has shown that approximately 50 per cent of the wintering great northern divers come from breeding sites in Iceland. The remaining birds originate in Greenland and north-eastern Canada.

Sea-ducks include the sociable eiders ('dunters' in Shetland dialect), which collect in groups along the shore. Their calls sound like the gentle murmuring of gossiping old ladies. In late winter the black-and-white males throw back their heads in display. There are also long-tailed ducks, goldeneyes and red-breasted mergansers.

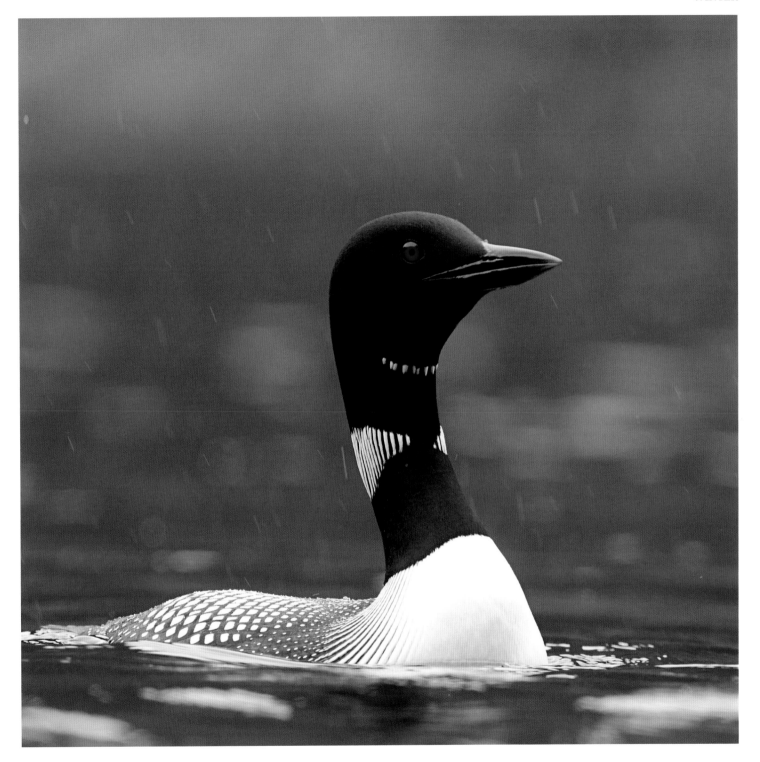

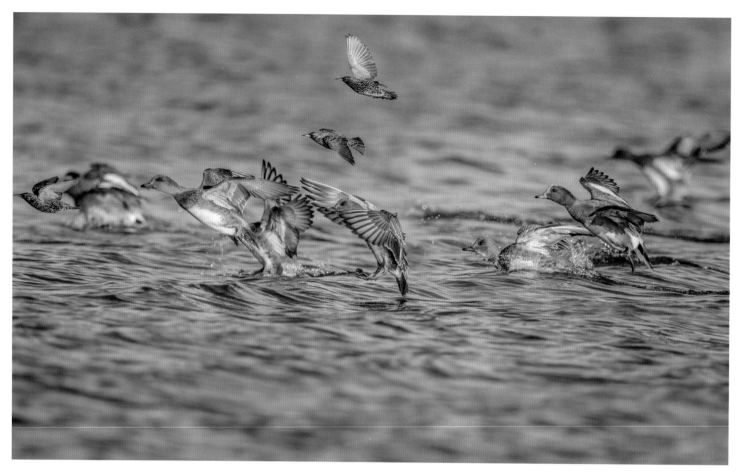

A large group of wigeon, another species of duck, might be seen in the low farmland pastures. Their distinctive whistling sound of 'wee-oo' carries far along the coast as they crop the short grass. They will have travelled from Iceland, Scandinavia or Russia.

Wading birds find a winter home in the islands. Turnstones and ringed plovers are widely distributed. They can be seen on rocky headlands as well as along the shore in sandy bays. And dark-purple sandpipers, recognizable by their curved bills, forage among the seaweed and barnacle-covered rocks. It has been discovered that the shorter-billed birds originate from the Norwegian archipelago of Svalbard and from Scandinavian populations, and the longer-billed individuals are from Arctic Canada; both groups can figure in Shetland's wintering and migratory flocks.

Greylag geese breed in Shetland, but their numbers increase substantially in winter. They find the low grassland to their liking and the habitat can attract up to 10,000 individuals. Many of these birds will have come from Iceland.

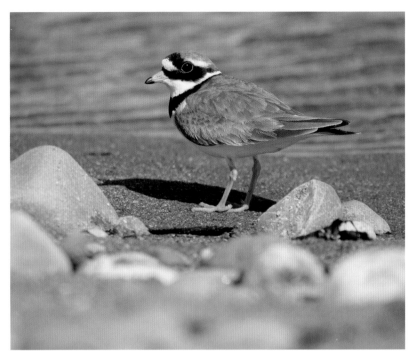

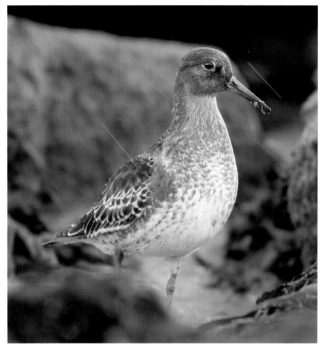

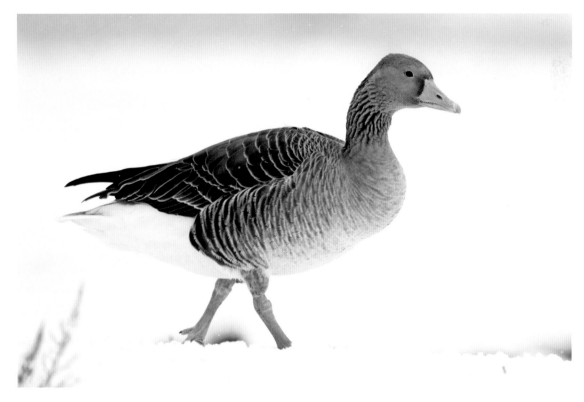

LEFT *A flock of wigeon.*

ABOVE *A ringed plover.*

ABOVE RIGHT *A purple sandpiper.*

RIGHT *A greylag goose.*

Even in stormy weather it's possible to hear whooper swans over the noise of the wind, before you see them flying in from the coast. They are named after the loud whooping of their call. When the swans travel in family groups it's easy to spot the browner young birds, which have hatched in Iceland that summer. Most whooper swans seen in Shetland are birds passing through in the autumn, but some stay and spend the winter on one of the larger lochs. These birds first bred in Shetland in 1994, and very small numbers have been recorded breeding in recent years. Their movement has been charted by ornithologists, who mark the swans with numbered coloured rings. When I worked in the observatory in Fair Isle I helped the scientists one night when they went to catch swans for ringing on Golden Water, a loch to the north of the island. One person dazzled the swan with torchlight while the other moved behind it to catch it. I travelled back to base in the observatory Land Rover with a swan on my knee; once there, it was weighed, ringed and then released.

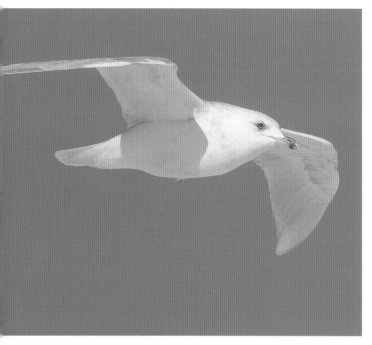

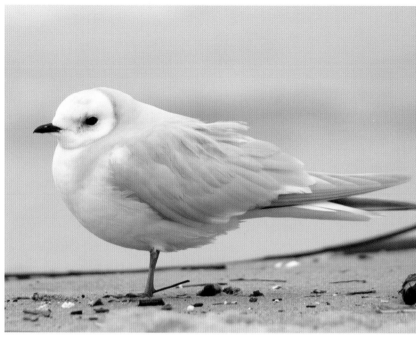

**ABOVE** *An Iceland gull.*

**RIGHT** *A Ross's gull.*

Interesting gulls can be seen in Shetland's harbours and inshore waters as they search for food. In recent years the area around the Shetland Catch fish-processing building in Lerwick has been a great place to watch. Birders are looking out for the 'white wingers' (birding slang for glaucous and Iceland gulls). The glaucous gull is a heavy-backed monster, which may have come from Svalbard or from further west. Confusingly, Iceland gulls don't come from Iceland, but breed in Greenland!

While these gulls catch the attention of birdwatchers, there are two even rarer visitors to the islands, which are considered much more exciting. Both Ross's gull and the ivory gull are beautiful and very occasional visitors. Ross's gull is a stunning bird, with its delicate black bill and diamond-shaped tail. The first-ever British Ross's gull was found in 1936 between Whalsay and the Out Skerries by a fisherman called John Irvine. Perhaps it's no coincidence that there is a Whalsay fisherman today named John Irvine, who is a keen birdwatcher, photographer and descendant of the finder. The species is named after the British explorer James Clarke Ross, who collected a specimen of the bird in northern Canada in 1823. Most of the Ross's gulls

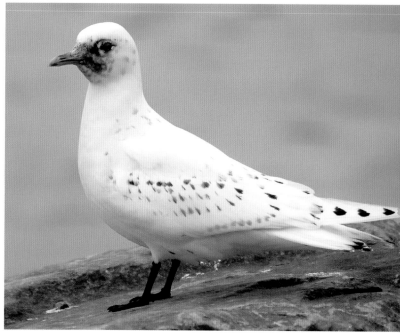

**ABOVE** *A glaucous gull.*

**RIGHT** *The rare ivory gull.*

found in Shetland have been seen between November and January.

The graceful ivory gull is another Arctic species that occurs occasionally in Shetland. Normally wintering on the pack ice, and often following hunting polar bears to feed on their faeces or take scraps from their seal kills, the ivory gull is tough and, despite its eating habits, very elegant. Records in Shetland span the months from November to February, and most birds are in juvenile plumage: white with black ermine markings on the wings.

In the past, birds occupying the inshore habitats have come into contact with the development of the oil industry and with spillages from larger fishing vessels. Oil spills in 1979 and from the *Braer* disaster in 1993, for example, killed several hundred long-tailed ducks. Careful counting by local ornithologists revealed that the numbers of wintering water fowl took several years to recover. A funded and very positive relationship between the oil industry in Shetland and expert seabird biologists has developed over many decades. Now a regular and accurate census of birds, preventative methods and strategies, and good forward planning have reduced the risk to local wildlife.

Perhaps the most famous of Shetland's animals is domestic rather than wild. Although they appear to roam wild, all the unique Shetland ponies are owned and looked after by local crofters. Their coats change with the seasons, and in winter they develop a double coat with guard-hairs to shed the rain. They also have a thick mane and tail to help protect them against the worst of Shetland's weather. For at least 4,000 years these small ponies – which don't exceed forty-two inches in height – have roamed the hills in comparative isolation. This has led to the evolution of individuals ideally suited to their environment. It is said that Shetland ponies 'are foaled in the hills, live in the hills and die in the hills'. They graze on hill ground, known as 'scattald', and in some places forage on seaweed on the beaches.

In the mid-nineteenth century new laws prevented British coalmines from employing women and children in the pits. Shetland's ponies made ideal substitutes; they were sufficiently hardy to survive the conditions underground, and small and strong enough to haul trucks of coal through the tunnels. At first ponies were simply rounded up and transported south, but later in the century there were breeding studs – the best known of these operated in the islands of Noss and Bressay. At home, Shetland ponies were used as workhorses to cultivate the land and to transport peat from the hills. Now they are a huge tourist attraction and every visitor wants a photograph of these captivating creatures.

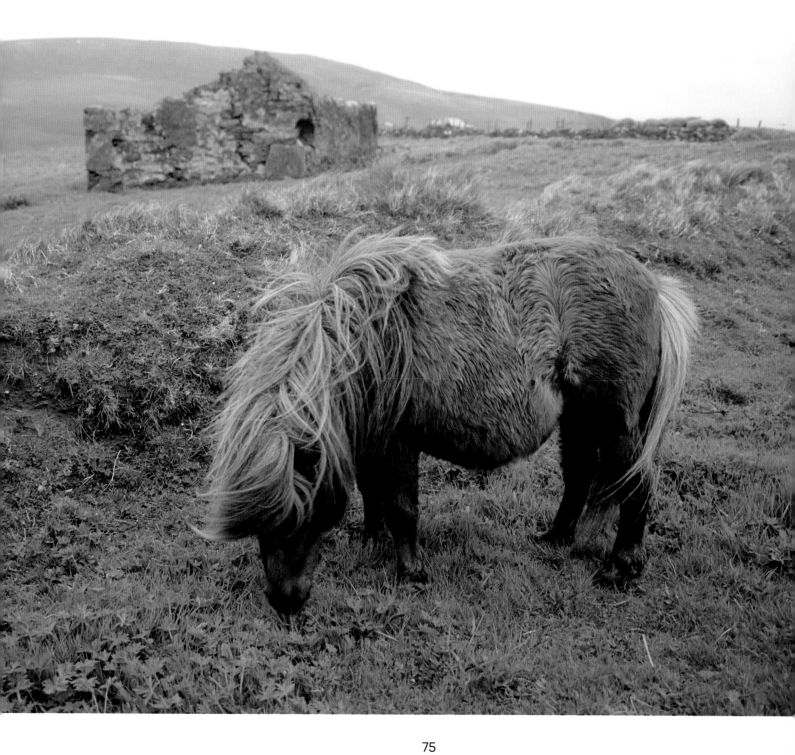

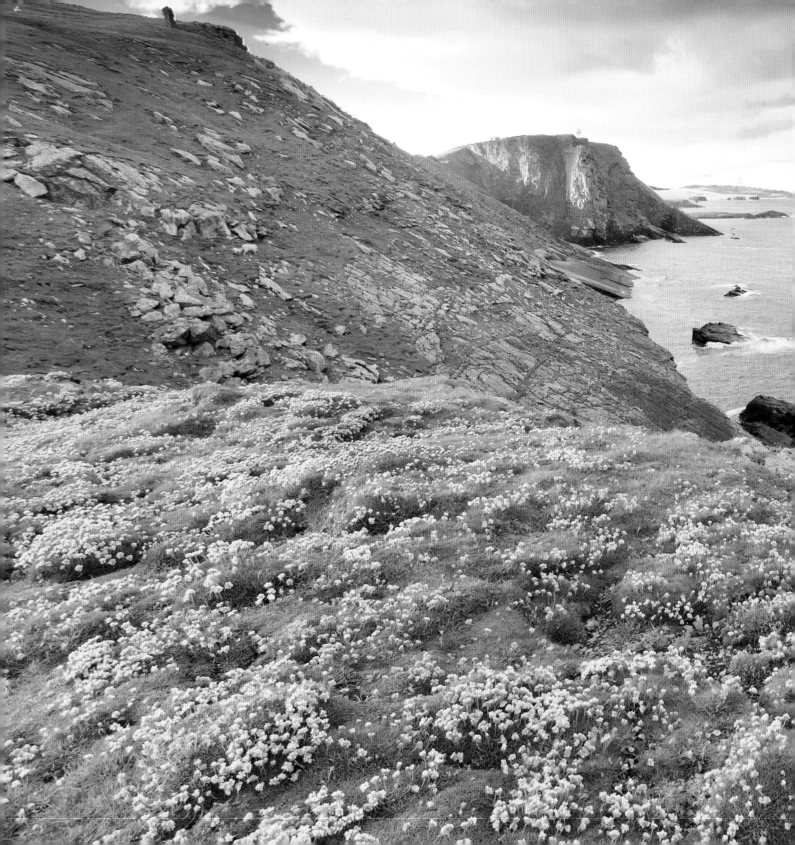

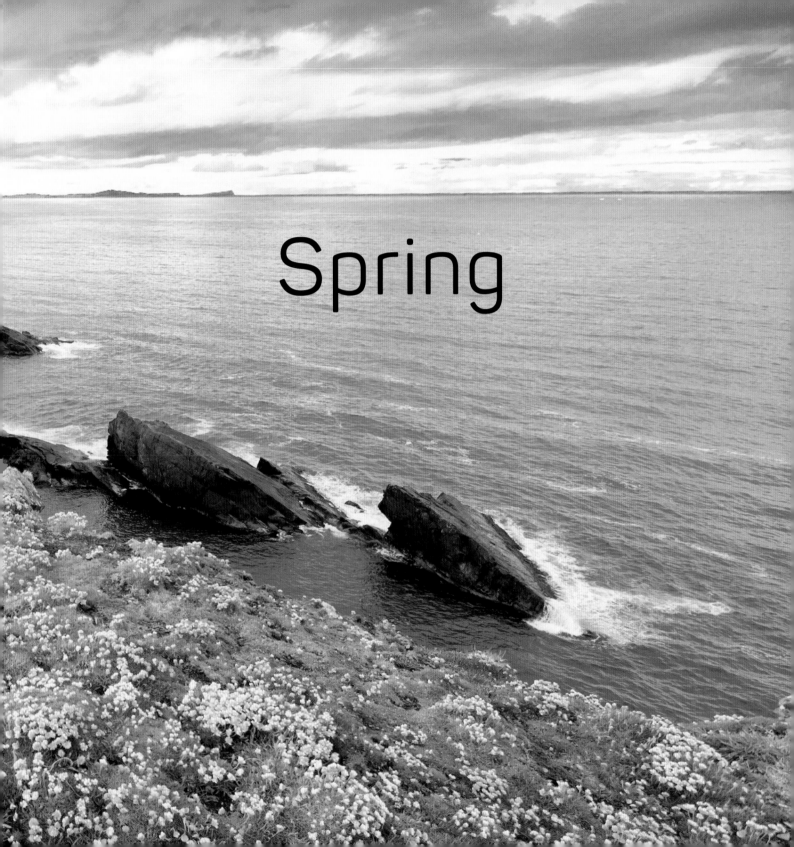

Spring

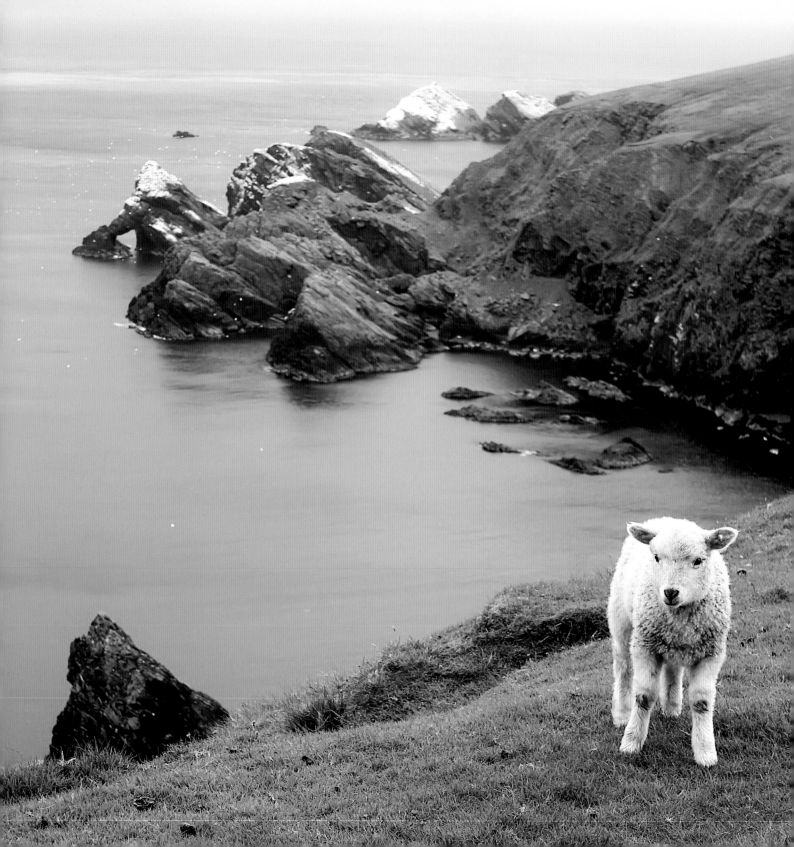

**Voar Day** by Lollie Graham (1924–2009)

Oh, whin I göd furt dat moarnin
da hale o da heevins abön
wis singing a sang a gledness
as toh winter hed never been.

Dere wis da birds i da heevins
singing der hych clear sangs
blyde, O blyde for da sunlycht
warm ipon vimmerin wings.

An whin I cam hame i da mirknin
wi da starns aa happit fae sycht
da sang wis still liltin athin me,
da croon o da lift was brycht.

*Spring Day*

*Oh, when I went out that morning*
*the whole sky above*
*was singing a song of gladness*
*as though winter had never been.*

*There were the birds in the heavens*
*singing their high clear songs*
*glad, O glad of the sunlight*
*warm upon quivering wings.*

*And when I came home in the twilight*
*with the stars all hidden from sight*
*the song was still lilting within me,*
*the crown of the sky was bright.*

Spring, or 'Voar' as it's known in Shetland dialect, comes late to the islands. While lambs are born in January and February in the south, they don't appear on the Shetland hills until March or April. The species of Shetland sheep is thought to have originated in Scandinavia; it's small, hardy and adaptable and can survive the wild island weather. Like the Orkney North Ronaldsay animals, Shetland's sheep feed on seaweed and can be seen clambering around the rocky beaches. The wool is exceptionally soft and fine and the meat is very tasty, whether it's cooked as lamb or mutton. Recently the Shetland has been cross-bred with Cheviot, Blackface or Suffolk sheep to provide heavier fleeces and bigger carcasses, but some of the quality of both wool and meat is lost. Wool brokers in Shetland send the spun yarn all over the world.

I've set two of my books in spring, and I first arrived in the islands in late April. After a long, dark winter it's a time of hope, of getting outside to work the land and getting small boats back onto the water for fishing, setting creels or just for pleasure. The first rowing regattas begin at the end of April, when teams throughout the islands race the traditional yoals. The whole community is involved: there are women's and veterans' teams, as well as those made up of fit young men. The flowers appear and the seabirds return. Tourists take advantage of the longer days and better weather to visit the islands. Cruise ships can be seen again, moored in the harbour in Lerwick.

**CHAPTER OPENER** *Spring flowers at Sumburgh.*

**PREVIOUS PAGE** *A spring lamb at Hermaness Nature Reserve on Unst.*

**LEFT** *Symbister Marina.*

**RIGHT** *A quiet corner of Whalsay.*

*Red Bones* was my first spring book. It was planned after a chance meeting in a Lerwick cafe with a birding friend, who at that time was a GP on the island of Whalsay. He leaned across the table and seemed very serious: 'You do know they hate you in Whalsay, Ann?'

I make every effort not to alienate my island readership, so this came as rather a shock. But, on reflection, I could see what might have caused the problem. I write traditional crime fiction and my central character, Jimmy Perez, is clever and compassionate. His sidekick, Sandy Wilson – in the way of detective pairings since Holmes and Watson – isn't so bright; he had to come from somewhere, and quite by chance I'd decided that he should come from Whalsay.

In the first two books in the series we don't learn very much about Sandy, except that he's young and inexperienced, and maybe a little bit stupid. I decided that in the third novel we should see him on his home patch and view the world through his eyes. I wanted to set him in context, and for readers to know more about his family and its traditions. That was enough for me to begin *Red Bones*.

Whalsay is an island of contrasts. It is home to the biggest pelagic fishing fleet in Shetland, with huge and expensive trawlers moored in the natural harbour of Symbister when they are not at sea. And it's a friendly island, where traditions are valued and maintained. The Whalsay dialect is different from anywhere else in the islands and, even though my ears are pretty well attuned to Shetland voices, when two Whalsay folk are speaking together I don't understand a word. They have to 'knap' for me. 'Knapping' means speaking 'proper' English and is sometimes seen as an affectation, but in Whalsay I'm often very grateful for it.

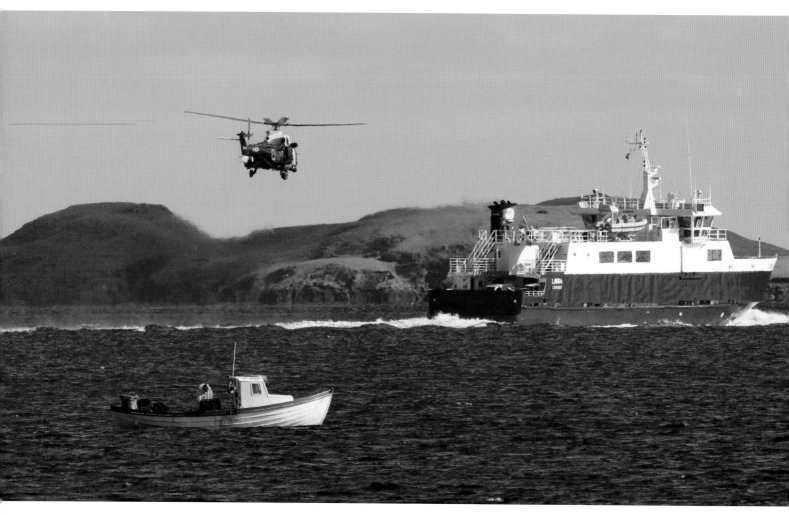

**ABOVE** *The two Whalsay ferries,* Linga *and* Hendra, *pass one another, while a helicopter hovers nearby. The fisherman in the foreground is setting creels.*

**LEFT** *Whalsay Golf Club.*

**RIGHT** *Sundews, tiny carnivorous plants, thrive in Shetland bogs.*

The Skerries school has just one pupil. The poet Hugh MacDiarmid lived in Whalsay; his former house is now a camping böd. There are böds throughout the islands, often in the most spectacular places. They are council-owned buildings that can come in many shapes and sizes – there's a tower in Nesbister and a sail loft in Voe – and they provide cheap hostel accommodation for visitors.

Because most families on Whalsay are engaged in fishing, there is little intensive cultivation on the island and fewer sheep than elsewhere. The result is a profusion of wild flowers in the spring. The most northerly golf course in the UK is found in Skaw, in Whalsay; it's beautifully maintained and has a view to the north-east across to the Out Skerries, two islands linked by a narrow bridge, and one of the more remote communities in the archipelago.

A wedding in Whalsay is a huge island event. After the ceremony perhaps 800 people will gather in the hall for music and dancing. The island has a special cookhouse; the men of the family cut up twelve sheep and cook the meat in giant pots over an open peat fire. The pots are then carried to the hall, where supper is served in sittings in a side-room. The mutton is eaten with bannocks – flatbreads made without yeast – and afterwards there are home-baked cakes. In the middle of the wedding the bride and groom go out and visit the old people of the island who

Val Turner, the archaeologist, appears as herself in the novel. I offered to change her into an elderly man, but she insisted that she wanted to stay just as she was! She also helped create the dig on-set – on Mima's land – for the BBC adaptation of the story. The first trench dug by the crew apparently looked nothing like the real thing. I've become relaxed over the years about the changes that take place in character and story in the adaptation process. This is especially true of location, and while locals are puzzled when island locations jump to shots obviously filmed on the Scottish mainland, I'm beginning to appreciate why this has to happen. The production team of the *Shetland* pilot *Red Bones* decided that Bressay (an island with a direct and very short ferry service into Lerwick) was a more convenient location for filming than Whalsay; and the place they used for Mima's house was actually in Whiteness to the west of Shetland Mainland, and was the home of the then head of Shetland Arts. Then they had to decide how to describe Shetland Mainland and distinguish it from the Scottish mainland. While every Shetlander and visitor understands that when islanders talk about 'Mainland' they mean the largest Shetland isle, it was felt that might not be clear to an overseas audience, so the rather clumsy phrase 'the main island' was used instead.

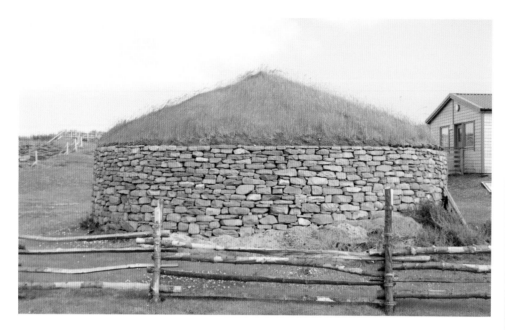

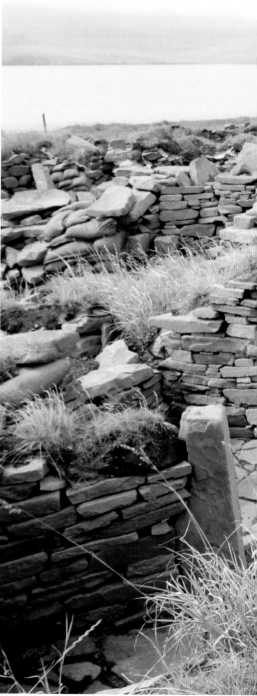

ABOVE AND RIGHT *The partially restored settlement at Old Scatness Broch.*

Archaeology is important in the islands. Shetland is believed to hold several thousand prehistoric sites. There are Bronze Age burnt mounds and Iron Age brochs, and from later periods Pictish wheelhouses, Viking and Norse longhouses and post-medieval fortifications. The best example of an Iron Age settlement is at Old Scatness, where excavations undertaken by Bradford University and Shetland Amenity Trust have revealed a broch surrounded by a whole Iron Age village. Today it's possible for visitors to see the re-created roundhouses and to feel that they're experiencing the period, by taking part in the guided walks and living-history demonstrations.

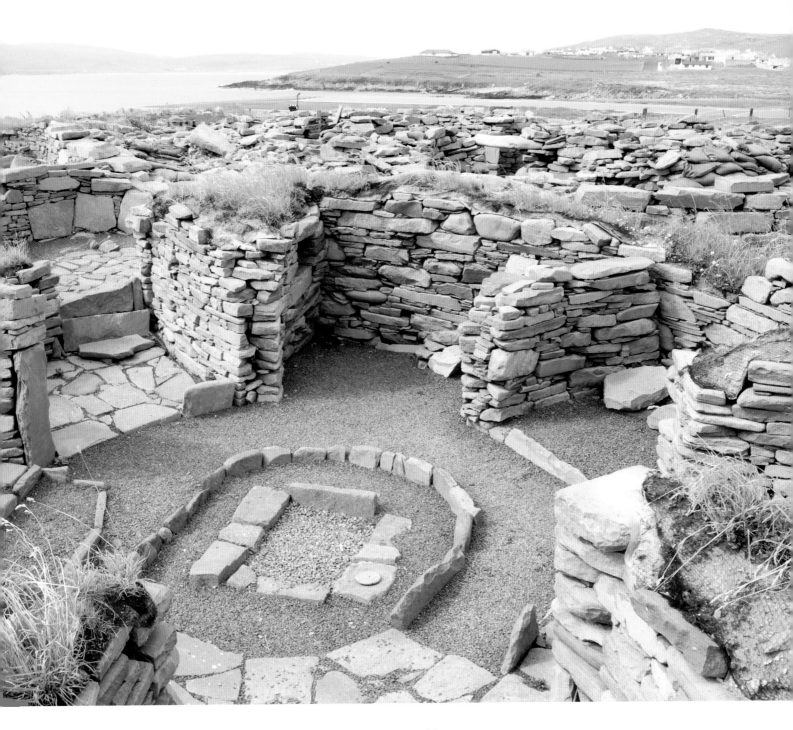

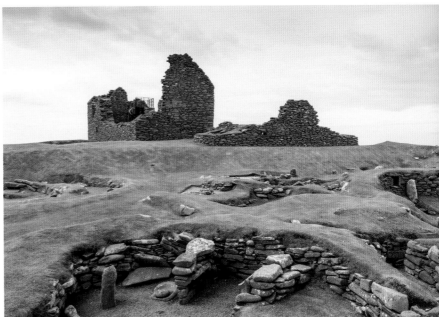

**LEFT** *Law Ting Holm.*

**ABOVE** *The 1604 Old House at Jarlshof is the newest building at the site: the earliest dates from before 2500 BC.*

There is evidence of Viking and Norse settlements throughout the islands. Shetland was ideally placed as a stepping stone for North Atlantic travel from Norway. The most impressive and most visited site is at Jarlshof, a multi-period settlement close to Sumburgh airport in South Mainland. There has also been an excavation at Law Ting Holm, the site of the parliament in the Ting Loch, inland from Scalloway. Debate took place on this promontory at the northern end of the loch until the 1570s, when the parliament was moved to Scalloway Castle.

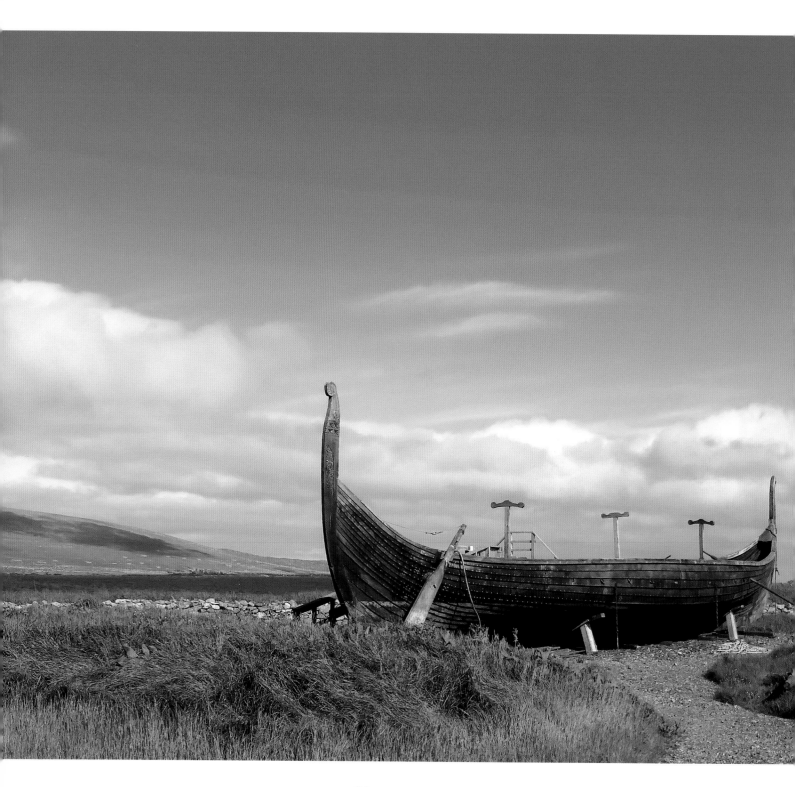

**LEFT AND ABOVE** *The replica longship and longhouse at Haroldswick, Unst.*

Unst, the most northerly of Shetland's islands, was one of the first landfalls for Vikings coming from Scandinavia and has fantastic evidence of their presence. More than thirty Viking longhouses have been discovered so far, and the Unst Viking project has enabled access to three: Belmont, Hamar and Underhoull. A replica longhouse and longship can be found at Brookpoint, Haroldswick, which is said to represent the first footfall of Vikings in Shetland.

In the sixteenth century landowners built castles at Scalloway in Mainland and at Muness in Unst. Fort Charlotte was built in Lerwick, during the Second Dutch War in the seventeenth century. Visitors can explore an array of twentieth-century military remains too.

Music weaves its magic throughout Shetland life. It's a major part of the festivities at family celebrations, weddings and hame-farin's; and dances in community halls still bring communities together. Music charts the history of Shetland life: there are tunes to mark special events and to keep old legends alive. You hear live music in bars, and often on the NorthLink ferry from Aberdeen to Lerwick. And that's certainly true in the run-up to the Shetland Folk Festival, which takes place every year in late spring – the festival seems to start on the boat and doesn't stop until the early hours of the last day.

The Folk Festival was born in 1981, and the format that was decided on by the founding committee is still followed today. The event celebrates the islands' unique fiddle tradition and rich musical heritage, but local artists share the stage with performers from all over the world. Among the artists at the first festival were Kathryn Tickell from Northumberland, my own part of the world; the late Sean McGuire; and Dick Gaughan, whose verdict after the four-day event was: 'This Festival should carry a Government Health Warning – nobody sleeps.' This, too, seems to be a tradition that continues to the present day.

The festival has always been run and organized by a committee of volunteers, whose aim is to take the music and musicians to venues throughout the islands. The long weekend features music from many traditions – from American bluegrass to Scandinavian progressive folk rock. The visiting artists are accommodated in local people's homes, and volunteers run the bars and drive the musicians to the community halls where they will be performing. The special mix of fostering local talent while welcoming the new, the exotic and the unusual provides a unique Shetland experience.

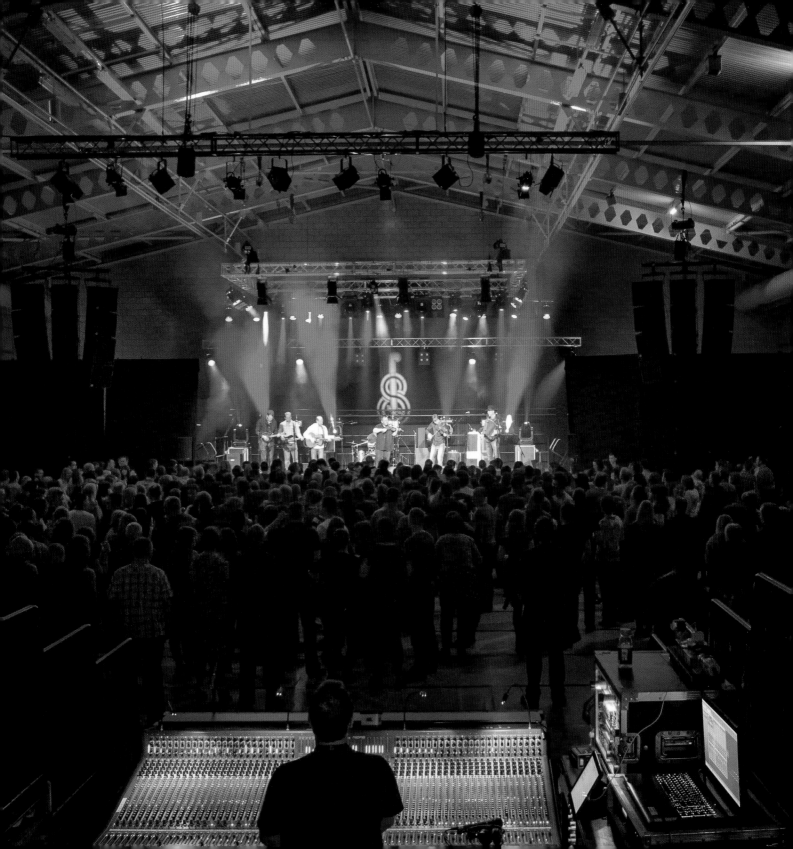

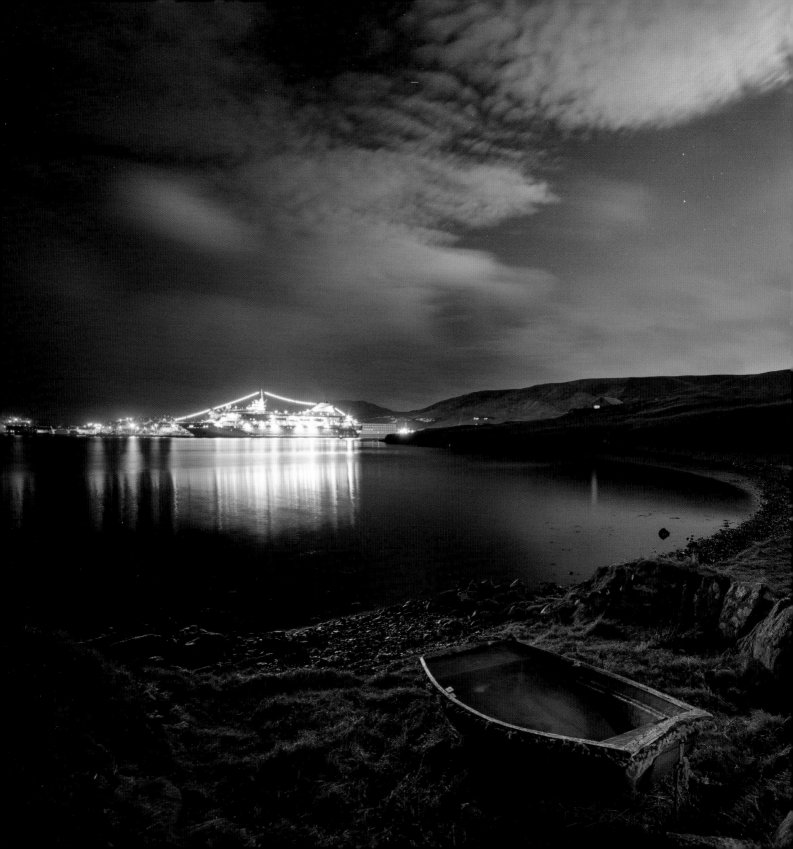

LEFT *The lights of Scalloway by moonlight. The large ship is an accommodation vessel, housing workers building a new gas plant at Sullom Voe.*

*Dead Water* was my second spring book. I had only intended there to be four novels in the *Shetland* series, but after the first quartet (which ended with *Blue Lightning*) I felt that I still had things to say about the islands. The first books are rather quiet and domestic; they're about families and the way they can crack under stress. *Dead Water* covers the same territory, but has a slightly different background and atmosphere, setting families within a wider community context.

The novel considers the debate that exists in the islands about energy, oil and gas. Recently the flow of oil into Sullom Voe has declined, but in the last few years construction of a gas terminal close to the original site on the Voe has brought in a fresh wave of workers to the islands. Flotels – floating hotels – have appeared in Lerwick and Scalloway, and a big new hotel was built in Brae solely for people involved in the gas business. The situation seems to have stabilized now, but when I started *Dead Water* the place felt a little as it did when I first arrived in Shetland in the Seventies, as everyone came to terms with another influx of strangers.

**RIGHT** *A solitary wind turbine.*

Shetland is windy, so it's an obvious place to site a wind farm. There are already turbines on the hill outside Lerwick, and some friends have a small windmill in their garden to help provide power for their house and for the electric car they use for driving short distances. Wind provides all the energy for small communities like Fair Isle. Some time ago there was a proposal to create a giant wind farm on a spine of hillside running north in Mainland. Perhaps because the farm would provide more power than the islands could ever use, this has been a matter of great controversy. Some people ask why Shetland should spoil its natural environment to provide energy for the rest of the UK – a cable would be sunk between the island and the north of Scotland, to export the power. Others believe that the wind farm would bring in a considerable source of income, just as the oil revenue is drying up. And once the cable attached Shetland to the UK mainland, it might make economic sense to develop other forms of sustainable energy: there is an immensely powerful tidal race between Shetland Mainland and the island of Yell, for example, so tidal energy might become viable – and I was interested in exploring how different islanders might react to that.

So at the beginning of the book I describe the oil terminal in Sullom Voe, as part of an industrial landscape. Many visitors to the islands never see this site, except perhaps for the burning flare in the distance. It's very well hidden by folds in the hills and, unless you drive along the road from Brae towards Mossbank, you will be completely unaware it's there:

*Jerry Markham looked across at the voe. Behind him was the open hill, peat and heather, brown after the long winter. Ahead of him the oil terminal. Four tugs big as trawlers, two alongside, one forward and one aft, nudged the* Lord Rannoch *backwards towards the jetty. The tankers were always moored to face the sea, ready for escape in case of incident. Beyond the still water he saw an industrial scene of oil tanks, office accommodation and the huge bulk of the power station that provided power for the terminal and fed into the Shetland grid. A flare burned off waste gas. The area was surrounded by a high fence topped by razor wire. Since 9/11, even in Shetland, more care had been taken to secure the place. At one time all that was needed to get into the terminal was a laminated pass. Now every contractor was vetted and put through a safety course, and every truck was inspected and badged. Even when the gates were opened there was a further concrete wall to block access.*

*Jerry took a photograph.*

In contrast, one of the novel's characters works at a croft house museum, so the reader has a sense of the traditional way of life in the islands. Although in the book this is set in West Mainland, Shetland's actual Croft House Museum is at Boddam in Dunrossness to the south, on the way to Sumburgh airport. This was a mid-nineteenth-century house, which was lived in until the Sixties. The house, barn and byre were all accessible under the same roof, and everything in it was made from materials that had been found and collected.

The mystery in *Dead Water* begins when Rhona Laing, the Procurator Fiscal, discovers the body of a man floating in a yoal in the marina in Aith. Aith is a small community in the West Mainland, with a lifeboat station, a school and a community shop. It's rather isolated and the road into it crosses a moonlike landscape of steep hills and peaty pools. The Fiscal, played by Julie Graham in the BBC production, is a smart and rather aloof incomer in the novel. There are rumours that she returns to Edinburgh every month to have her hair cut! She has come to Shetland because she loves sailing and has a passion for the sea. In the story she becomes far closer to the investigation than she really wants to.

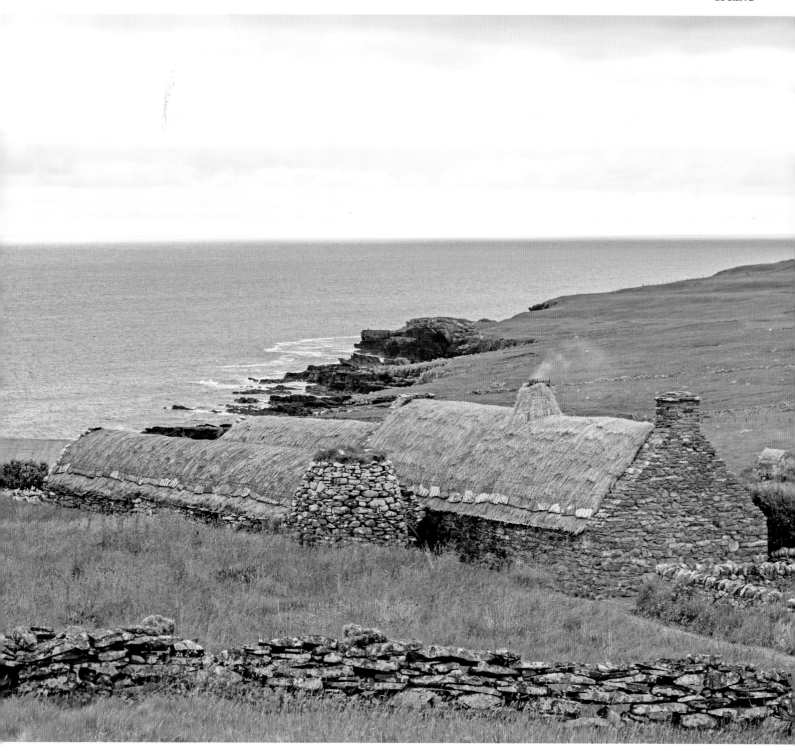

RIGHT *Ian Best working on a yoal,*
*a traditional Shetland boat.*

OPPOSITE *A snowy owl.*

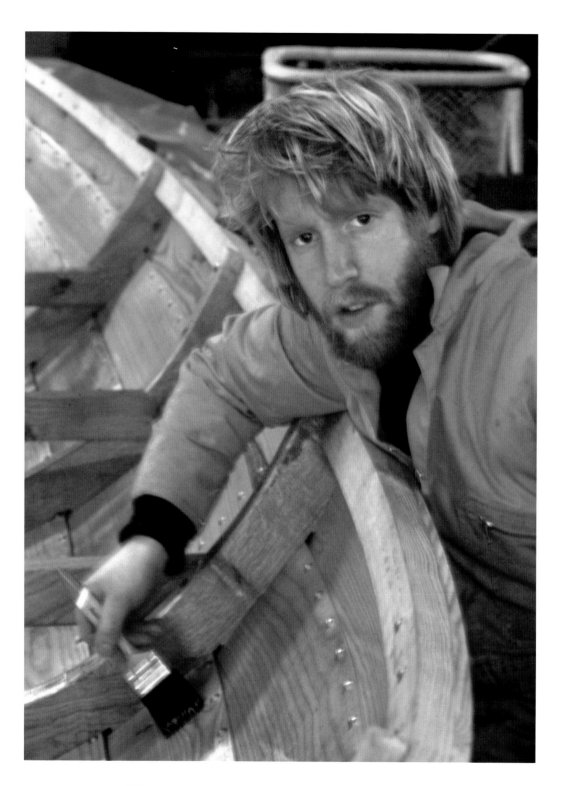

RIGHT *Ian Best working on a yoal,*
*a traditional Shetland boat.*

OPPOSITE *A snowy owl.*

I love undertaking research for the *Shetland* books. It's all about chatting to Shetlanders about their preoccupations and everyday life, and drinking tea in croft kitchens. I enjoy bringing the scriptwriters for the BBC series to the islands too. It's important for them to meet Shetlanders and the more often they visit, the more authentic the drama becomes.

One of the characters in *Dead Water* is a boatbuilder who makes traditional yoals. He stands for the old values of self-reliance. I needed to find out about the craft and I was fortunate that Ian Best, a boatbuilder in Fair Isle, provided excellent information for those scenes. He talked me through the work, described the clinking, the hammering of grooved copper nails into the overlapping planks, and the smell of sawdust. And my old friend Jim Dickson, who had recently retired as harbour master at Sullom Voe, was invaluable concerning the work of the pilots based in the Shetland Islands Council facility at Sella Ness and the control room there. It's these small details that bring a character or an activity to life and I'm always very grateful for the insights provided by local people.

In the book Francis Watt, the boatbuilder, lives in Fetlar, one of the smaller islands accessible by roll-on, roll-off ferry from Gutcher in north Yell. Each of the inhabited islands has its own characteristic flavour. I first went to Fetlar when I was working at the bird observatory in Fair Isle in 1975. At that time

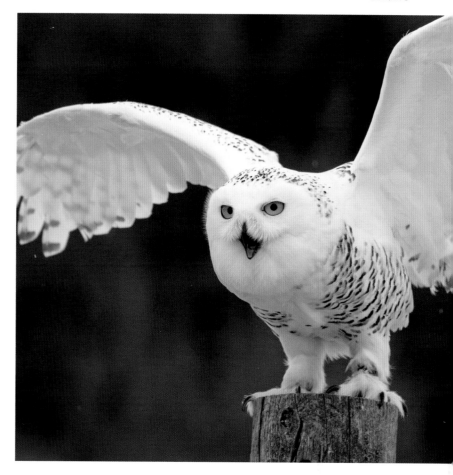

snowy owls were breeding in Fetlar – their discovery in 1967 by local naturalist Bobby Tulloch caused something of a sensation in the birding world. There are some wonderful stories about the excitement generated by these birds. My particular favourite concerns the time when Bobby and Dennis Coutts, a keen birder and professional photographer with a shop in Lerwick's Commercial Street, dressed up as the back and front ends of a pantomime horse, in an attempt to get close to the owls to photograph them. I would have loved to see that!

**ABOVE** *Sunset on Fetlar.*

In 1975 Peter Roberts, the Fair Isle observatory assistant warden, had been invited to Fetlar to ring the young owls, and I went along for the ride. We camped next to a long sandy beach where Manx shearwaters came in at night and were woken early in the morning by the call of a corncrake. We never saw the bird, although it must have been tantalizingly close; and corncrakes no longer breed in Shetland. The owls have left too, but their presence started a movement that led to the Royal Society for the Protection of Birds buying and managing land in Fetlar. Now the island is home to the rare red-necked phalarope, and it's possible to see the phalaropes on Funzie Loch from the RSPB hide or from the road. Fetlar is worth a visit even for a non-birder like me. It's a beautiful place, and otters are common and so are both species of seal.

Fetlar is small; it's only five miles long and two-and-a-half miles wide and its tiny population is supported by a shop and a primary school. But it has a range of habitats: there are gentle moors, higher bleak hills, beaches, low rocky

**ABOVE** *Funzie Bay, Fetlar.*

shores and dramatic cliffs. It's as if all the variety of Shetland's landscapes is here in one place. The whole of Shetland's history seems to be represented here too. There are prehistoric house sites and standing stones. Legend has it that the stone circle at Hjaltadans is made up of trows who were tempted out of their underground homes to dance to wild music and were then caught at sunrise and turned to stone. The centre stones are supposed to be the fiddler and his wife. A Celtic Christian monastic site is thought to have been present in Fetlar – such sites weren't uncommon in the fifth and sixth centuries in the Northern Isles. The monks would probably have grown much of their own food and worshipped in a small chapel. There is still evidence of the clearances too, when greed caused the lairds to take the land for their own use, believing sheep to be more profitable than people. Ruined buildings, drains and walls show where crofters once lived. Some of the 'big houses' also remain, as does evidence of early fishing.

Not all Shetland traditions go back centuries. The prosperity of the islands since the 1970s has meant that young people come home to live and work. There is very little unemployment in Shetland, and many graduates have the confidence to start their own small businesses. The Internet means that they aren't restricted to an island customer base. These young people have developed traditions of their own and one of these, featured in *Dead Water*, is the 'hennie bus'. Unless you live in Lerwick, the traditional pub crawl for a hen night is impossible. Away from the town, bars are few and far between. So the women dress up, as they would anywhere on the mainland, and a bus carries them from home and between the hotels and bars.

Another unique wedding practice finds its way into the book. I was intrigued to see two life-sized models of people – rather like scarecrows or Bonfire Night guys – lying at the entrance to a croft in North Mainland. The models were dressed and wore masks made from the photographs of a couple's faces. Although these figures are made in celebration of a newly married couple, they seemed a little sinister to me. And I thought they would be even more sinister if one of the guys was replaced by a dead body . . . You can see straw skekler costumes that were part of Shetland's guizing tradition in the Shetland Museum in Lerwick, so perhaps this is simply a modern development of a more ancient practice.

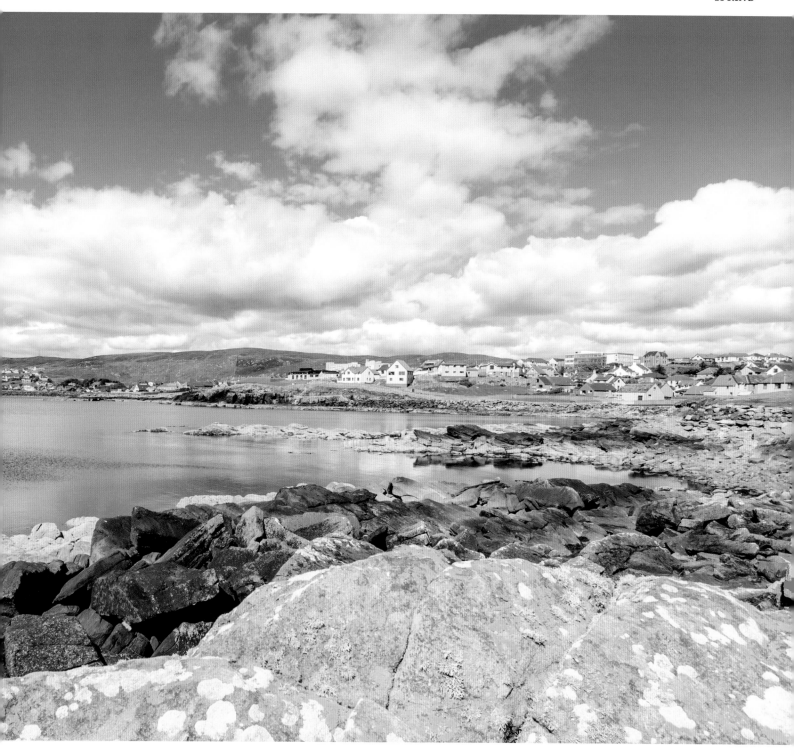

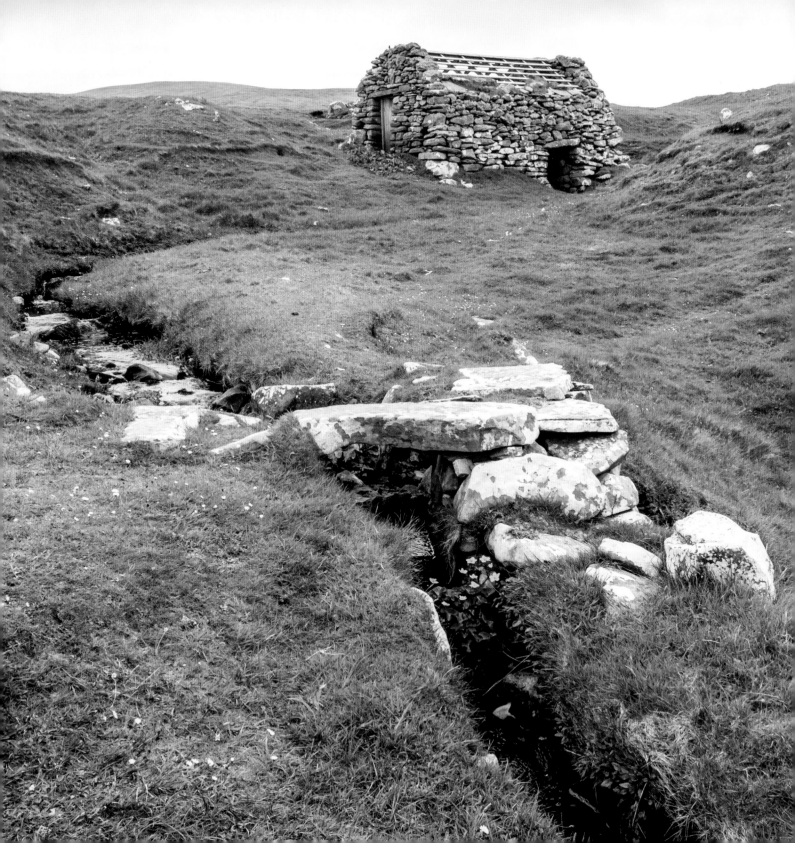

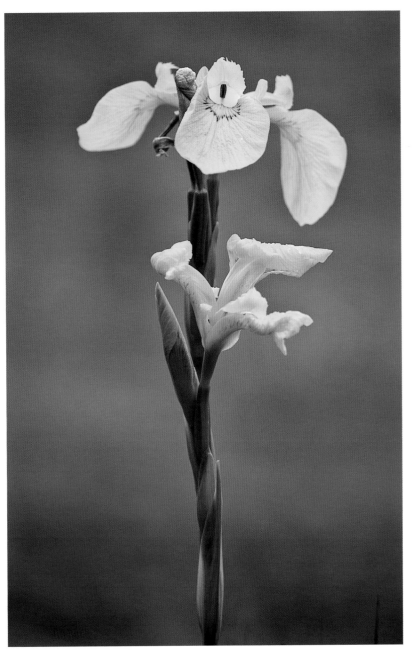

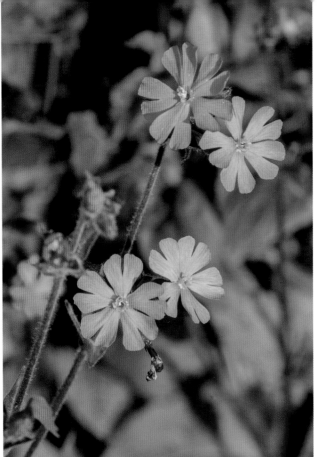

While spring seems to come in a series of false starts in Shetland, with cold windy days intruding far into the season, the natural world responds to the longer daylight. As the season progresses, the islands become a riot of colour after the greys and browns of winter. The tops of the cliffs are covered in the blue of spring squill and the pink of thrift. The pressure of grazing by sheep restricts the wild flowers to the cliff tops, to fenced fields and to marshy areas. The waterlogged bogs are home to bright-yellow kingcups and marsh marigolds, to 'seggies' (yellow flag irises) and to the dark-pink Shetland red campion.

**LEFT** *Marsh marigolds by the ruined watermills at Huxter.*

**ABOVE** *Yellow flag iris.*

**RIGHT** *Red campion.*

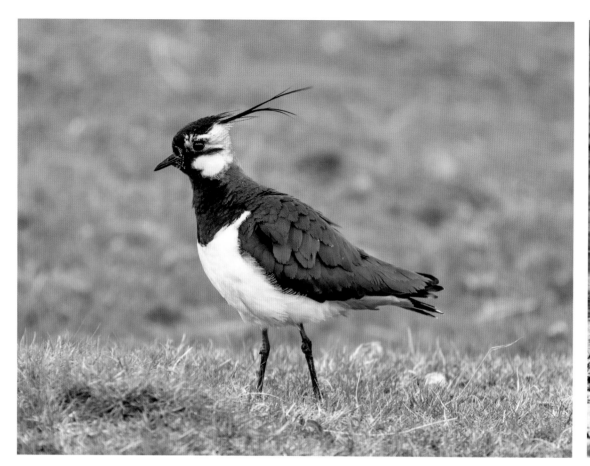

Perhaps the first signs of spring in the birding world occur in gardens when the local blackbirds start to pair up and seek out a nest site. By late March ravens have selected their nest sites and are still cementing their pair-bonds by rolling and tumbling in the sky. Further south in Britain, wading birds have been under pressure for decades, squeezed by agricultural improvements and changes in farming practice. In contrast, Shetland still retains a reasonable number of curlew, lapwing, snipe and redshank. By late March curlews are bubbling across the open hillside. On the low in-bye land lapwing are displaying too and their characteristic 'pee-wit pee-wit' calls echo around the crofts. Skylarks make their presence known as well; you might not see them, except as specks high in the sky, but you will hear their liquid, never-ending song.

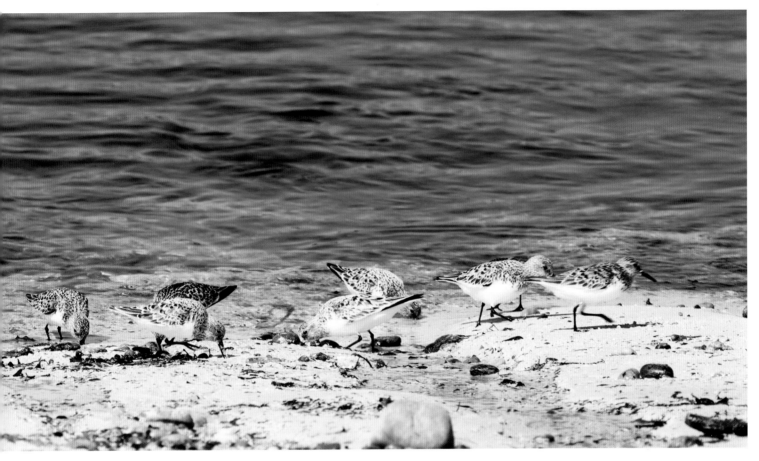

**ABOVE LEFT** *A Scottish lapwing.*

**ABOVE** *Curlew feeding at the shoreline.*

**RIGHT** *A skylark.*

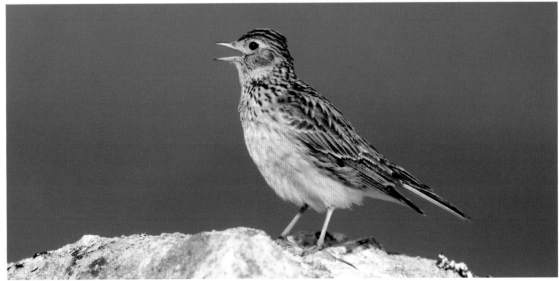

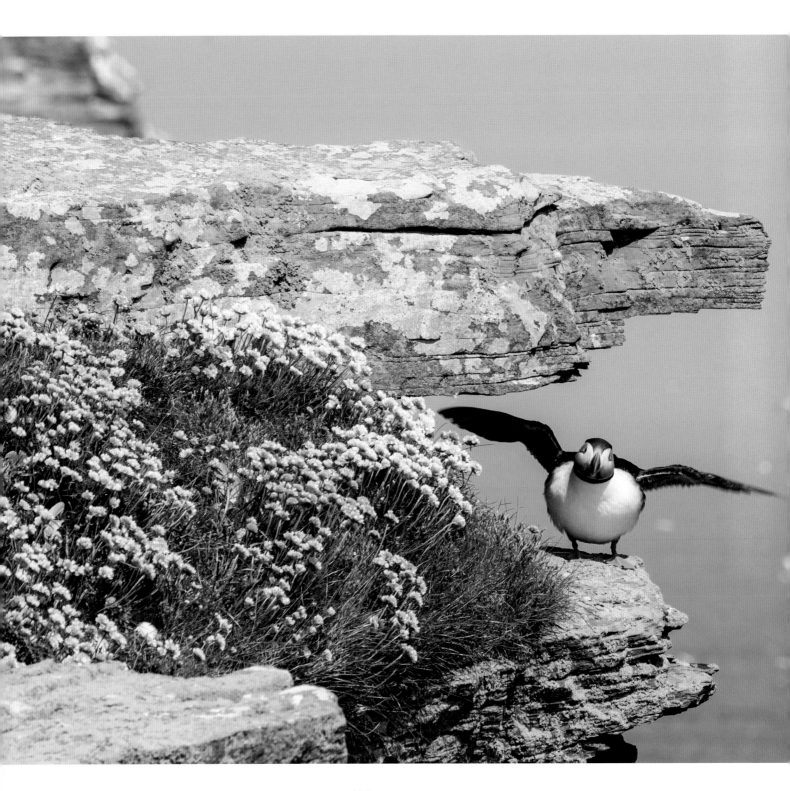

**LEFT** *A puffin on Noss.*

**ABOVE** *A wheatear.*

For me, spring in Fair Isle means the arrival of wheatears hopping along the drystone dyke that separates the road from the flower-rich marshy area of Gilsetter. The bird's name is taken from the old English words 'hwit' and 'aers', meaning 'white arse', and it's the white rump of the bird that we glimpse in short cropped grass or on stone walls. And, of course, in Shetland spring is the time when the seabirds come back to the cliffs, and with their arrival we know that we have almost reached summer.

Summer

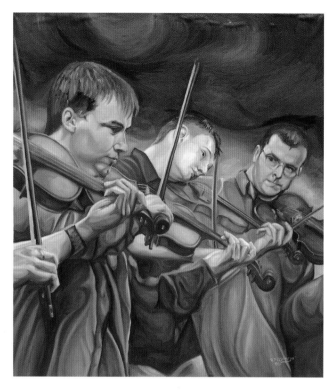

**CHAPTER OPENER** *The tombolo (spit of land) between Bigton and St Ninian.*

**PREVIOUS PAGE** *Sea mist over Noss.*

**LEFT** *Fiddlers' Bid painted by Richard Wemyss. Chris Stout is on the right.*

**RIGHT** *Sunset over Mavis Grind.*

logistical nightmare for the production team, as actors and crew were stranded on the Scottish mainland when flights were cancelled, and there were frantic drives to Aberdeen to catch the NorthLink ferry. The appearance and disappearance of the low cloud and mist must have caused severe problems of continuity.

In *White Nights* I tried to capture the magic and madness of midsummer in the islands. I hope it's a book about theatre and pretence, and things not being quite as they seem. The sense of performance and showiness is represented by one of the characters in the book, a young fiddler called Roddy Sinclair. Roddy is inspired by (though not exactly based on) a musician called Chris Stout, a Fair Islander by birth, who was a founder member of the Fiddlers' Bid band. There is a terrific painting of the group by Richard Wemyss in the library in Lerwick, and I used that too as part of the plot of my novel *Dead Water* – postcards of the painting are found on the bodies and provide a clue to the identity of the murderer. Chris Stout has gone on to work with musicians from Scandinavia and South America and has achieved worldwide recognition. One of his albums is called *White Nights* and was inspired by the novel. So there has been a circle of influence, and at the heart of it all was the wildness of midsummer.

I hope this extract sums up the joy and exhilaration of the music, the man and the time of year:

*Roddy stood framed by light in the middle of the space. It was nine in the evening but still sunshine came through the windows cut into the tall, sloping roof. It was reflected from the polished wooden floor and the whitewashed walls and lit his face. He stood still for a moment, grinning, waiting until the guests started to look at him, absolutely sure he would get their attention. Conversation faltered*

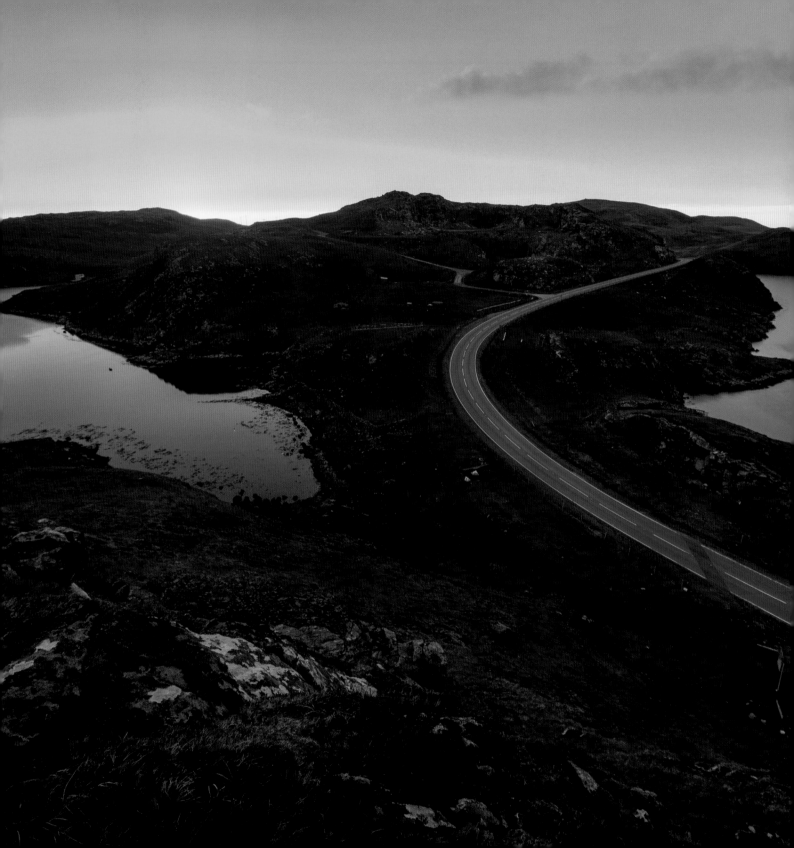

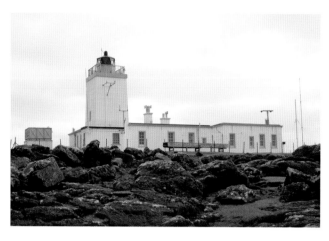

*and the room grew quiet. He looked at his aunt, who gave him a look that was at once indulgent and grateful. He lifted his fiddle, gripped it under his chin and waited again. There was a moment of silence and he began to play.*

*They had known what to expect and he didn't disappoint them. He played like a madman. It was what he was known for. The show. That and the music. Shetland fiddle music, which had somehow caught the public imagination, was played on national radio and raved about by television chat-show hosts.*

*He hopped and jigged, and the respectable middle-aged people, the art critic from the south, the few great and good who'd driven north from Lerwick, set down their glasses and began to clap to the rhythm. Roddy fell to his knees, lay back slowly so he was flat on the floor and continued playing without missing a beat, then sprang to his feet and still the music continued. In one corner of the gallery an elderly couple were dancing, surprisingly light-footed, arms linked.*

I've set *White Nights* in a very different part of Shetland in a fictionalized part of north-west Mainland, known in reality as Northmavine. I call my settlement Biddista, but in my head its location is very close to the village of Hillswick on the west coast. The Pit O'Biddista, where one of the murders takes place, with its deep hole gouged out of the top of the cliff, is based on the Hols o' Scraada, close to Eshaness Lighthouse. This amazing geological feature is practically invisible from the hillside around it, and lots of people look for it and fail to see it. It was caused when a sea cave collapsed inland from the steep coast. The hole goes right down to water level, and a tunnel from its base leads out to the sea. Watch out for the Hols o' Scraada in the new series of the BBC drama – the scriptwriter was so intrigued by the place that he set one of the scenes there and it should provide a chilling background to the action. Some of the most dramatic cliff scenery in Shetland can be seen from Eshaness. It's possible to park right by the lighthouse and walk from there. And for tourists looking for an interesting place to stay when they visit the islands, the lighthouse is available to rent as a holiday home.

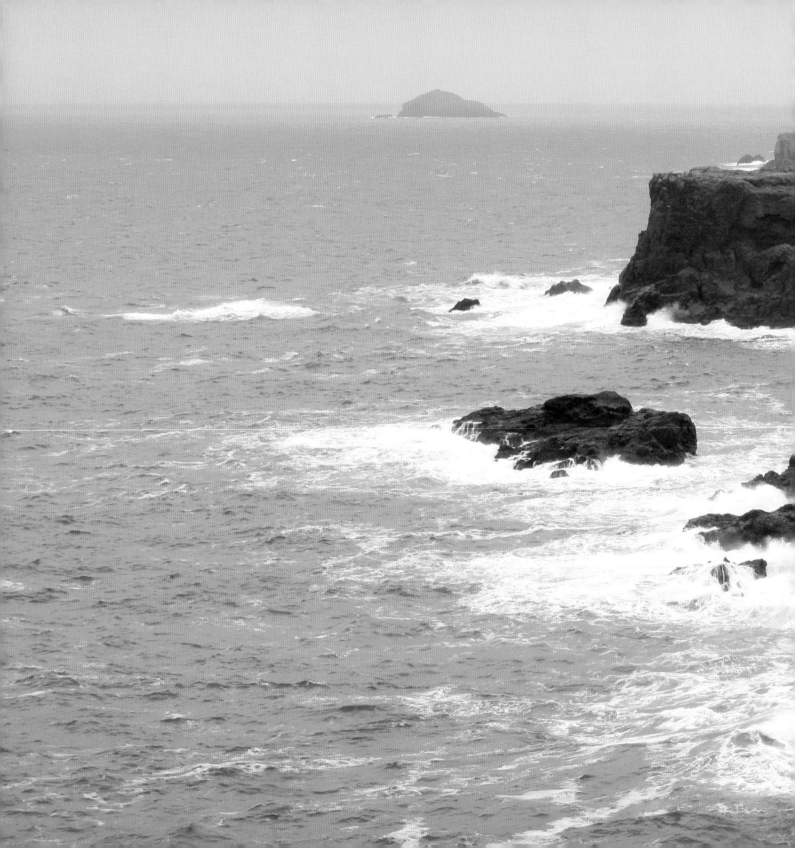

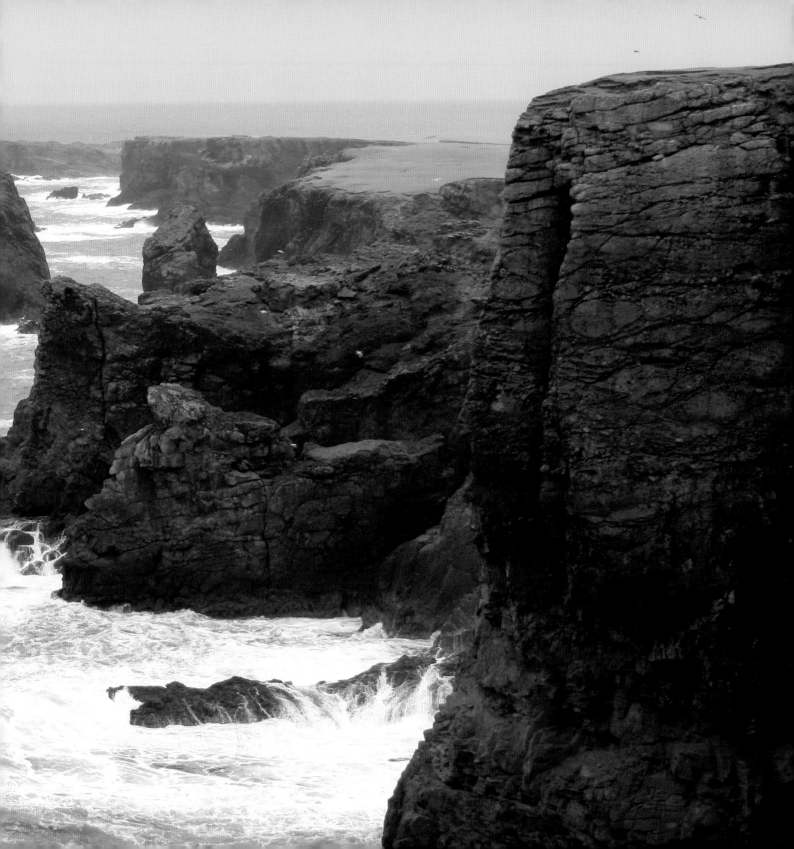

LEFT *Ronas Hill.*

Northmavine is almost an island in its own right, joined only by the narrow bridge of land called Mavis Grind. *Grind* (with the 'i' pronounced as in 'inn') means a gate, though my husband says that Mavis Grind should be the name of a sultry and somewhat sleazy nightclub hostess. The landscape here is dominated by Shetland's highest point, Ronas Hill. Although it's only 1,475 feet high, so it doesn't come close to other mountains in the UK, the severe exposed conditions mean that plants growing here are similar to those growing at 3,000 feet elsewhere. At the top of the hill is fellfield – bare and exposed granite where ice action causes the stones to shift. The plants here are alpine, and only ferns grow in the more sheltered cracks and gullies.

There are a number of settlements in Northmavine; each has an atmosphere of its own and whenever I visit, ideas for stories swoop into my head like the terns that swoop towards people who wander too close to their nests. The people here are proud of their wild and dramatic landscape and are self-reliant. The shop at Ollaberry is a community-owned and run co-op; many of the residents bought into it when the private owners were forced to sell. Hillswick has its own community shop too.

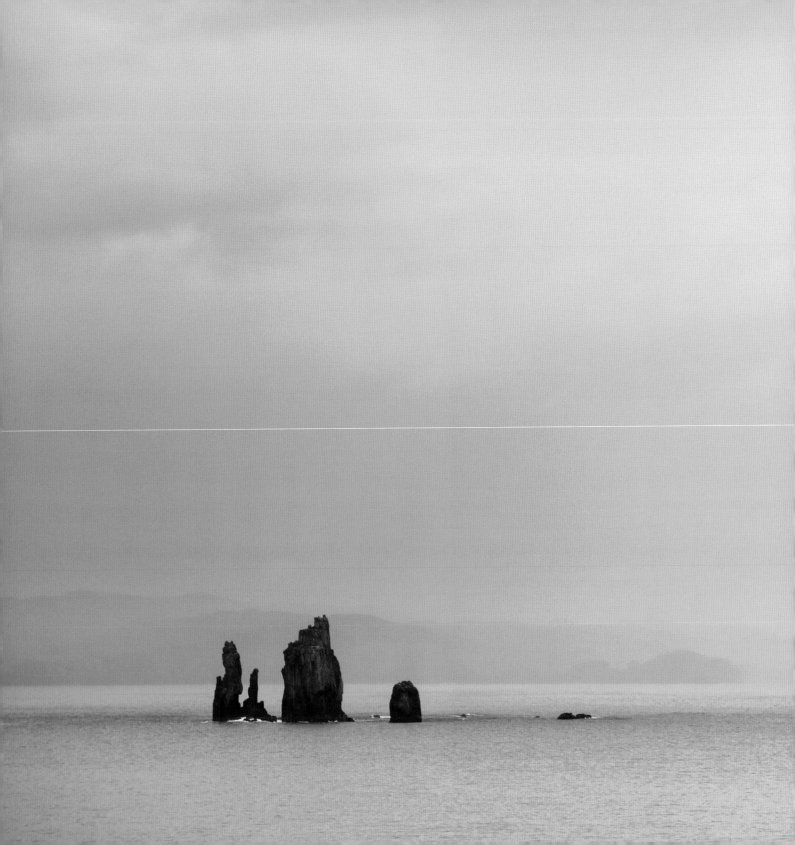

**LEFT** *The Drongs lie a mile offshore from the Ness of Hillswick.*

Hillswick was the main township in Northmavine from Hanseatic times, and this is the place visitors head for when they come to the region – the St Magnus Hotel provides meals and accommodation and in the summer there is a cafe. I always feel that it has a balmy, west-coast feel to it – but perhaps I've been lucky with the weather whenever I've visited. Hillswick is also home to the Shetland Wildlife Sanctuary, which takes sick or injured seals and otters and works to return them to the wild when they're sufficiently fit to survive on their own. Tangwick Haa is Northmavine's own little museum; it holds tools from old crofting days and domestic furniture, so visitors get a real sense of what it must have been like to live in the area when times were much harder.

I love bringing the BBC scriptwriters to the islands. It's always a delight to see the place through other people's eyes and to watch their amazement at Shetland's very special beauty. By talking to local people and visiting possible locations they can bring a real sense of place to the productions, which would otherwise be missing. And I learn more about the islands too. I've spent time in the coastguard watch office in Lerwick, chatted to an undertaker and taken a trip round the waste-to-power plant, all in the name of BBC research.

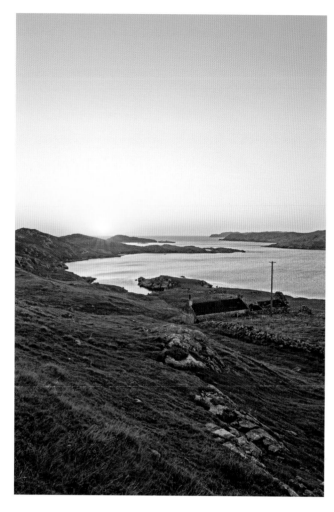

scriptwriters seemed haunted by this landscape, by the tattered remains of past lives still visible in the ruins. I look forward to seeing the result of the visit on-screen.

Part of the *White Nights* plot centres around Bella, Roddy's aunt. She's an artist who owns a gallery that has been converted from a former herring house. In Weisdale on the west side of Shetland Mainland the Bonhoga Gallery has been converted from an old water mill, and this certainly provided the inspiration for the gallery in the novel. The Weisdale Mill was founded in 1855 to mill barley and bere (a traditional grain still available in the islands), and its past reflects the history of nineteenth-century Shetland. It was constructed on the instructions of the Black family, who cleared the Weisdale Valley and replaced people with sheep. There was little concern for the safety of the people who operated the mill, and there were two accidents during its operation. In both cases it seems that pieces of clothing got caught in the machinery. In one incident the miller, Andrew Lundie, was killed. When he hadn't arrived home for his tea, his wife went to find him and saw his body being carried round and round on the wheel. Her shock was so great, apparently, that she couldn't find the strength to go for assistance.

On the most recent writers' recce – besides visiting Eshaness and the Hols o' Scraada – we went to Nibon on the west coast, not far north of Mavis Grind. The scriptwriters were interested in visiting a remote community, with ruined houses. Here the road leads down a valley scattered with crofts, and ends (as is always the case in Shetland) by the water. Some of the land is still farmed and the houses still lived in, although many have been abandoned. The

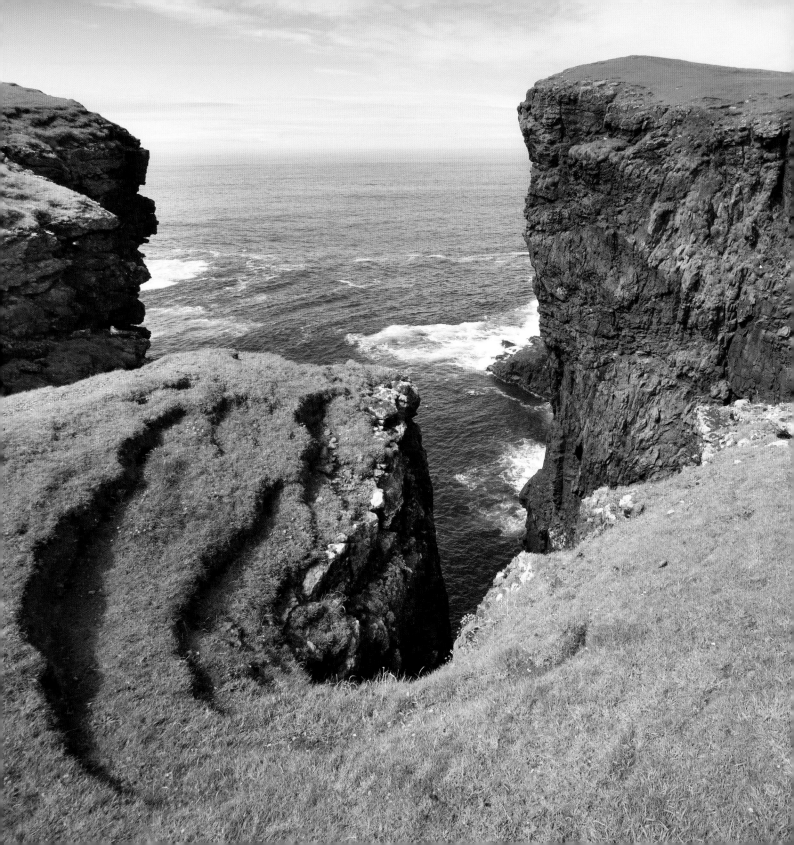

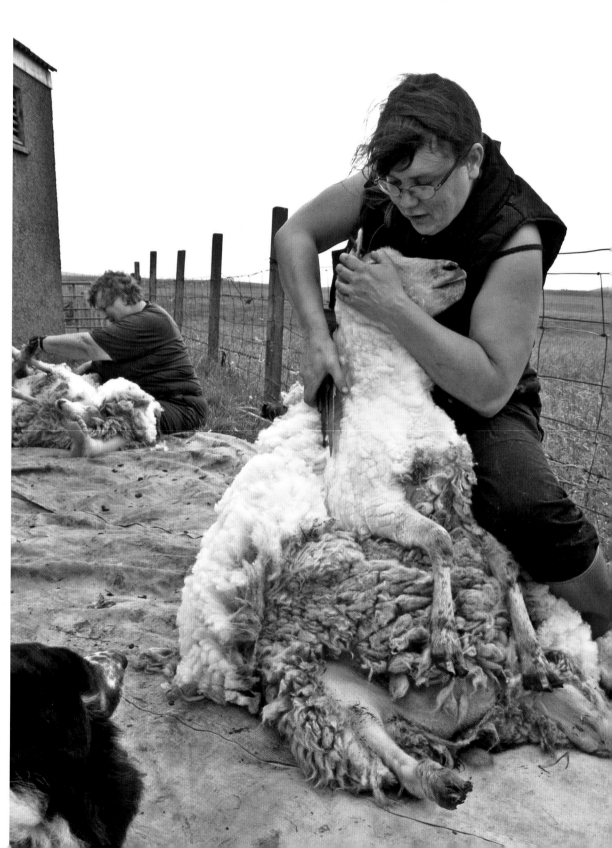

**RIGHT** *Sheep shearing on Fair Isle.*

**OPPOSITE** *Bonhoga Gallery at Weisdale Mill.*

**OVERLEAF** *The Knab at Lerwick.*

Of course, if I were writing the story as a novel I'd question whether her lack of action had some other motive! Ideas for fiction come from everywhere, and the tale of Andrew Lundie would make a great murder mystery for a writer of historical crime.

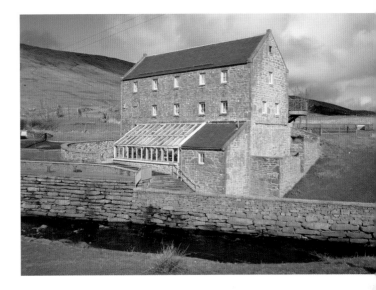

The gallery was opened in 1994 and is run by Shetland Arts. There is an upper-floor gallery space, a small shop and a very good cafe on the lower floor, built into the hill and looking out over the Kergord burn that once powered the mill. The cafe is very popular with locals for lunch and afternoon tea, and usually when I visit I bump into someone I recognize. The tradition of home-baking continues in most of the cafes in the islands, and the Bonhoga scones are particularly good. If the sun is shining, we like to sit outside and enjoy the view across the burn and down towards the voe. The gallery curates seven exhibitions a year and chooses to display work by local, national and international artists and craftspeople. Short films are shown on the screen in the stairwell. The word 'Bonhoga' means 'my spiritual home', and on its website Shetland Arts says it intends that the gallery should be the spiritual home of contemporary arts and crafts in the islands.

Summer is the time when hill sheep are gathered up and clipped for their fleeces. I used the annual sheep gather, or 'caa', as a device to bring my suspects together on the hill in *White Nights*. Again it was helpful that I was able to draw on my own experience. All the observatory staff members were roped in to help with the sheep gather when I was working in Fair Isle. This is a task that's made much easier if there are more bodies on the ground. Besides, it's a community occasion and everyone on the island takes part. The islanders walk in a line across the hill, pushing the sheep ahead of them. When the beasts reach the drystone wall that cuts across the width of the island, separating the hill from the lower land to the south, they're funnelled into a pen and held there until they have been clipped. I was given a pair of clippers by Leogh Willie, one of the older crofters, talked through some rudimentary training and told to get on with it. The most important thing was to try to keep the fleece intact and not to nick the skin of the sheep. Willie was very forgiving of my lack of speed and accuracy, but I don't really think I helped him very much.

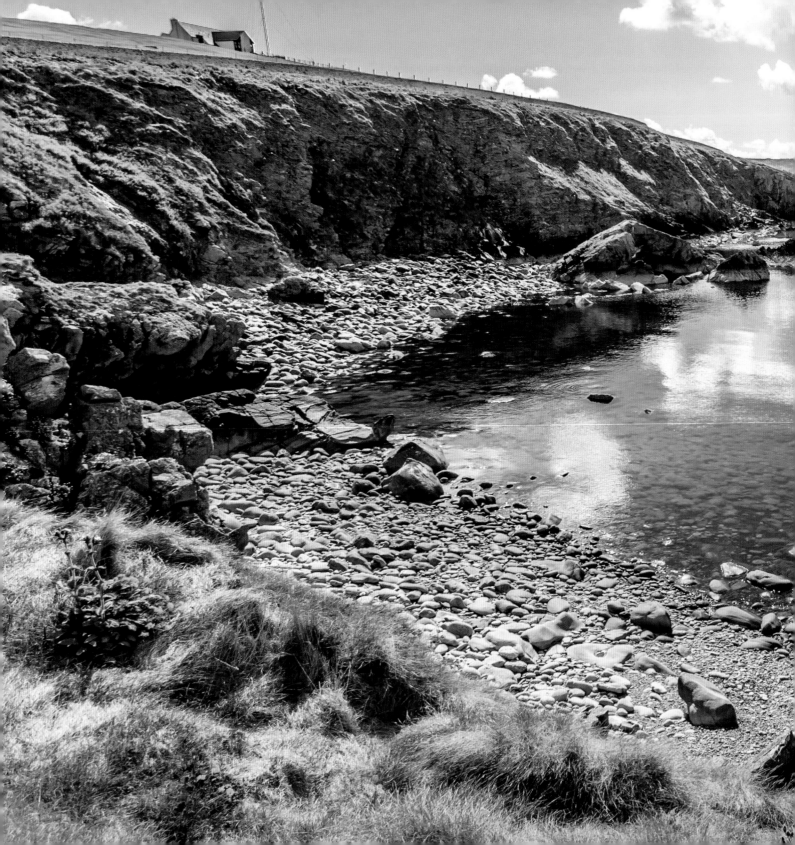

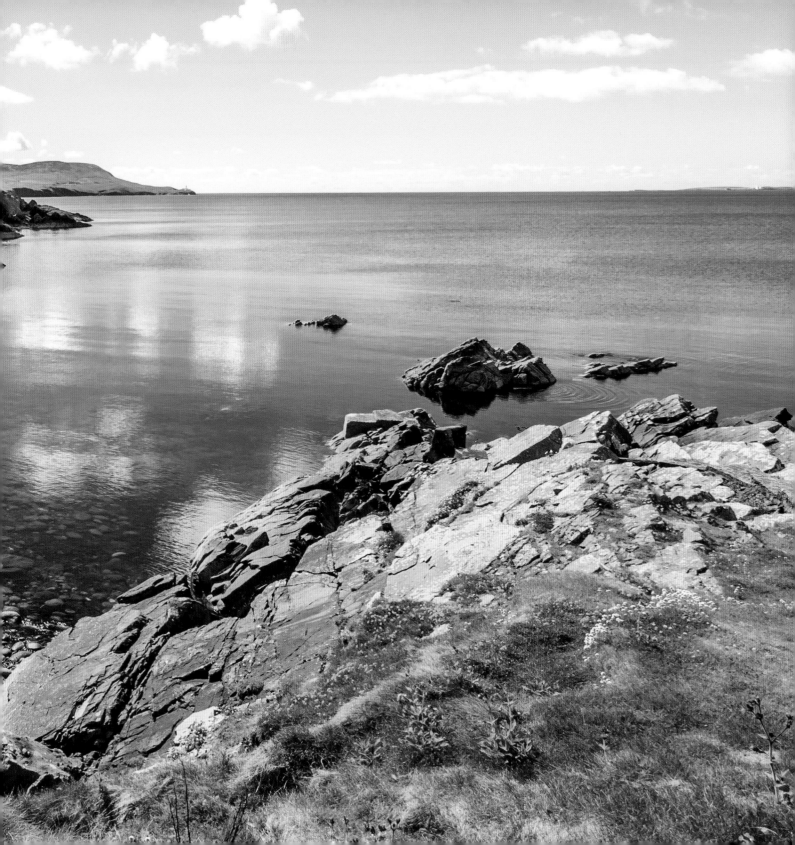

**LEFT** *Vidlin.*

**OVERLEAF** *St Ninian's Isle.*

I know exactly when my second summer book, *Thin Air*, was conceived. It wasn't in summer at all, but in February, and my husband and I had been invited to a hame-farin' in the Vidlin community hall. I'd been to hame-farin's when I was living in Fair Isle – in fact I was one of the guests when musician Chris Stout's parents, Andrew and Kathleen, returned to the Isle after their wedding in mainland Scotland in 1975. Neil Thomson, who is now skipper of the mailboat, the *Good Shepherd*, married in the same year and he and his wife Pat had a hame-farin' too. If a couple marries away from Shetland, they have another party when they come home: the hame-farin'. The bride wears her gown and everyone dresses up as if they were at the wedding itself.

The Vidlin party was to celebrate the wedding of Steven and Charlotte. Steven Robertson is the actor who brings Sandy Wilson to life in the TV series. He also played Jimmy Perez in BBC Radio 4's adaptation of *White Nights*, so I was aware of his work and was delighted when I found out that he had been cast as Sandy. It's fantastic to have a Shetlander as a regular member of the show. And now another actor who grew up in the islands – Marnie Baxter – will join him, so we'll have two authentic Shetland voices.

My husband and I travelled to Shetland especially for Steven's party and had decided to use the ferry – perhaps not the best idea at that time of the year. It had been a rough crossing, we didn't get much sleep and we were still feeling a little light-headed and weird in the evening when we arrived at the Vidlin hall. It had been decorated for the event with bunting and balloons, and there was a big banner with the happy couple's names on one wall. The Cullivoe band had already started playing, and during the bridal march Steven and Charlotte paraded around the room to the applause of family and friends. When I lived in Fair Isle I'd started to learn some of the steps of the more common dances, but the memory had faded and I was put to shame by even the youngest children, so for most of the party I sat and watched the action. I was a disengaged observer, a state when most writers are at their happiest.

Halfway through the evening there was a break for supper. There is a tradition that the young friends of the bride and groom serve the meal, and the food is traditional fare too. In Vidlin that night there was lentil broth, followed by cold meat and bannocks. The meat was salt beef and reestit mutton. I was chatting to poet and broadcaster Mary Blance, who is an old friend (and who coached actor Brian Cox on his accent when he played Magnus in the TV episode of *Raven Black*). She mentioned that the food we were being offered was known as 'bannocks and flesh' in the islands. And just that phrase was enough to give me the idea for the start of my next novel. The word 'flesh', after all, comes with baggage – there is something sinister about it, especially if it's being eaten. It makes me think of cannibalism, and also reminds me a little of the ritual of Holy Communion. So it conjured up the traditions of the islands, but set them within a wider context.

**LEFT** *Sandwich Beach on Unst.*

And as I was sitting there watching – still feeling a little strange because of the ferry, and feeling an outsider because I couldn't join in with the dancing – the premise of the novel arrived like a wonderful form of magic. Sometimes a novel comes after weeks of deliberation, of grappling with stray notions and ideas; there are false starts and weeks of discouragement. *Thin Air* felt more like a gift. In the book I would bring a group of educated thirty-somethings from London to a wedding party in Shetland. They would bring with them the confidence of people who have a comfortable income and a sense that they understand the world better than the islanders, who seldom travel away from home. One of them would be a specialist in legend and folk tales, and another would be a television documentary-maker. They too would be outsiders looking in. Almost as if they were visitors to a human zoo, they would be interested in island customs, but they would appear superior and a little patronizing. Then, as the book progressed and bizarre events occurred, they would realize that their knowledge and experience of the city would be unable to help them.

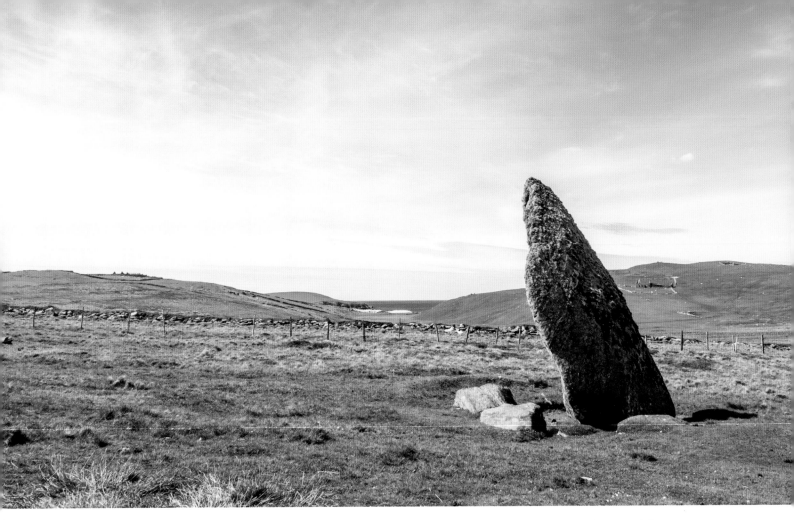

*Thin Air* isn't set in Vidlin, where the book was conceived, but in Unst, Shetland's most northerly inhabited island. Unst is two ferry rides away from Lerwick, and I wanted to send my fictitious group of friends to the furthest extreme of the archipelago. And I changed the time of year, so that the hame-farin' takes place in midsummer, the natural season for a Shetland party, and to give another example of the extremes that the island can provide.

It's said that Unst has a ghost. She's called the 'White Wife' and she appears to lone male drivers when they're driving down the road from Baltasound late at night. The Unst brewery has named a beer after her. The White Wife didn't seem a very interesting apparition to me, so I created my own ghost, a young girl called 'peerie Lizzie' ('peerie' is the Shetland dialect word for small). In the story Elizabeth Geldard was the daughter of the big house, who was drowned in 1930.

This scene comes from the beginning of the book, where we first meet the child who could be 'peerie Lizzie':

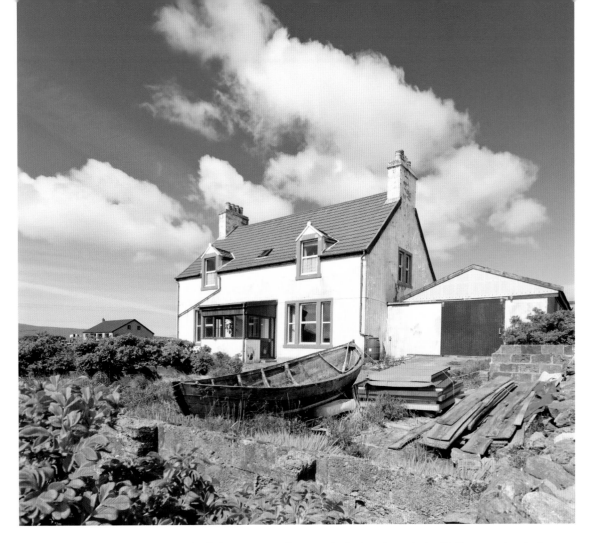

From the hall behind her came the sound of the band finishing another tune, laughter and the clink of crockery being washed up in the kitchen. On the beach below a couple sat smoking. Polly could see them only as silhouettes. Then a little girl appeared from nowhere. She was dressed in white and the low light caught her and she seemed to shine. The dress was high-waisted and trimmed with lace and she wore white ribbons in her hair. She stretched out her arms to hold the skirt wide and skipped across the sand, dancing to the music in her head. As Polly watched, the girl turned to her and curtsied. Polly stood and clapped her hands.

She looked around her to see if there were any other adults watching. She hadn't noticed the girl in the party earlier, but she must be there with her parents. Perhaps she belonged to the couple sitting below her. But when she turned back to the tideline the girl had vanished and all that was left was a shimmering reflection of the rising moon in the water.

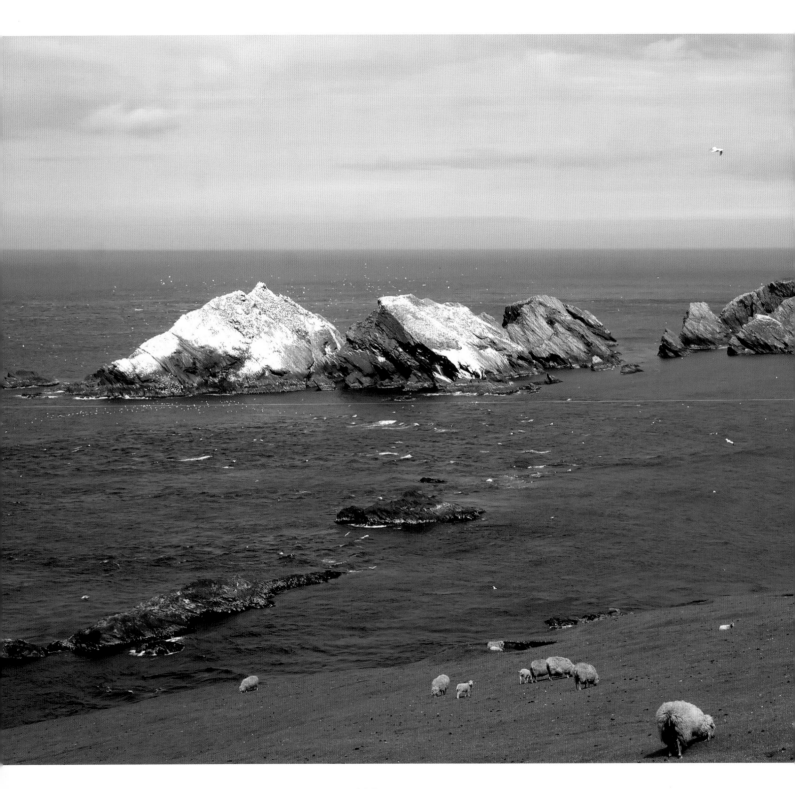

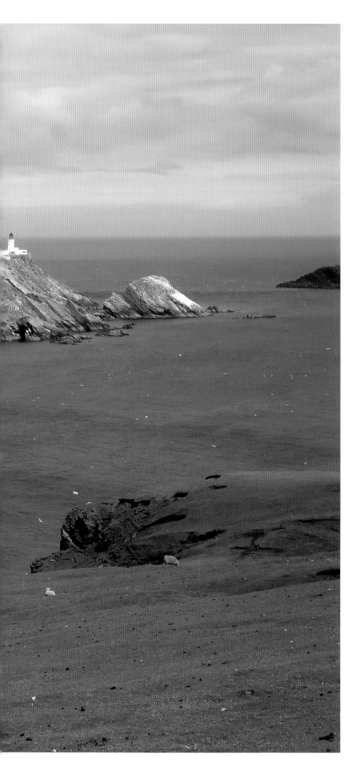

There is nowhere further north to live in the UK than Unst. Apart from the stacks of Muckle Flugga and Out Stack, the next land north from the top of the island is the Arctic. Muckle Flugga has a famous lighthouse built in 1858 during the Crimean War by David and Thomas Stevenson. It is claimed that the men's nephew, Robert Louis, based his *Treasure Island* map on Unst, a place he visited when his uncles were working there, though we don't know that he actually wrote the book on the island. Perhaps the place sparked the idea for the novel, just as the wedding party in Vidlin sparked the idea for *Thin Air*. I'd like to think so.

Unst is twelve miles long from north to south and five miles wide from east to west, and it has a population of approximately 700. It's a very scenic island and some Shetlanders who live in the town of Lerwick have holiday homes there, to which they can come during summer weekends to relax. It's that sort of place: relaxed, sociable, with some beautiful sandy beaches and great walking. Unst has its own festivals and traditions and even holds its own Up Helly Aa – in fact it has two fire festivals, one in Uyeasound and another at Norwick.

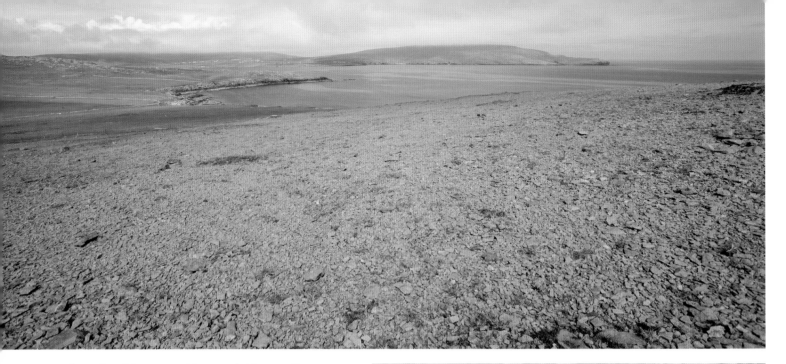

The island has two National Nature Reserves, one at the Keen of Hamar and one at Hermaness. The Keen of Hamar is famous for the flora that grows on the serpentine fellfield there. Most important is a species of arctic chickweed only found on the island. Its significance was first recognized by a young Unst botanist called Thomas Edmondston. He published a paper describing the plant in 1843 when he was just eighteen, and since then it has been known as Edmonston's chickweed. There is a sad ending to his story, however. He became a professor of botany at the University of Glasgow at the age of twenty, but died only a year later when he was on a scientific expedition to Peru.

I first visited Hermaness, Unst's second National Nature Reserve, on my first visit to Shetland in 1975 and was astounded by its spectacular cliffs and the ferocity of the breeding

TOP *The Keen of Hamar.*

ABOVE *Edmonston's chickweed.*

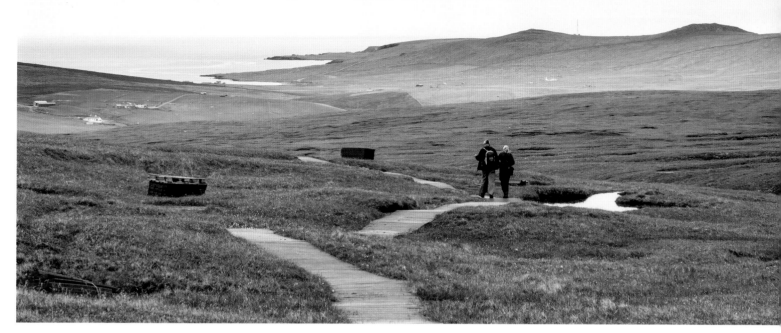

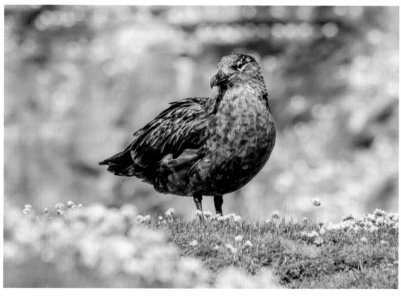

**TOP** *The boardwalk through Hermaness Nature Reserve should be safe!*

**ABOVE** *A bonxie.*

**OVERLEAF** *Looking south from the Knab Golf Course in Lerwick.*

great and arctic skuas. Great skuas, the heavier browner species, are called 'bonxies' in Shetland and the name is now common among birdwatchers throughout the UK. The skuas are fiercely protective of their breeding sites and dive at anyone who dares to wander close to their nests. They tend to aim for the intruder's highest point and, when walking over the hill there, I often put my hand in the air – I'd rather be hit by a passing bird on my hand than on my head.

Amazingly, a black-browed albatross, only found in the southern oceans, arrived on the cliffs in Hermaness in the early Seventies and returned there each spring until the late Eighties. The bird was an adult when it first came to Unst, so the albatross is clearly a long-lived species. In 1976 it even built a nest. Many birdwatchers made the pilgrimage to see it, and it was known affectionately as Albert.

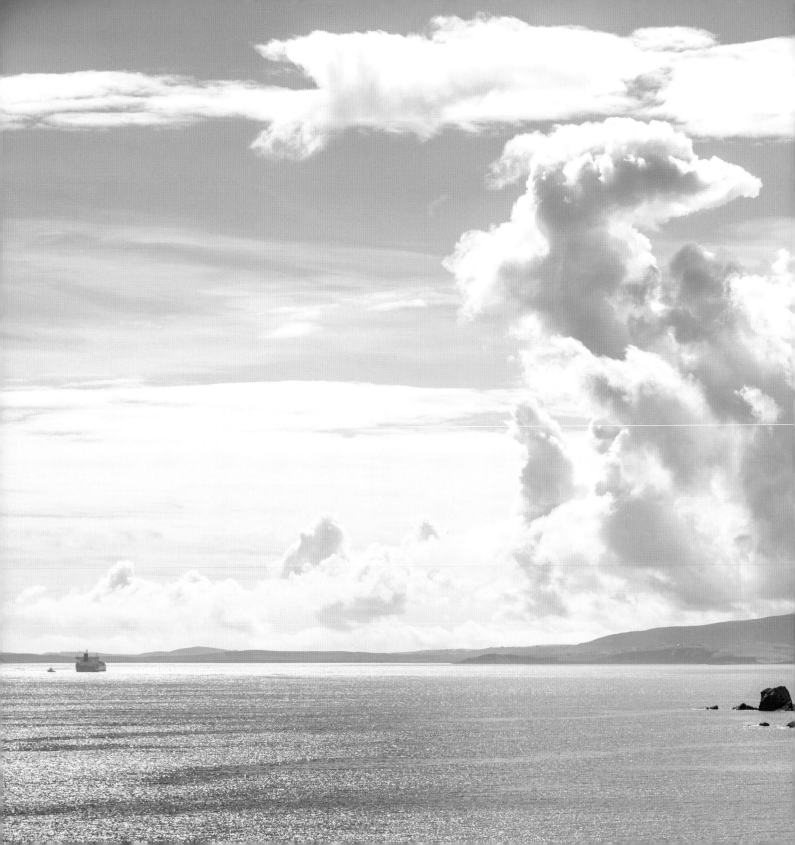

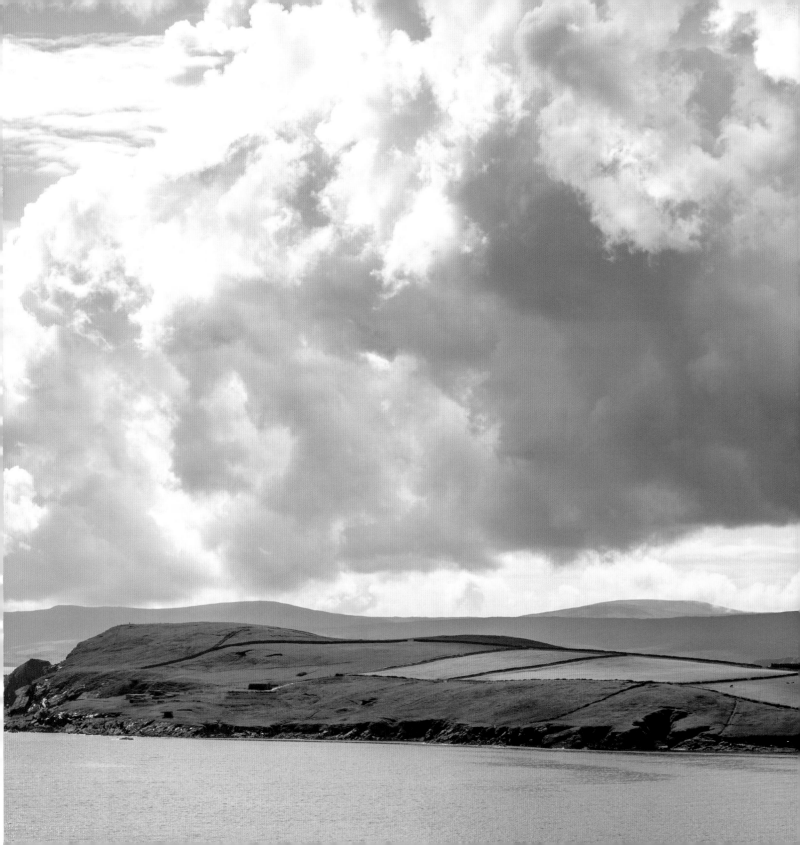

**RIGHT AND OPPOSITE** *Sunday Teas in North Roe, 2015.*

I was in Shetland that week for a wedding. My friend's daughter had planned a ceremony on the site of the Ting, the ancient parliament; the nearby fields were owned by her uncle and he was happy to give her the use of them. There were tents for supper and for dancing, but the wedding itself was planned to take place outdoors. Luckily the rain held off until the couple were married, but the wind was so strong that the marquee sounded a bit like a grand boat under sail itself, as the canvas billowed and creaked in the gale – perhaps this was appropriate, because the bride was a marine engineer who had worked on a sail training ship.

The informal and very friendly Sunday Teas have become a major part of a Shetland summer, and indeed have become so popular that they now take place in other seasons too. They are a great way for outsiders to meet local people and experience something of the island way of life. The Sunday Teas take place in community halls and are fund-raisers for local charities or groups. Everyone is welcome. The guests pay a flat fee of a few pounds, and in return can help themselves to as much tea and as many home-baked cakes, scones and bannocks as they can manage. Occasionally there is live music, often there is a plant or bric-a-brac stall and there is always good conversation and fantastic baking. The following week's Sunday Teas are advertised in *The Shetland Times*, which is published every Thursday and read by everyone, and details are also broadcast on BBC Radio Shetland's 'What's On' diary on Friday evenings.

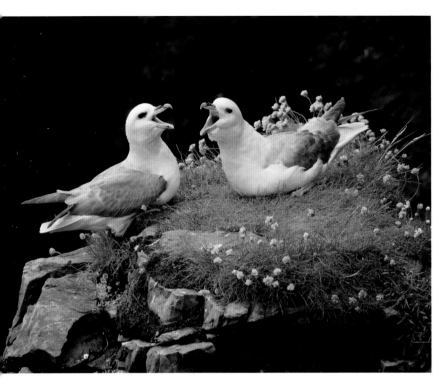

ABOVE *A pair of fulmars.*

RIGHT *Cliffs on Bressay.*

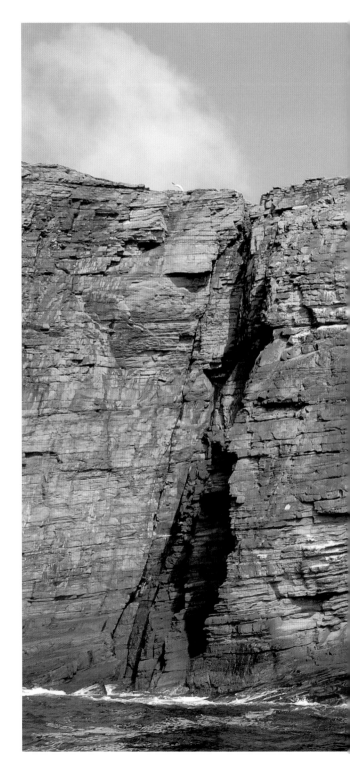

Many visitors make the trip to Shetland just to see the magnificent spectacle of breeding seabirds. In summer the sandstone cliffs of Noss, Bressay and South Mainland become lively seabird cities. The noise is deafening and the smell – made up of guano and spilt fish – overpowering. At the bottom of the cliffs the ledges are occupied by shags and some cormorants. Higher up there are razorbills and guillemots, whose stubby wings propel them out from the cliffs to search for sand eels and sprats in the local waters. The biggest seabird in the UK is the dramatic gannet – startling white,

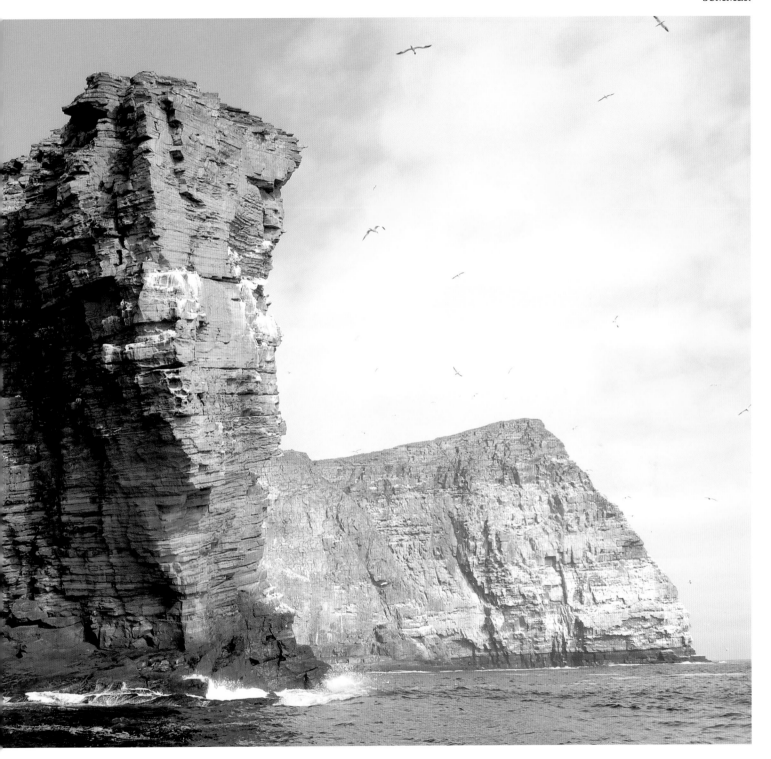

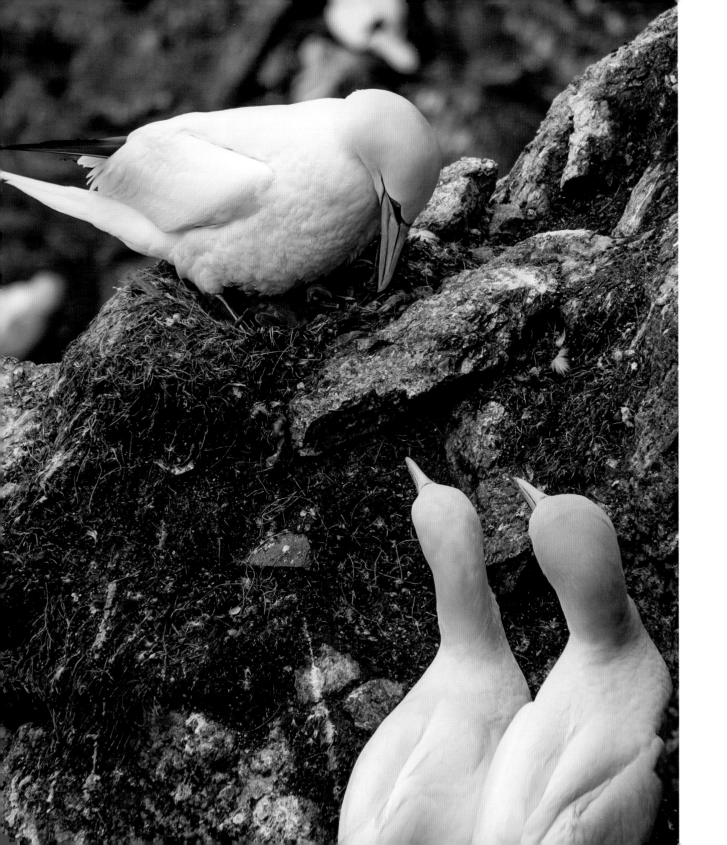

LEFT *A nesting gannet with its chick. The nests are made of seaweed mixed with guano.*

RIGHT *Puffins on Noss.*

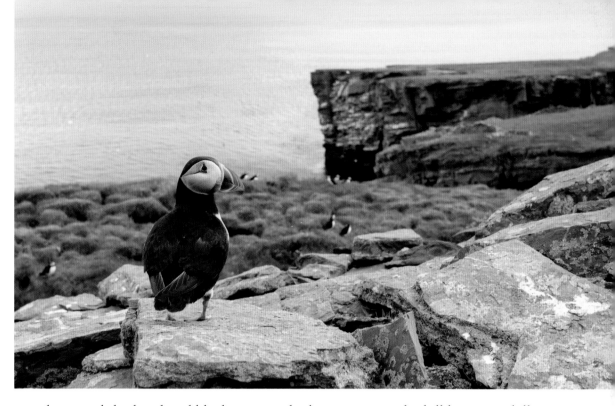

with a yellow wash around the head and black markings near the eye. It's an amazing sight to see these birds fold up their wings and dive from a great height into the sea for fish.

Gannetries can be found at the north end of Fair Isle, on Foula, on Hermaness in Unst and on Noss. Like many seabirds, gannets usually lay just one egg, so a lot of time and energy is expended on rearing a single youngster. Even further up the cliffs the air is alive with fulmars, wheeling in mesmerizing circles; and even against the background sound of the other seabirds, it is possible to hear the 'kitti-wake' call that gives this bird its name.

In the loose soil near the top of the cliffs, puffins make their burrows and lay their single white eggs. The puffins' brightly coloured beaks are shed in winter, so the bill becomes dull then and much more utilitarian. But a summer puffin carrying ten or more sand eels back to its burrow seems a miraculous sight. How do they catch and carry all these fish at once? Some puffins use natural fissures in the cliffs as nest sites, some take over rabbit burrows, and others dig their own burrows with their powerful feet. Sumburgh Head, right at the south of Shetland Mainland, is a great place to see puffins. The RSPB has a reserve there, and most seasons a webcam is set up in one of the burrows so that you can see the birds, up close and personal. There are also organized boat trips throughout the summer to the seabird cliffs on the island of Noss, a nature reserve, and this is a unique experience for birdwatchers and photographers.

LEFT *Harbour porpoise.*

RIGHT *A puffin with a beak full of sand eels.*

While in the southern oceans the staple diet of most seabirds is krill, in Shetland the sand eel is most important. These fish make up some 10–15 per cent of the total fish bio-mass in the North Sea and form the key food source for many of Shetland's seabirds, including guillemots, puffins, arctic terns and kittiwakes. From the mid-1970s sand eels were fished commercially around the islands, and this was thought to be the main cause of the decrease in seabird numbers in recent years. The Scottish Office eventually closed the sand-eel fishery in 1990. When it opened again several years later there were strict time limits on the season, and restrictions on boat size and overall catch. Detailed monitoring of the sand-eel fishery now takes place.

If the seabird colonies in Shetland are thrilling, then a fin slicing through the water offshore can generate even more excitement among lovers of wildlife. Cetaceans – whales and dolphins – can appear at any time in Shetland's waters, but are probably easiest to see in the calmer waters of summer. The smallest and most common marine mammal is the harbour porpoise, which has a very short, broad dorsal fin set midway along its back and a rather blunt head-profile. The animals show their short triangular fins when they surface for air.

Orcas, or killer whales, can also be seen at any time of the year, but they are more obvious in Shetland waters when they come inshore to hunt for common seal pups in June and July. They have been seen from the Queen's Hotel on the waterfront in Lerwick – a real bonus for the hotel's guests. The male orca is very dramatic, with a tall, black dorsal fin and a black body

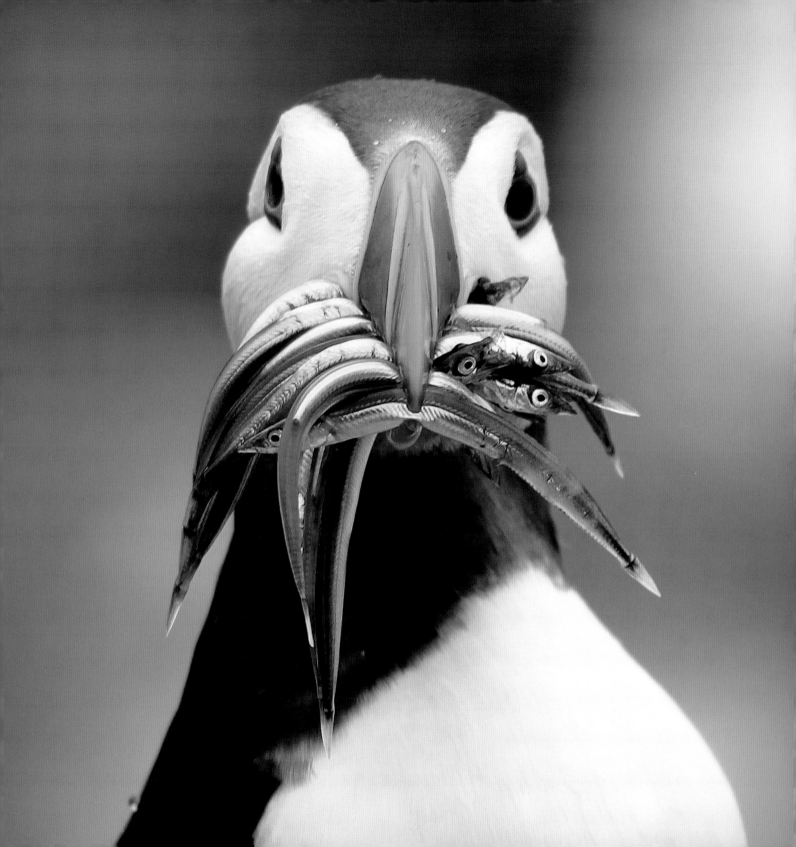

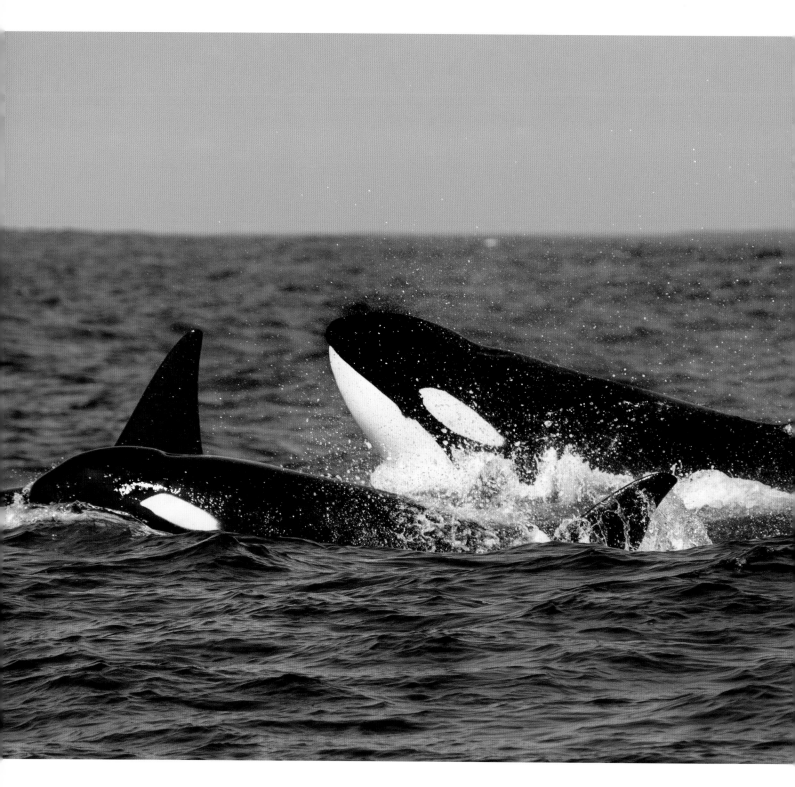

**LEFT** *Orcas.*

**RIGHT** *A minke whale.*

with white patches behind the fin and to the side of the head; the underparts are also white. The female orca has a smaller, backward-curving dorsal fin. These animals often travel in small family groups of three or four individuals. I remember the excitement caused when a group was seen from the Fair Isle mailboat on a calm summer crossing.

A surfacing whale with a very long, sleek body and a small curved fin towards its tail is almost certain to be a northern minke whale, which can reach twenty-three to thirty-three feet long. This is the most common whale seen in Shetland waters, and animals reach their peak numbers in August. The usual sightings of minke whales are of single individuals, though groups of up to fifteen have been recorded.

While the long-finned pilot whale is only an occasional visitor, it has been recorded in pods of more than a hundred individuals. In the past these animals were hunted by Shetlanders; if they were seen to enter a voe, the islanders would launch their boats and drive the whales into the shallow water, where they would be killed. Now the pleasure for visitors and locals comes from the sight of these magnificent beasts, rather than from their slaughter.

Other whale species are rare in Shetland, though humpbacks are gradually becoming more common, with between one and three individuals seen annually, usually in late spring or early summer.

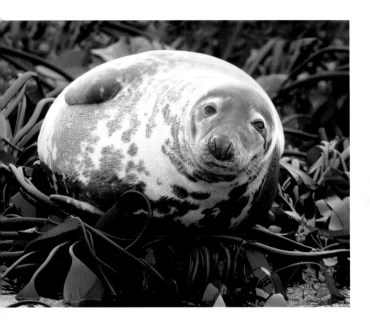

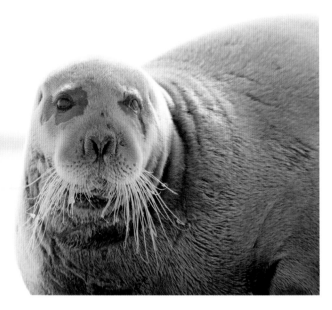

**ABOVE LEFT AND OPPOSITE**
*Grey seals.*

**ABOVE RIGHT** *A bearded seal.*

A range of dolphin species occur in Shetland's waters. Risso's dolphins have curved black dorsal fins and blunt heads and can be seen between April and November. In the deeper pelagic waters to the north and west of the islands the Atlantic white-sided dolphin can be found. They can also be seen from the east coast of Shetland Mainland, and in the water between Sumburgh Head in South Mainland and Fair Isle. Large parties of these animals – with numbers occasionally reaching 1,000 – have been recorded. White-beaked dolphin numbers peak between July and September; its distinctive tall, hook-shaped dorsal fin is black, behind the fin is a white saddle, and the tip of the blunt head usually has a white-tipped beak.

Grey and harbour (or common) seals are easy to spot on Shetland's shores, but some rare species of seal, normally found in the Arctic, visit too. One of these is the ringed seal, which has been recorded on a number of occasions. Another is the bearded seal, which has whiskers like a tough nylon brush and uses them to search for clams and other shellfish along the ocean floor. About twelve of these sturdy creatures have been seen in modern times. The final rare species of seal seen in Shetland is again an Arctic dweller – the hooded seal. It has only been possible to track these animals through specialist telemetry studies, which have proved that the species spends time to the north and west of Shetland and in waters around the Faroe Islands.

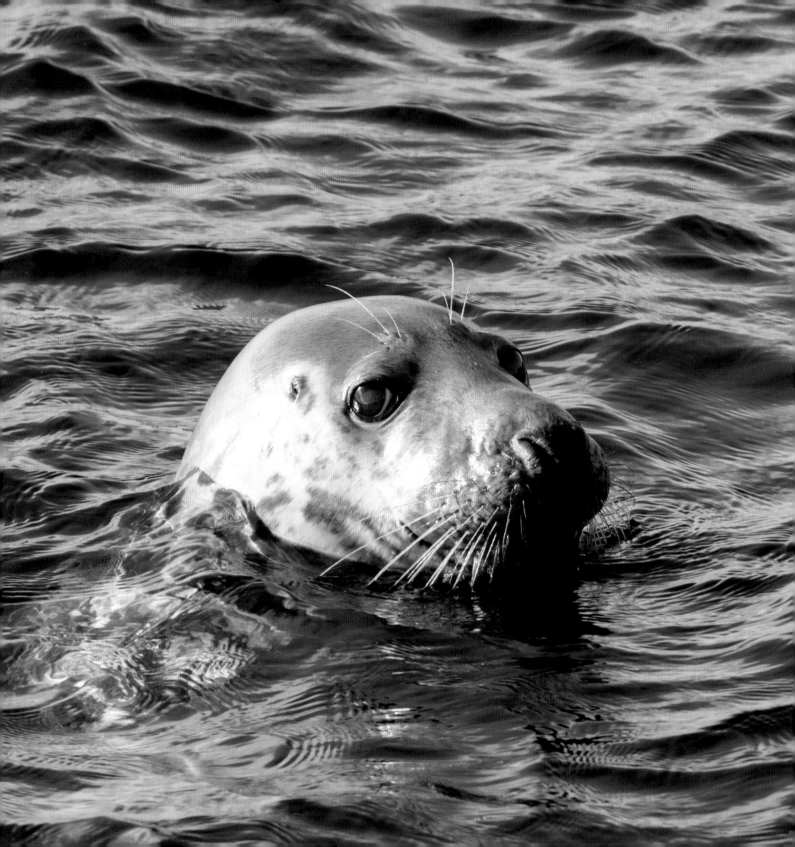

LEFT AND RIGHT *Harbour seals.*

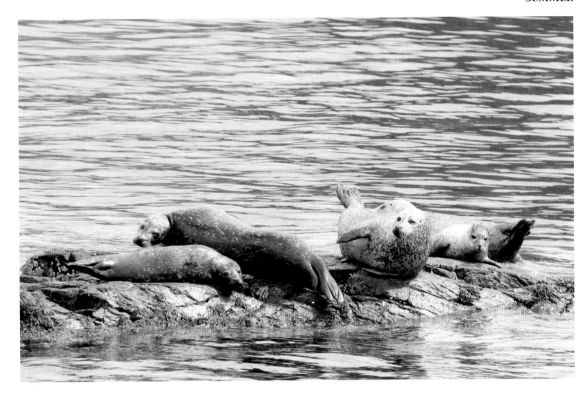

Both grey and harbour seals breed in Shetland and delight visitors, who can get very close to them. A good place to see them is in Lerwick, near the big supermarket by Clickimin Loch, or from Fjara, the new cafe bar in the same area. Harbour seals have their pups in the summer. The adult harbour seals have a rather rounded, pug-shaped face, whereas grey seals – especially the larger bulls – have a longer, flattened 'nose'. When they are ashore resting, harbour seals have a characteristic banana-shaped profile with both head and tail raised. They hunt in the rich kelp beds along the coasts. Grey seals are longer than harbour seals and tend to hunt in deeper waters. They produce their pups in autumn, and many young animals can be lost when huge waves caused by seasonal storms blow into the exposed sites at the foot of the cliffs. As with the seabirds, sand eels form a considerable part of the seals' diets.

Seals have inspired many legends and folk tales. The most common concerns the selkies, or seal people, who are human on land and become animals in the water. There is one midsummer story about a Shetlander who falls in love with the human form of a selkie and follows it beneath the waves, to his doom.

Shetland is also famous for its otters. Unlike the rest of the UK, where they are most often seen in freshwater streams and rivers, otters here are found almost entirely on the coast. They hunt in the sea in sheltered bays, among seaweed, on small islets or boulder beaches, and their food consists of a variety of inshore fish, although they also take crabs. Signs indicate where drivers should take care of them crossing the roads! While there are no otters present in Foula or Fair Isle, there are perhaps 1,000 individuals in the other islands. Otters usually have two young or kits, born between May and August. While in mainland Britain otters are largely nocturnal, because of increased summer daylight they have become accustomed to diurnal living in Shetland and it's possible to see them at any time of the day. A traveller waiting for an inter-island ferry has a good chance of glimpsing an animal close to the breakwaters, because these large boulders are ideal sites for an otter holt.

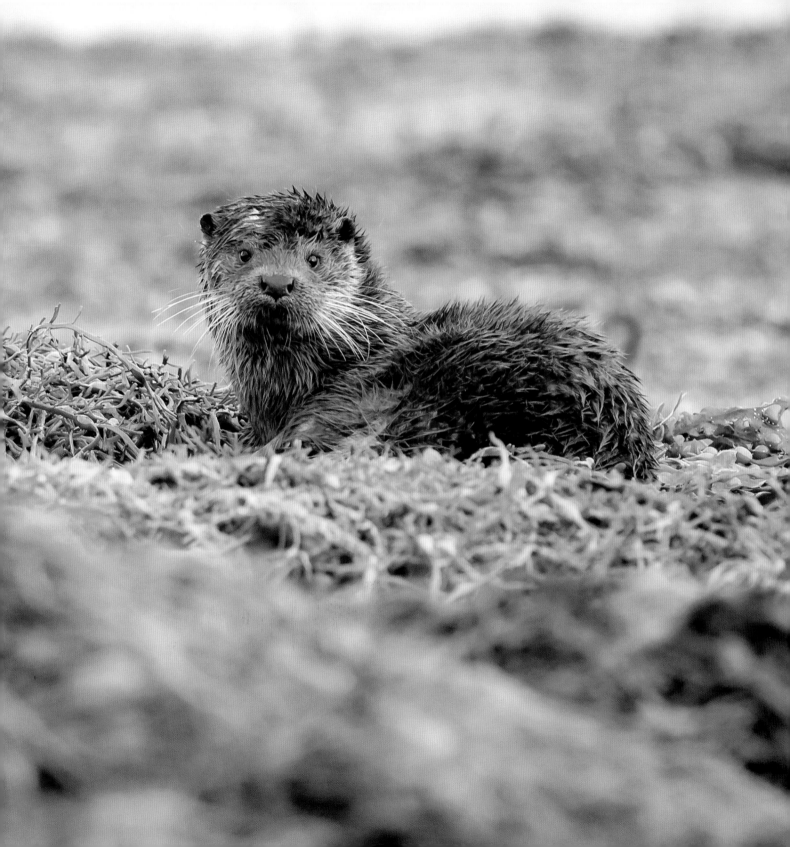

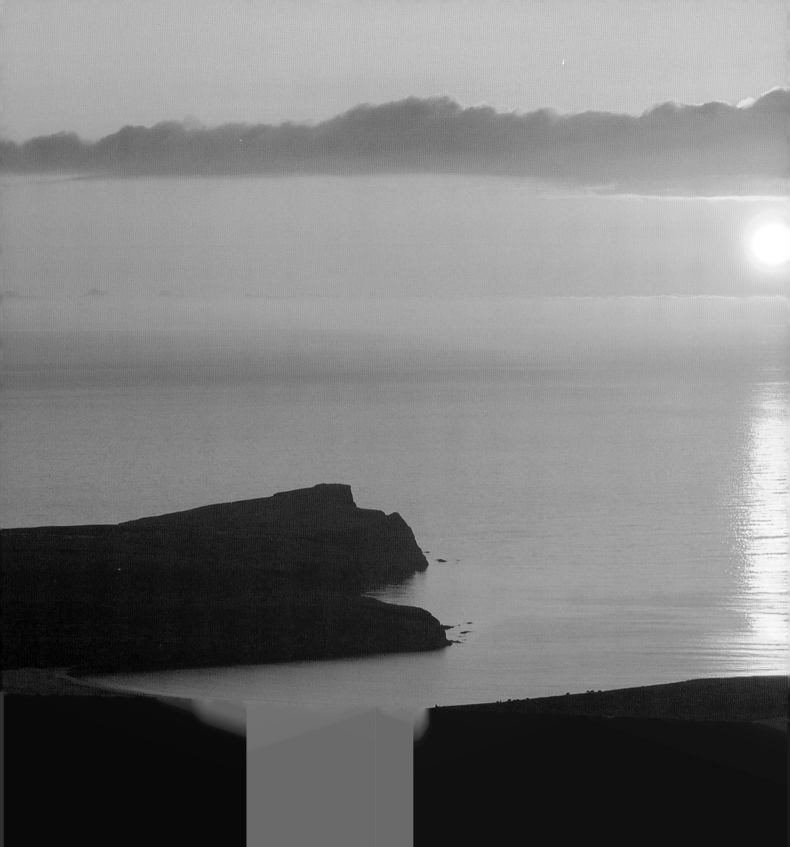

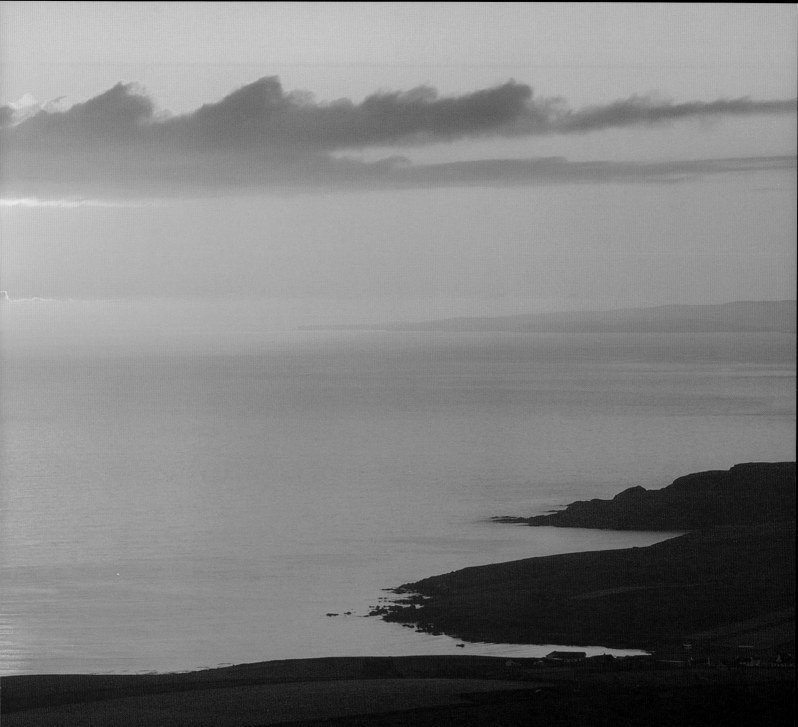

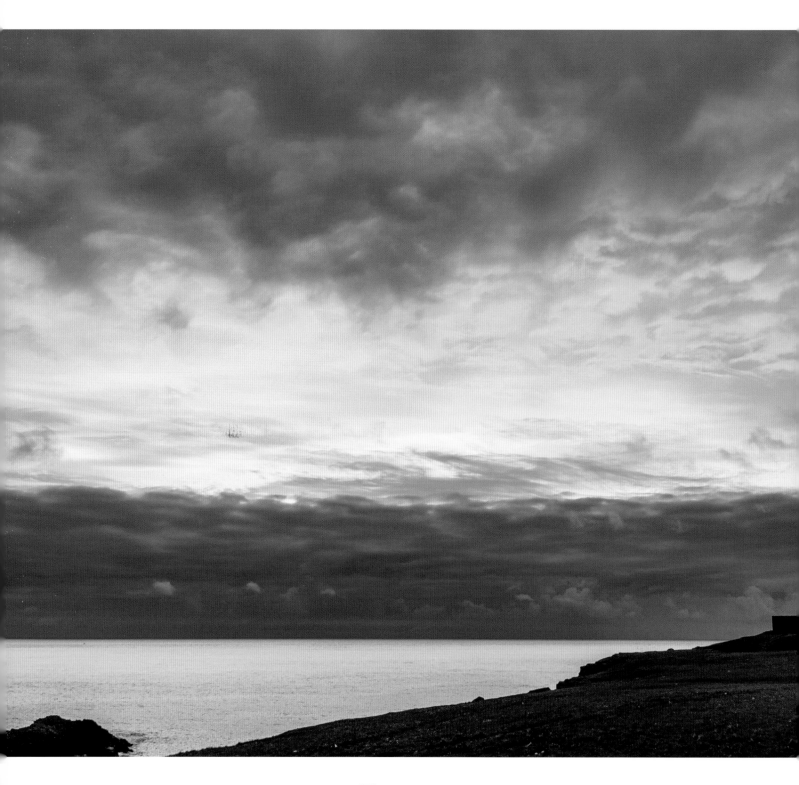

Midsummer is the time to experience one of the more magical Shetland moments – something that brings the sea, the wildlife and the history of the islands together in one place. Mousa is an uninhabited island to the south of Mainland, visible from the main road from Lerwick to Sumburgh. It is managed by the RSPB and is famous for its broch – the most complete tower of its kind in the world. Mousa was first mentioned in Icelandic chronicles in the ninth century, and the broch itself features in two of the Viking sagas. In the eighteenth century the island supported eleven households, but by the end of the nineteenth century the last residents had left.

In midsummer the ferryman who provides visitor access to Mousa from the pier in Sandwick organizes a very special trip. The boat leaves late in the evening just as it is getting dusk – in May and July the departure time is 10.30 p.m. and in June it's 11 p.m. On a fine, clear night it's a magical experience to travel to the small island in the strange half-light of a Shetland midsummer, which local people call the 'simmer dim'. We made the trip with local friends who came well prepared, with flasks of hot tea and extra-warm clothing.

As we walked towards the broch it was still light enough to see how well the tower had been preserved, and to marvel at the skill that went into the building of it. It's even possible to climb the steps between the double-skin of the outer wall and stare out from the lookout points, as people must have done centuries ago. As it grew darker we began to hear noises from the walls of the broch and from the ruined field walls close by. It sounded a little like the murmuring of small mammals. Then we were aware of the movement of tiny bat-like birds flying into the island, black and shadowy against the grey dusk sky. These were storm petrels, which feed during the day at sea and use the half-light to protect themselves from predators as they return to their nests to feed their young.

When the small boat returned to Sandwick, the darkest period of the night was already over. We were chilly by then and glad of the extra clothing we had brought with us. As we drove north to Brae, where we were staying, we could see the sun already sliding up from the horizon to mark a new day.

**ABOVE AND RIGHT** *A storm petrel nesting in the wall of Mousa Broch (right).*

Autumn

### Shetland Wren by Jack Renwick (1924–2010)

| | |
|---|---|
| Gale shriekin ta da high heevins | *Gale shrieking to the high heavens* |
| Wi a hail-laced fury o rain | *With a hail-laced fury of rain* |
| Ower a tangle-twistin, waarblade treshin | *Over a tangle-twisting, seaweed thrashing* |
| Froadin fish kettle o a sea | *Frothing fish kettle of a sea* |
| Aerial brakkin, pooer cutting, mains burstin, | *Aerial breaking, power cutting, mains bursting,* |
| Wire snappin Naetir-in-a-paashin | *Wire snapping Nature-in-a-rage* |
| An Man, smaa is a lempit | *And man, tiny as a limpet* |
| Oagin inta his shell | *Crawling into his shell* |
| Dan silence | *Then silence* |
| An in a sudden ray o sunlicht | *And in a sudden ray of sunlight* |
| A peerie broon wren singin. | *A little brown wren singing.* |

Autumn is a season of the equinox, of fierce gales and big tides. The wind seems to be predominantly westerly, as Atlantic lows chase across the sea from North America. I was interested in exploring in a novel the theme of obsession, and of emotion that grows and becomes uncontrollable. A Shetland autumn seemed a good backdrop for a novel about stormy passions and irrational behaviour. I very much wanted to set a book in Fair Isle too; although I visit it less often now than I'd like to, this is still the place in Shetland that I know best – it's where Jimmy Perez was born and where his fictional family lives and works.

*Blue Lightning* takes Jimmy back to his birthplace, and in a sense it takes my love of crime fiction back to its roots too. Golden Age detective stories were my introduction to the genre. I loved the tales of Dorothy L. Sayers and Margery Allingham. I read widely as a young woman, but always went back to traditional crime fiction for my comfort-reading. If I had a cold or had been dumped by my boyfriend, those were the books I returned to for escape and reassurance. In *Blue Lightning* I decided to write a book set in an enclosed community without access to the outside world – a setting beloved by Golden Age detective novelists. Agatha Christie made the device work for her with a train stuck in the snow and a boat on the Nile, but it was the wild autumn weather of Shetland that enabled me to follow the same format.

There are times throughout the year when Fair Isle is cut off from the Shetland Mainland for a few days, but in autumn a big sustained gale means that it can become isolated for even longer. The mailboat, the *Good Shepherd*, is hauled out of the water right onto the shore to keep it safe, and the small planes stay away. When I worked in the observatory those were the times when some visitors fretted, because no matter how influential or wealthy they were, there was no way they could escape from the island. They had to cancel their business meetings, alter work schedules and just sit out the storm. And when our supplies grew low in the kitchen, we baked our own bread, as islanders would have done before the regular mailboat service. In this situation Jimmy Perez would be without the help of a pathologist or crime-scene investigator, for it would be impossible to send samples off to the forensic lab. He'd have to solve the crime using his knowledge of the island and his own intelligence.

**CHAPTER OPENER** *Tourist boat passing Mousa Broch.*

**PREVIOUS PAGE** *Looking back at Fair Isle.*

**ABOVE AND RIGHT** *The Fair Isle ferry.*

**OVERLEAF** *Buness and Fair Isle Havens with bird observatory sheds in the foreground.*

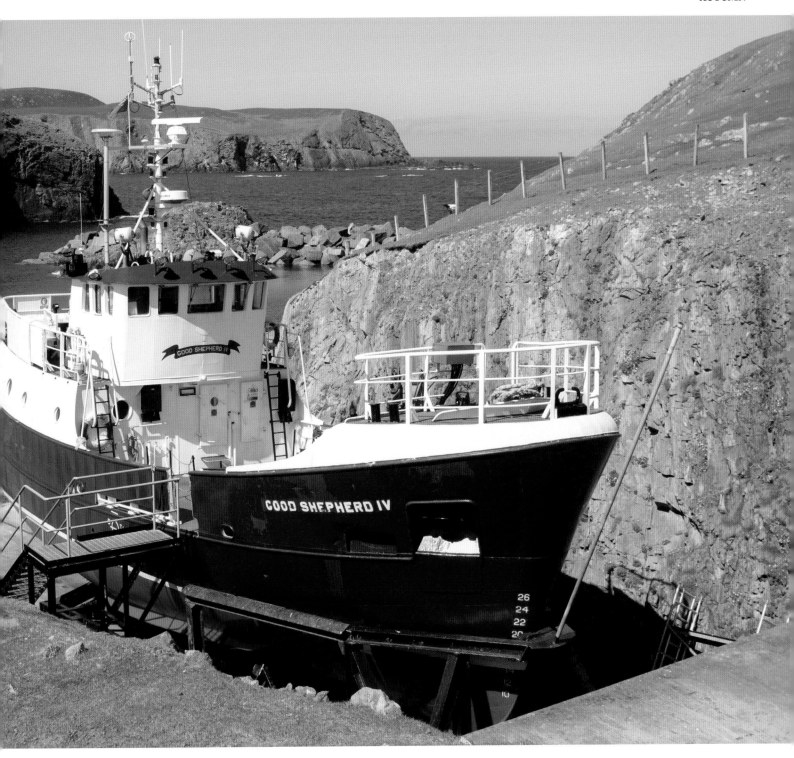

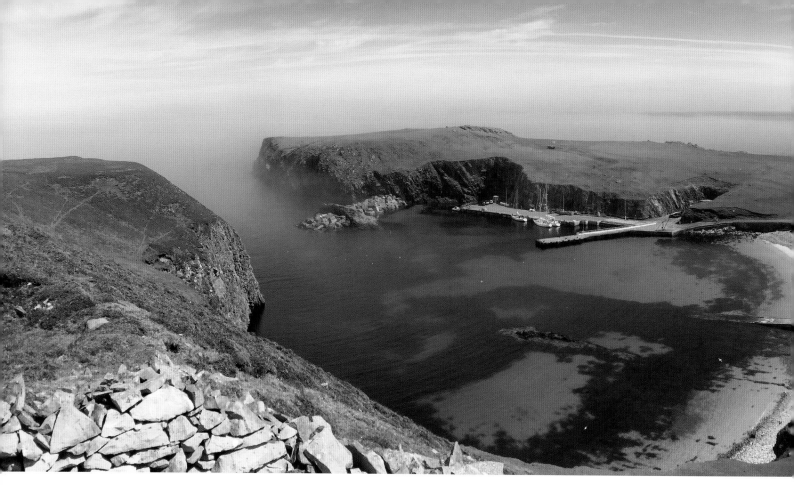

In this extract, Jimmy Perez and his fiancée Fran arrive into Fair Isle by plane just before the weather deteriorates so much that travel becomes impossible:

*Fran sat with her eyes closed. The small plane dropped suddenly, seemed to fall from the sky and then levelled for a moment before tilting like a fairground ride. She opened her eyes to see a grey cliff ahead of them. It was close enough for her to make out the white streaks of bird muck and last season's nests. Below, the sea was boiling. Spindrift and white froth caught by the gale-force winds spun over the surface of the water.*

*She imagined the impact as the plane hit the rock, twisted metal and twisted bodies. No hope at all of survival. For the first time in her life she was scared for her own physical safety and was overcome by a mindless panic that scrambled her brain and stopped her thinking.*

*Then the plane lifted slightly, seemed just to clear the edge of the cliff. Perez was pointing out familiar landmarks: the North Haven, the North Light, Ward Hill. It seemed to Fran that the pilot was still struggling to keep the aircraft level and that Perez was hoping to distract her as they bucked*

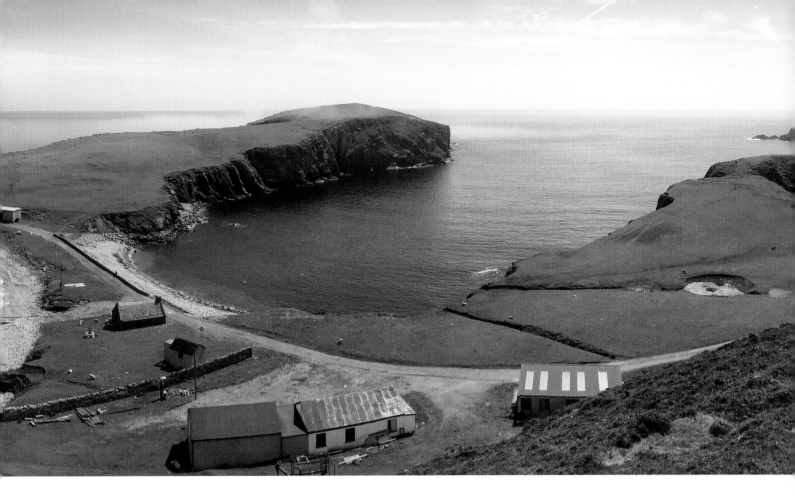

*and swivelled to make a landing. Then they were down, bumping along the airstrip.*

I first arrived into Fair Isle after a strong gale, and the mailboat crossing made me realize how precarious the life of the islanders must have been in earlier times. The need for self-reliance and cooperation was obvious. When I reached the North Haven – the natural harbour where the *Good Shepherd* is moored – it seemed as if the whole island had turned out to help unload the boat. Many of the goods were carried to the south end of Fair Isle, where most of the residents live, on the back of an ancient lorry. Groceries were for the shop, and mail was for the post office (these days the post office is also located in the shop at Stackhoul). Occasionally a new car would be transported on the boat and winched ashore. Sometimes the boat carried livestock, building materials, and often there were passengers: relatives visiting for a break, kids home for school holidays, and holidaymakers who planned to stay at the bird observatory or at one of the crofts that offered bed and breakfast.

181

Even today when the scheduled plane service is much more frequent than it was forty years ago, some visitors choose to arrive into the island by boat. It's very much cheaper than the plane and there is always the chance of seeing a rare bird on the way across or a pod of orcas or dolphins showing off. In calm weather it's a wonderful way to catch a first glimpse of the isle.

The *Good Shepherd* leaves Fair Isle early in the morning and picks up its cargo and passengers at the pier at Grutness, which lies close to the airport and Sumburgh Head. There is nothing at Grutness except the jetty and a small shelter, where passengers can wait out of the rain. Once a fortnight in the summer the boat goes all the way to Lerwick – this is a much longer journey, but it means that Fair Islanders can make a day-trip to town. Lerwick must seem very busy in comparison to Fair Isle; I always wonder how the eleven-year-old children who come from the small islands to board in the Anderson High School find their new life, away from their family in a town with street lights, noise and traffic. I used the experience of moving from Fair Isle as a youngster to board in the high school as part of Jimmy Perez's back-story – another way to make him an outsider.

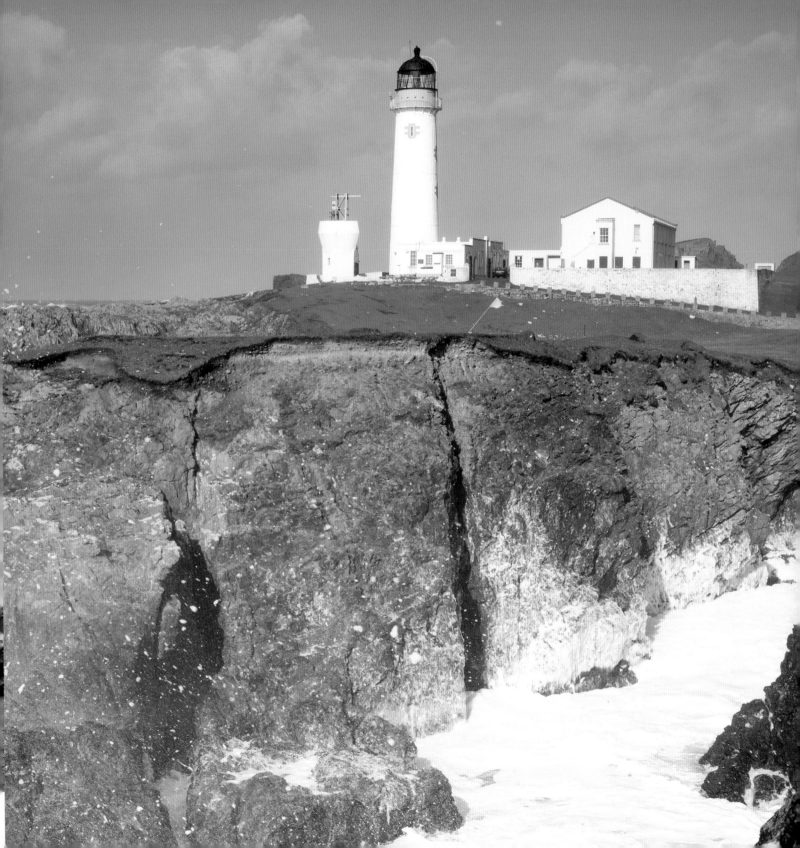

**LEFT** *Commercial Street.*

**ABOVE** *The ferry to Bressay.*

town hall and the library: these are known as 'the lanes'. At the pier end of Commercial Street is the Market Cross, where the Up Helly Aa bill is posted in January each year.

In Commercial Street in 1858 there was a real and very sad case of murder. *The Spectator* of 10 April of that year wrote:

*A fearful tragedy has occurred in Lerwick – a merchant has killed his wife, three of his children and himself. Mr Peter Williamson carried on a good business at Lerwick where he was agent for the Peterhead whalers.*

For locals, a shopping trip down 'the street' can take a long time. It's impossible not to meet people you know and stop for a chat. On the shore side, small alleys lead down towards the Victoria Pier, where some of the grand cruise ships are moored. Close by, the ferry departs on its regular trip to the island of Bressay on the other side of the Bressay Sound. It's become so common to commute to Lerwick that the Bressay island school has recently closed – it seems that it's more convenient for people to bring their children to school in Lerwick on their way to work. On one of these sea-facing alleys sits the Peerie Shop Cafe, which provides good coffee and even better home-bakes and home-made soups. On the other side of the street, the alleys are steep and narrow and lead up to the

The article went on to describe how the brutal murders were carried out, and how the oldest son survived the attack and a fifth child was away from home. In modern crime fiction we're much concerned with motive, but in this case Williamson's motive seemed unsatisfactory. *The Spectator* talked about 'an insane impulse' and continued: 'An alteration in his manner had been observed of late. He had lost a very intimate friend.' In the time just before the murders Williamson had become obsessed with the work of Cakraft the hangman and with notorious murderers. The fascination with celebrity killers strikes a contemporary note and, as with the Weisdale Mill case, I'd love to read a piece of historical crime fiction set around the event. Whatever the motive for the tragedy, this incident must have deeply shocked the close community in 'the street', and Shetlanders as a whole.

LEFT *A cruise ship in mist off Lerwick.*

RIGHT *'Da Lounge'.*

OVERLEAF *Lerwick silhouetted under a cloud.*

Close to the Market Cross in Lerwick is Da Lounge. The bar looks a little rough from the outside (and, indeed, from the inside), but this place is a Shetland institution. Upstairs in the Lounge every Wednesday throughout the year musicians gather to entertain themselves and other people. If a visitor were to wander into the bar in the early evening, he might find a group of young people playing traditional tunes. They might seem out of place in a pub, especially if they have a teacher in charge of them, but it's a good venue in which to perform in front of an appreciative audience. Later on in the evening they will probably be replaced by more experienced musicians. Sometimes half the people in the bar seem to have joined in the session.

On the other side of the lane from Da Lounge stood Monty's, a bistro that appeared in *Raven Black*. Monty's used to sell good Shetland food: seafood and lamb so local that diners were told which croft it grew on. Unfortunately it has recently closed and will be deeply missed by islanders, and by visitors tracing the footsteps of Jimmy Perez, who often ate there.

North of the town centre, between the new museum and arts centre and Gremista, is the big NorthLink ferry terminal. Every evening a substantial car ferry – either the *Hrossey* or the *Hjaltland* – leaves for Aberdeen. The time of departure depends on whether or not the ferry will call into Orkney on its way south. Lorries on these ferries, and on the sister freight boat, carry fish, lamb and other Shetland produce south, and also import everything the islanders need. I enjoy travelling by ferry, especially if the weather's calm. The cabins are comfortable and there is something romantic about going to sleep in one place and waking up in another. Sometimes the boat sails very close to Fair Isle – so close that it seems possible to reach out and touch the rocky shoreline. Then I feel homesick for the island and feel it's time to return again.

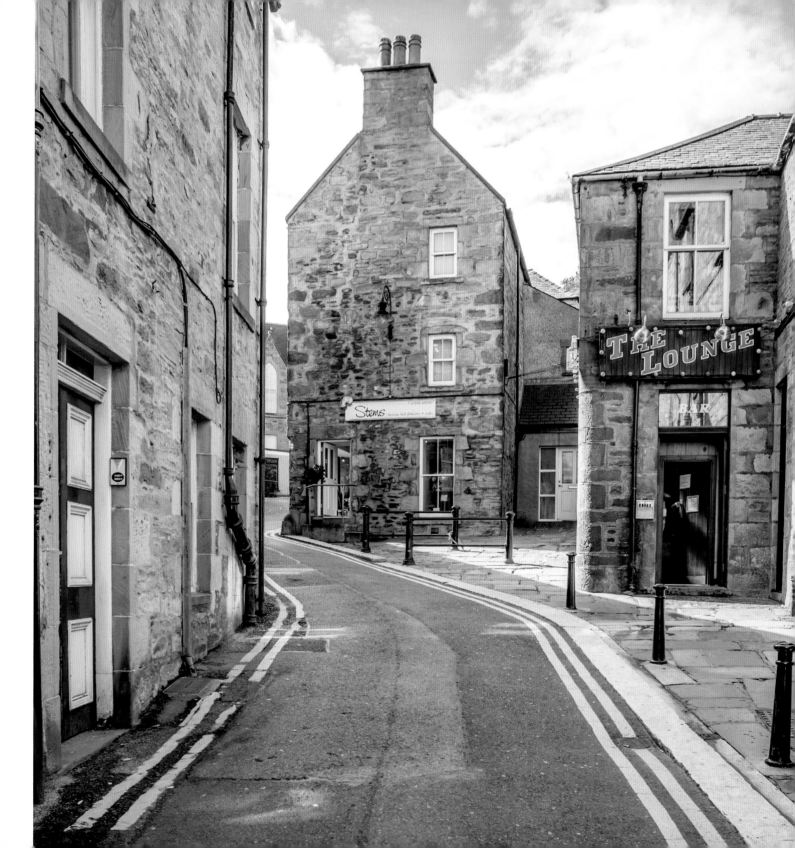

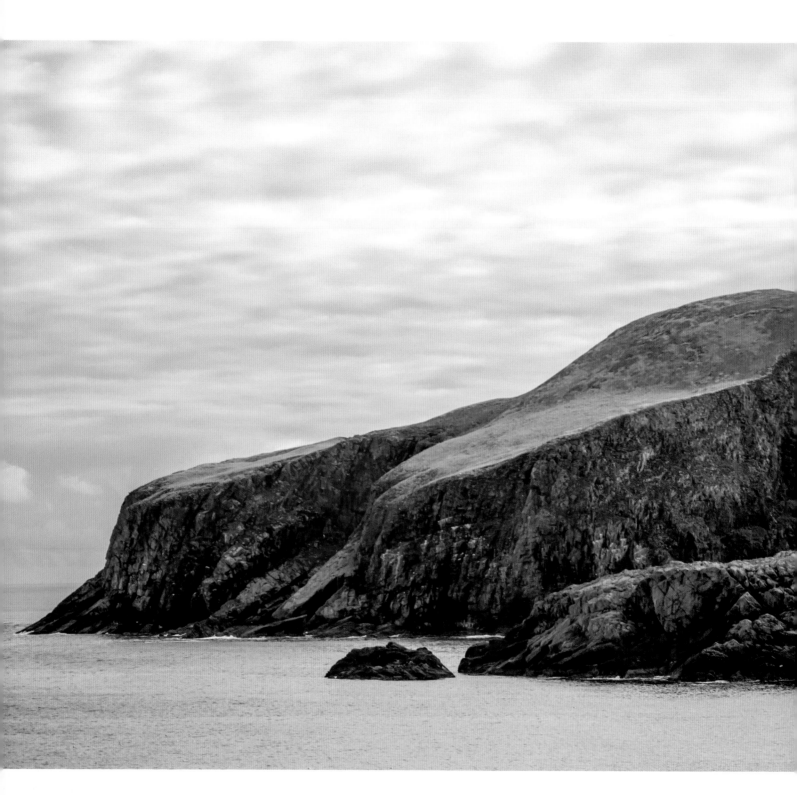

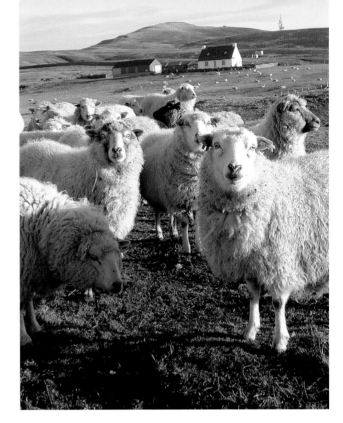

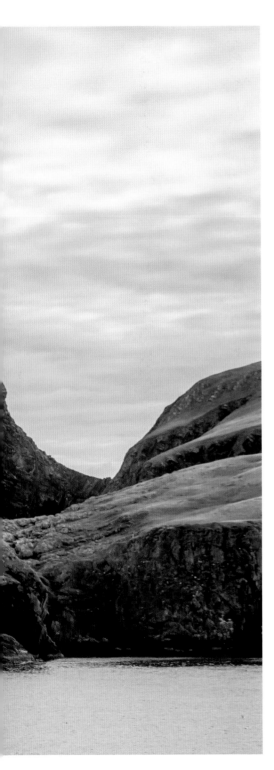

**LEFT** *Sheep Craig off Fair Isle.*

**RIGHT** *Sheep on Fair Isle.*

**OVERLEAF** *Geese flying through mist towards Fair Isle.*

Fair Isle was named Fridarey, meaning 'island of peace', by its Norse settlers. Its outline, visible from the Shetland Mainland on clear days, is distinctive and caused by the silhouette of Sheep Craig to the east of the island. Sheep were still grazed on the rock while I was working in the observatory – traditionally the grazing belonged to the shop, which had no croft land attached to it. When Barry Sinclair, who ran the shop then, decided he no longer needed to keep sheep there, my husband went over in a small boat with him and other men to bring back the redundant fencing. There is a chain attached to the cliff to help with the steep climb to the top. It was a precarious walk, but Tim felt that he was taking part in a piece of island history.

Since the middle of the nineteenth century Fair Isle's history and prosperity have been influenced by the rare birds that visit it. Although the autumn winds are usually westerly, occasionally they move to the east, blowing towards Shetland off a high-pressure system over Scandinavia. If an east or south-east wind meets a bank of cloud or fog over the islands, the conditions are just what the birdwatchers who flock north in the autumn are hoping for. Birds that have started their migration in Asia can get blown off-course. And if they land in Fair Isle, exhausted after the long flight, the fog and cloud can prevent them from leaving. Fair Isle has recorded more rarities in its three-and-a-half-mile by mile-and-a-half land mass than any other place of its size in the UK. Now a new lodge, on the site of the previous building at

the North Haven and very close to the original
Nissen huts that formed the first observatory,
provides excellent accommodation for the
scientists who ring and census the birds, and
for visitors. It also provides a social space for
islanders and guests.

Fair Isle was recognized as a special place
to study migratory birds by early pioneers in
ornithology. Yorkshireman Dr William Eagle
Clarke encouraged some of the islanders –
particularly George Wilson Stout of Busta – to
learn more about the rarer birds that occasionally
arrived into the Isle; and presumably to shoot
anything that he thought was interesting. In the
days before adequate binoculars or telescopes,
the saying went: 'What's hit is history. What's
missed is mystery.' Between 1865 and 1937
Mary du Caurroy Tribe, Duchess of Bedford,

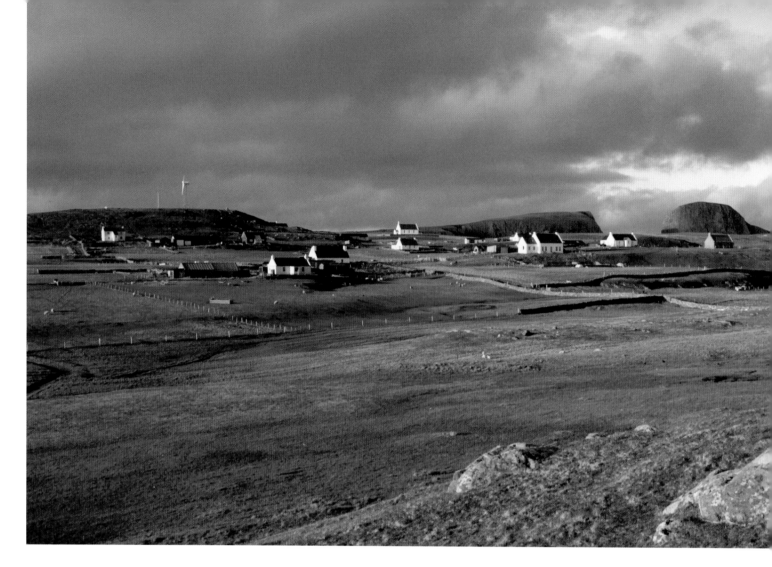

was a regular visitor to the island for the purpose of birdwatching. She stayed at the Pund for an annual rent of £2. The Pund has fallen into disrepair now, though when I worked in the observatory in the Seventies it was used as a camping böd, and it becomes one of the locations for the novel *Blue Lightning*. Even when the house was first built, however, despite its wood panelling and loft bed, it must have been rather primitive and uncomfortable, in contrast to the luxury to which the duchess was accustomed.

Fair Isle was put firmly on the ornithological map by one man: George Waterston (1911–1980). By the outbreak of the Second World War, George was already a regular visitor to the Isle – he first arrived in 1935 after being rowed ashore from the Aberdeen steamer as it passed by. He developed a close relationship with George (Fieldie) Stout, one of the island crofters, often staying with him in his croft at Field. With

**LEFT** *The southern crofts on Fair Isle.*

**ABOVE** *George Waterston.*

the outbreak of war, Waterston became a captain in the Royal Artillery, but was captured in Crete in 1941. During his time as a prisoner-of-war he dreamed of founding a bird observatory on the Isle, and it seemed a portent that on being invalided home via neutral Sweden, his first sight of the UK was the distinctive shape of Fair Isle's Sheep Rock. He wrote to a friend: 'Can you imagine my excitement when the first land sighted was none other than Fair Isle!'

Soon after the war he purchased the island from Robert Bruce of Sumburgh, and in August 1948 the Fair Isle Bird Observatory was opened in a group of naval huts near the North Haven. George became aware that, as laird of the island, he had a responsibility for the people who lived there, as well as for the birds that passed through. He felt that Fair Isle would have a more sustainable future with a different owner, and in 1954 the National Trust for Scotland took over as

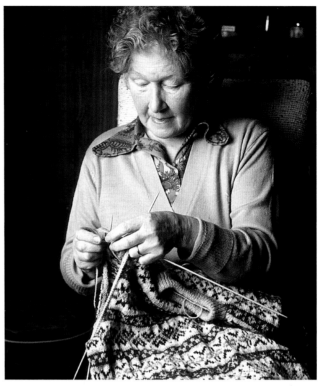

landlord. The Trust still owns the island and has provided consistency and security for its residents. However, George's role hasn't been forgotten, and the small museum in the middle of the island has been named after him. In recent years the island has developed as a centre where traditional culture and crafts can flourish. Within the small population there are still fantastic knitters, a maker of hand-built spinning wheels and Shetland chairs, and a boatbuilder. Lise Sinclair, a Fair Isle poet and musician, brought the haunting beauty of the Isle to a larger audience through her work. She was much too young when she died in 2013 and will be very much missed.

Fair Isle attracts visitors from all over the world, and not all of them are birdwatchers – many come just to explore the beauty of the island. Although it's so small, its indented coastline and steep cliffs mean that there is plenty of exciting walking to do. Craftspeople want to meet the residents who keep the traditions alive, and many visitors develop friendships that last for numerous years. Some visitors come because they recognize the name from the Met Office's 'Shipping Forecast', the almost poetic litany of weather in the UK's shipping areas, broadcast by BBC radio. Meteorological records are still taken by the same man who was providing the service when I stayed on the island forty years ago: Dave Wheeler, who lives at Field. At one time he ran a successful croft, worked shifts as a lightkeeper and was the Met officer – an example of the multiple occupations that islanders often need to undertake to survive.

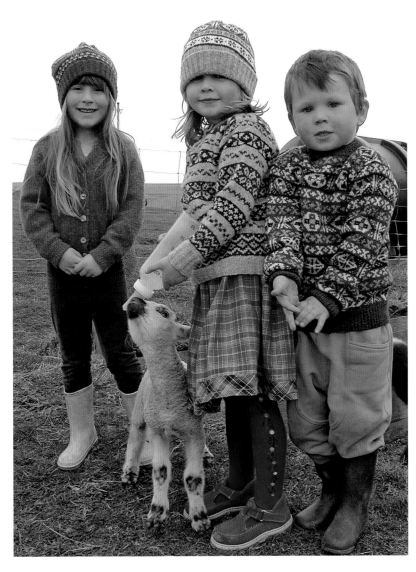

**FAR LEFT** *Stuart Thomson, retired lighthouse keeper, fiddler and spinning wheel maker.*

**LEFT** *Stuart's wife Annie at work on a Fair Isle sweater. Stuart and Annie were Lise Sinclair's grandparents.*

**ABOVE** *The next generation of Fair Islanders.*

## 2 Ply by Lise Sinclair (1971–2013)

| | |
|---|---|
| athin a room | inside a room |
| whaur fiddles | where fiddles |
| an wheels pluy | and wheels play |
| athin dy hands | in your hands |
| my graandfaider, | my grandfather, |
| nu a moorit | now a brown |
| fleece, still | fleece, still |
| sheepy, trau | sheepy, through |
| dy haands | your hands |
| den, apo da pirm | then, on the bobbin |
| moorit yaarn | brown yarn |
| biggs up | builds up |
| aleng da line | along the line |
| o heuks. | of hooks. |
| | |
| an as I pluy | and as I play |
| da auld tunes | the old tunes |
| du's learnin me | you're teaching me |
| du sets | you set |
| my doithter | my daughter |
| til a wheel | to a [spinning] wheel |
| suyan | saying |
| dis is da een fur dee | This is the one for you |
| see, wirk dee fit | see, work your foot |
| pull back | pull back |
| pull back | pull back |
| Dunna lat da snud | Don't let the twist |
| geen athin da oo | get into the wool. |
| Dat's da wye. | That's the way. |
| | |
| Alice sits, | Alice sits, |
| ee fit wirkin da treed | one foot working the thread |
| da tidder, dancin | the other, dancing |
| tae da baet o da fiddle | to the beat of the fiddle |
| pull back | pull back |
| pull back | pull back |
| Dunna lat da snud | Don't let the twist |
| geen athin da oo | get into the wool. |
| Dat's da wye. | That's the way. |
| | |
| an nu tree hank | and now, three skeins of yarn |
| twaa ply | two ply |
| ee straand o her yaarn | one strand of her yarn |
| wi ee straand o dine. | with one strand of yours. |

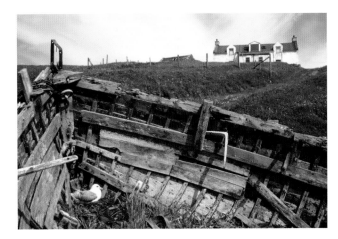

**LEFT AND ABOVE** *Foula.*

Foula is another remote, inhabited island to the west of Shetland, and it too attracts rare migrant birds and the birdwatchers who seek them. Though it is similar in land size to Fair Isle, a visit to Foula is a very different experience. Perhaps because the island is still in private ownership, the community is less cohesive. There is the potential for tourism in Foula – the cliffs are second in height only to St Kilda's in the Hebrides, and the island is beautiful – but there is little accommodation for visitors. The self-catering cottage is some distance from the jetty and, because there is no shop in Foula, all food and drink have to be taken in. There is a regular plane service, but it isn't as frequent as the one to Fair Isle, and the boat times can be a little erratic. Foula is well worth the effort it takes to stay there, and the islanders welcome visitors, but the trip should be considered an adventure.

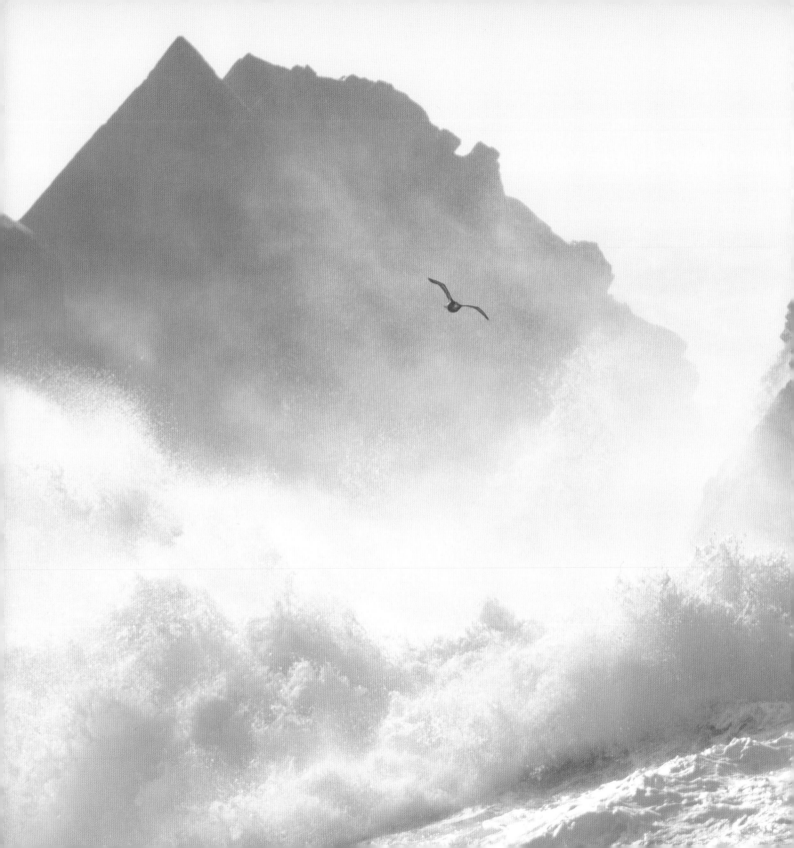

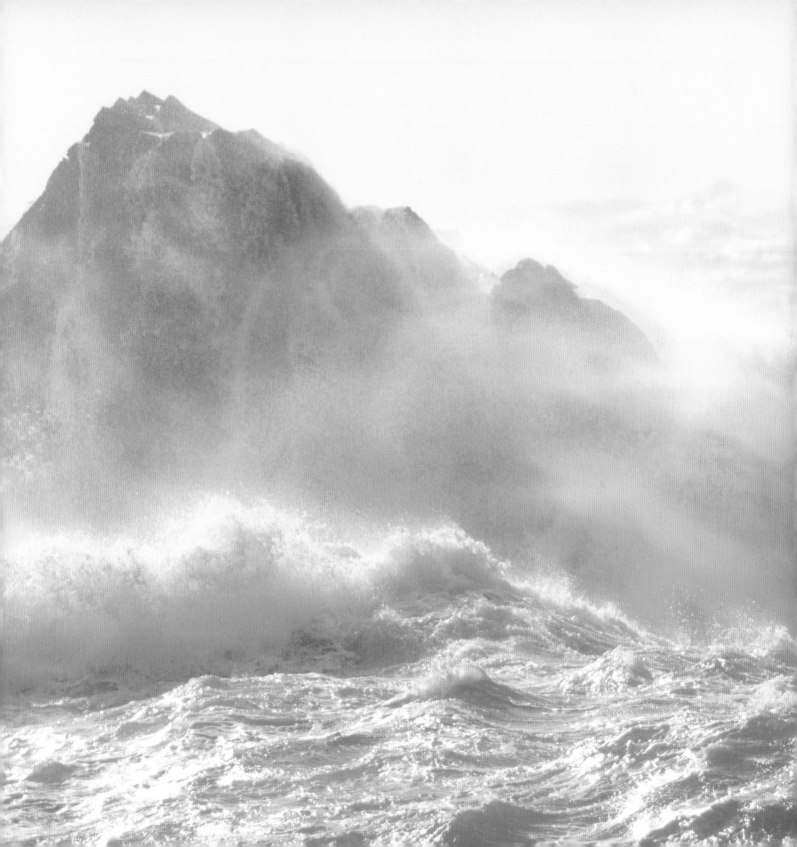

Birdwatchers aren't the only enthusiasts who migrate to the islands in the autumn, though. In late September or early October Shetland hosts its famous Wool Week. Knitters, spinners and dyers from all over the world make the pilgrimage to the home of Shetland wool and Fair Isle patterns. Until I met an American visitor who was playing a major part in the event, I hadn't realized that there was such a thing as a field guide to sheep. Each year there are workshops, masterclasses and exhibitions, and events take place in venues from the southern tip to the most northerly island of Unst, which is best known for its knitted lace.

Autumn is also the time when Shetland celebrates film and literature, with its Screenplay and Wordplay Festivals. Reviewer and broadcaster Mark Kermode and his wife, Linda Ruth Williams, regularly programme the film festival, and Wordplay attracts authors and poets with an international reputation. There are many reading groups in the island and the festival pulls in a terrific audience. Crime fiction – especially Nordic crime fiction – is particularly popular, and in 2015 Shetland Noir hosted writers and readers from Iceland and Scandinavia, as well as from Scotland and England. The Shetland library service is extremely well used and, under the leadership of Shetlander Karen Fraser, hosts imaginative events throughout the islands.

One of these was the 24/24 Challenge, which took place in September 2014 and gave me another and very exciting perspective on the islands. The project took me, BBC radio producer Joe Haddow and other writers to some of the more remote communities in Orkney and Shetland – and we had just twenty-four hours to complete the challenge of organizing reading events in twenty-four of the Orkney and Shetland Isles. The idea came from Stewart Bain, who works for Orkney Libraries in Kirkwall, when we were in a small plane flying back to Kirkwall airport from North Ronaldsay – the Orkney island closest to the Shetland archipelago. He and I had been there to celebrate the service provided to the small islands by the library, and the response from islanders to an author visit was astonishing. We decided to extend the project and acquire some well-needed publicity for the great work done by the library service in remote and rural areas. While Orkney and Shetland are very different island groups – Orkney is gentler, more fertile and much nearer to the Scottish mainland – they have much in common, and the challenge provided an opportunity for the two communities to work closely together.

I couldn't undertake the project all by myself of course, but the idea seemed to catch the imagination of readers and writers in both archipelagos. St Magnus Cathedral in Kirkwall opened late in the evening for readings of ghostly tales, and my Danish publisher (who happens to be a Shetlander) translated one of

**PREVIOUS PAGE** *Rough seas off Fair Isle.*

**RIGHT** *St Magnus Cathedral in Kirkwall, Orkney.*

my short stories into the Shetland dialect, while fellow published authors – both from the islands and from outside – turned out to help. Reading groups and library staff had their own ideas for imaginative events, and we hoped to make both island groups come alive with stories, poetry and rhyme.

I started in Orkney, with a visit to the school in Papa Westray, which involved taking the shortest scheduled flight in the UK, from Westray. The school children helped me count down to the beginning of the challenge

and, after several events in Orkney, I took the midnight boat to Shetland and arrived in Lerwick at 7.30 a.m., in time to chat to commuters on the Bressay ferry into the town. Then I jumped into the mobile library and was driven to the islands in the west that can be reached by bridge. We stopped at Burland, in the island of Trondra, where we saw how lovingly some of the traditional crofting methods and species have been preserved. We were treated to fiddle music and home-bakes too – a great example of Shetland hospitality.

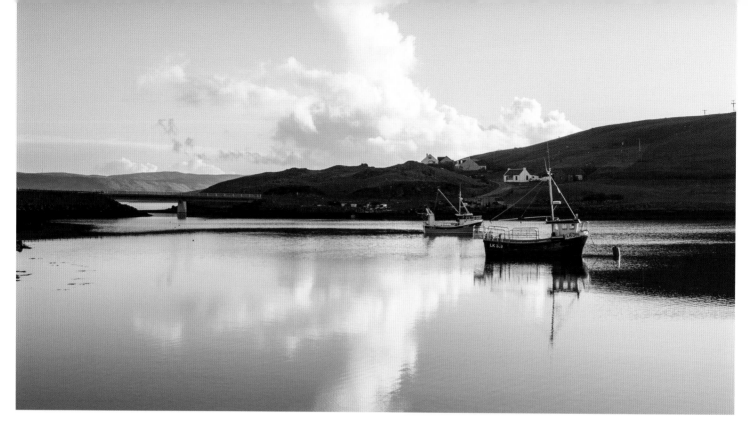

The twin-bridged islands of East and West Burra lie to the south of Trondra, and both of these counted towards our target of twenty-four islands. I chatted to the children in Hamnavoe School. Hamnavoe is a pretty village, which has thrived since the bridges were built and has attracted people who can now commute to Lerwick. There was great interest in our visit within the school, because some of the pupils had taken part as extras in one of the episodes of *Shetland* when filming took place on their island. I did a meet-and-greet in East Burra, chatting to the people who turned up at the mobile-library stop to share their passion for crime fiction. Burra has some of the most beautiful beaches in Shetland – Meal Sands is

**ABOVE** *Muckle Roe Bridge.*

**BELOW** *Hamnavoe.*

**OPPOSITE** *Muckle Roe from Mainland.*

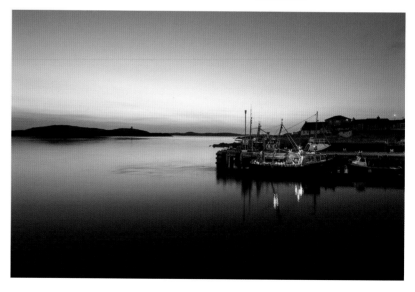

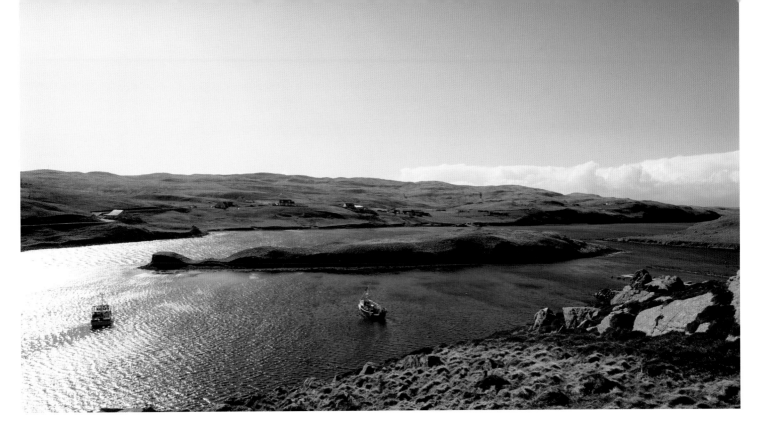

one of my favourites – but there was no time to explore the coastline that day. The clock was ticking and we had to move on.

I arrived at the community hall in Muckle Roe just as the Gruffalo was entertaining the pre-school children. The Gruffalo had been a great hit in Orkney, but the costume provided by Julia Donaldson's publisher was so bulky that it was impossible to transport it in time to Shetland. Luckily the children's character had featured in one of the Up Helly Aa sketches, and the squad that had performed with him was happy to lend its costume to us for the occasion. Muckle Roe is reached by a very small bridge from the west of Shetland Mainland beyond Brae. If the tide is right it's possible for a boat to pass underneath the bridge. In Muckle Roe there was just time to greet the children and their parents (and time for tea and more cake) before we had to set off again. Here I left the mobile library and was collected by some colleagues from Pan Macmillan to begin the drive north towards our final destination: the island of Unst.

But before we arrived in Unst we had to pass over the island of Yell. For many visitors, Yell is just that – a means to get to Shetland's most northerly communities in Unst – but it is certainly worth a visit in its own right. Writer Louise Welsh was based here for the twenty-four-island challenge, before joining me for our event in Unst. The ferry leaves the pier at Toft in the north of Mainland, crosses Yell Sound

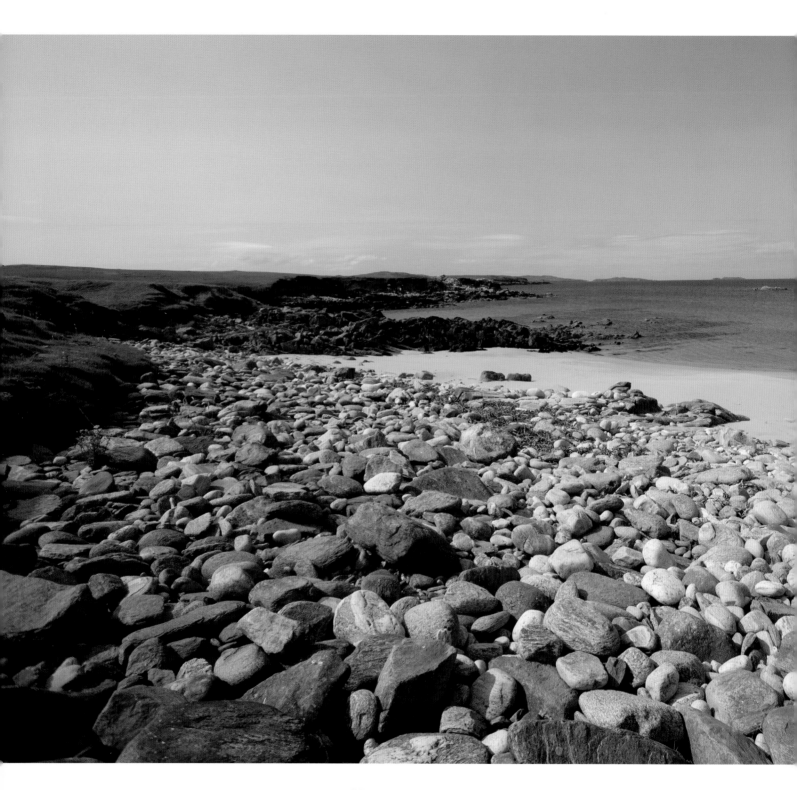

**LEFT** *West Sandwick Beach on Yell.*

**ABOVE** *The Old Haa, Burravoe, Yell.*

and arrives into Ulsta. Driving north to catch the onward ferry from Gutcher, it's tempting to believe that the island is one big peat bank; and indeed peat is still regularly cut here in the spring, sometimes by machine, but often by the traditional method, using a tushkar – a tool that has been used for centuries to cut the wet fuel and to lift the blocks into stacks to dry. However, it's worth deviating from the fast road north to explore more of the island. Burravoe faces south and was one of Yell's most important settlements during the time of Hanseatic trade. It has a local museum and interpretive centre in the Old Haa, a house dating back to 1672. Mid Yell is the island's largest community, and has a secondary as well as a primary school. In *Thin Air* some scenes take place in an art gallery in Yell, and the island does have its own gallery in Sellafirth. Whenever I visit I'm tempted to buy, because the Shetland Gallery exhibits some of the best of the islands' contemporary art and high-end craft.

Our twenty-four-hour challenge ended in Unst, in the school in Baltasound, which hosts the UK's most northerly library. Baltasound is the largest settlement in Unst, with a harbour protected by Balta Isle, which lies a few miles offshore to the east. At the beginning of the twentieth century it had a thriving herring fishery; now salmon-farming has taken over, and little remains of the fishing stations and piers of earlier times. Haligarth, to the north-east of Baltasound, has the UK's most northerly woodland. The garden is famous as a good place to look out for migrant birds, and my husband has spent many hours staring into it with his birdwatcher friends. That day in September, however, we had no time for sightseeing. We arrived in Baltasound with only minutes to spare before the twenty-four hours ran out. The library assistant was running a session for pre-school children and, just as children in Orkney had marked the start of our challenge, so the bairns in Unst counted us down to celebrate the end of it.

**B**y the end of autumn the days are getting shorter again. The seabirds have left and the ravens have the cliffs to themselves. There are no more cruise ships in the harbour in Lerwick. Shetlanders prepare for the festivities of Christmas, Hogmanay and Up Helly Aa, and for the cycle of the year to begin once more.

**RIGHT** *Sunset on Unst.*

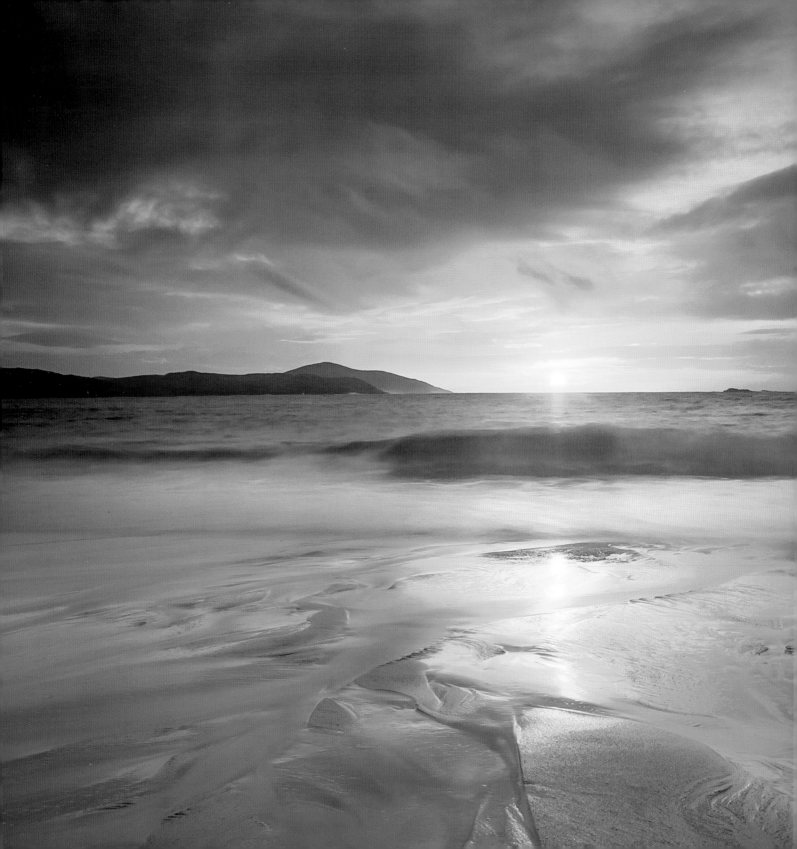

# Conclusion

**S**hetland is a landscape of contrasts. There are sheltered voes and beaches and dramatically exposed cliffs; lush meadows full of wild flowers in the summer and bleak hilltops where only the hardiest of plants will grow. With the changing seasons, the character of the place shifts as the dark days of winter give way to the light nights of summer.

In the islands, traditions are valued and celebrated, but new technologies and ways of working – especially in energy and fishing – are embraced. Shetland is the most remote place in the UK to live, yet often it feels at the heart of the artistic and cultural life of the nation. I find it welcoming, intimidating and inspiring.

Shetlanders have been unfailingly gracious about an outsider's attempts to capture the spirit of their home in fiction, and have encouraged me to celebrate the islands in this book. I hope it will persuade more people to travel north to experience Shetland's bleak beauty and to form their own relationship with a very special place.

**LEFT** *Meal Beach, Burra.*

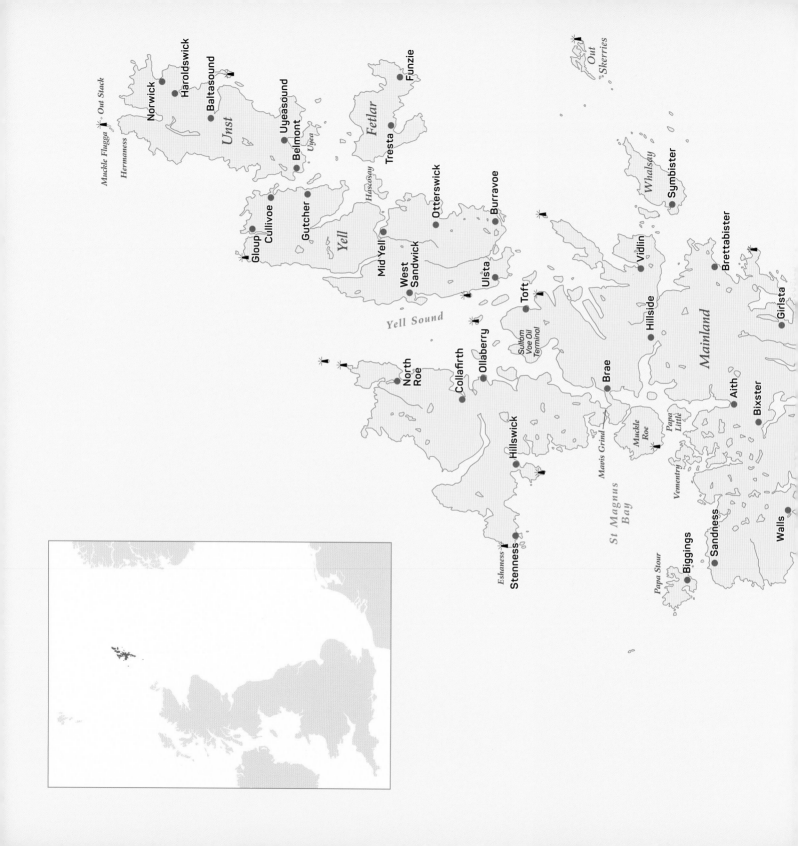

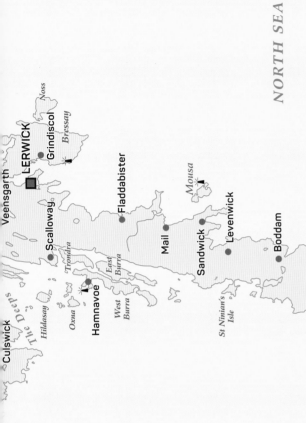

NORTH SEA

ATLANTIC SEA

*Noss*

LERWICK

Grindiscol

*Bressay*

Veensgarth

Fladdabister

Scalloway

*Mousa*

*Trondra*

Mail

*East
Burra*

Sandwick

Levenwick

Hamnavoe

Boddam

*Culswick*

*The Deeps*

*Hildasay*

*Oxna*

*West
Burra*

Sumburgh

*St Ninian's
Isle*

*Foula*

Ham

# SHETLAND

10km

*Fair
Isle*

Stonybreck

## AUTHOR ACKNOWLEDGEMENTS

I'm a writer of fiction and find facts hard and troublesome things, so I was very grateful for help in the writing in this book. I'm indebted to the books of Charles Tait and Jill Slee Blackadder for sending me in the right direction. Thanks to Tim Cleeves for his research into the natural history of these beautiful islands, for sharing his passion for wildlife and his attention to detail. Thanks to Paul Harvey, Ingirid Eunson and Jim Dickson, for helping to identify some of the images and to Karen Fraser of Shetland Library and the staff of Shetland Archives for finding the remarkable story of the Victorian Lerwick murder. Most especially thanks to Mary Blance for all her support and advice and for her sensitive translation of the dialect poems.

## PICTURE CREDITS

Antje Deistler: back flap

Dave Donaldson (davedonaldson.co.uk): 8, 130, 152 left

David Gifford (davegifford.co.uk): front & back cover, 6, 11, 14, 15, 16, 17 both, 20, 21, 29, 32, 35, 36, 38, 39, 40, 44, 45, 46, 50, 51, 52, 53, 55, 56, 59, 82 top, 85, 90, 94, 95, 96, 99, 121, 123, 136, 146 both, 150, 166, 172, 176, 178, 179, 180, 183, 190, 194, 202, 206 both, 208, 209, 212

Dave Wheeler (davewheelerphotography.com): 10, 102, 132, 193, 196, 198 left & right, 199

Dreamstime.com: Aiaikawa 58 left, 107, 184; Alfiofer 23; Brochman 168; Dudau 165; H368k74 13, 128, 138; Hkuchera 42; Lowlihjeng 88, 89, 126, 151; Marcandreletourneux 186, 189; Mirceax 68; Misha72 207; Orion9nl 78, 92, 144; Panalot 118, 192; Paulagent 122; Photonics 205

Gemma Dagger (gemmadagger.co.uk): 48, 49

John Simpson, Whalsay Golf Club: 82 bottom

Rachel Davis (vagabondbaker.com): 2, 25, 80, 81, 83, 91, 93, 104, 105, 106, 110, 114, 140, 142, 147 both, 152 right, 153 both, 156, 170, 173, 211

Richard Wemyss 120

Sazh1980/Wikimedia Commons: 133

Scottish Ornithologists' Club archives (www.the-soc.org.uk): 197

Shetland Museum Photographic Archive: 24, 26, 27 left & right, 43 left & right, 74

Shutterstock.com: ABB Photo 4, 71, 116, 131; Abi Warner 66; aiaikawa 76, 86, 108, 134, 143; Alessandro Colle 64; Alfio Ferlito 174; Andrea Obzerova 30; Attila JANDI 75; Barnes Ian 28, 101; BGSmith 34; Bildagentur Zoonar GmbH 161; BMJ 162 right; Chris Warham 111 right; Cindy Creighton 73 right; Dmytro Pylypenko 73 left; DrimaFilm 18; Erni 67 bottom, 113 bottom; Giedriius 60, 61, 115, 154, 157; Graeme Dawes 111 left; Graham Andrew Reid 188; JASPERIMAGE 112; Krizek Vaclav 163, 164; LesPalenik 103; MarcAndreLeTourneux 148, 185; Marek Szczepanek 62; Mark Caunt 67 top left, 158, 159, 162 left; Mark Medcalf 167; Mateusz Sciborski 72 right; Menno Schaefer 67 top right; Paul Reeves Photography 72 left; Paula Fisher 124; Steffen Foerster 19, 200, 201; Targn Pleiades 1; Tom Reichner 63; Tory Kallman 160; Trofimov Pavel 70; TTphoto 12, 22, 113 top, 187; WronaART 155

First published 2015 by Macmillan
an imprint of Pan Macmillan
20 New Wharf Road, London N1 9RR
Associated companies throughout the world
www.panmacmillan.com

ISBN 978-1-5098-0979-0

The publishers are grateful for permission to reproduce the following poems: 'Winter Comes In' (p. 33) and 'Shetland Wren' (p. 177) by Jack Renwick, from *The Harp of Twilight* published by the Unst Writers' Group, 2007; 'Water Lilies' (p. 119) by Vagaland, from *The Collected Poems of Vagaland* by permission of the Shetland Archives; 'Voar Day' (p. 79) by Lollie Graham, from *Love's Laebrak Sang* by permission of Mary Graham; '2 Ply' (p. 199) by Lise Sinclair by permission of Ian Best.

9 8 7 6 5 4 3 2 1

A CIP catalogue record for this book is available from the British Library.

This edition project managed by Emma Marriott
Designed by Perfect Bound Ltd
Map artwork by Perfect Bound Ltd from source material by Rainer Lesniewski/Shutterstock.com

Printed and bound by Rotolito Lombarda, Italy